Children's Paper Premiums American Advertising
(1890-1990s)

Loretta Metzger Rieger and
Lagretta Metzger Bajorek

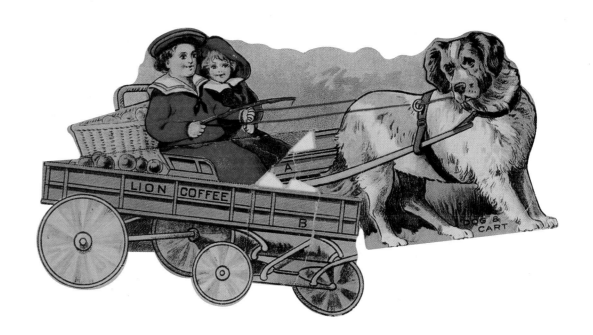

Schiffer Publishing Ltd

4880 Lower Valley Road, Atglen, PA 19310 USA

Dedication

To the two men in our households, Ben Bajorek,
our photographer, and Paul Rieger, our reviewer.

Library of Congress Cataloging-in-Publication Data

Rieger, Loretta Metzger.
 Children's paper premiums in American advertising (1890-1990s) /
Loretta Metzger Rieger and Lagretta Metzger Bajorek.
 p. cm.
 ISBN 0-7643-1012-7
 1. Advertising specialties--Collectors and collecting--United States
Catalogs. 2. Advertising--Brand name products--Collectors and
collecting--United States Catalogs. 3. Printed ephemera--Collectors
and collecting--United States Catalogs. I. Bajorek, Lagretta Metzger.
II. Title.
 NK1125.R53 2000
 741.6'7--dc21 99-41588
 CIP

Typeset in Americana XBd BT/ Aldine 721 BT
Designed by "Sue"

ISBN: 0-7643-1012-7
Printed in China
1 2 3 4

Published by Schiffer Publishing Ltd.
4880 Lower Valley Road
Atglen, PA 19310
Phone: (610) 593-1777; Fax: (610) 593-2002
e-mail: schifferbk@aol.com
Please visit our website catalog at
www.schifferbooks.com
or write for a free printed catalog.
This book may be purchased from the publisher.
Please include $3.95 for shipping.

In Europe, Schiffer books are distributed by
Bushwood Books
6 Marksbury Avenue
Kew Gardens
Surrey TW9 4JF England
Phone: 44 (0)208 392-8585; Fax: 44 (0)208 392-9876
e-mail: bushwd@aol.com

Please try your bookstore first.

We are interested in hearing from authors
with book ideas on related subjects.

Acknowledgments

We are thankful to the many children who first collected and preserved the premiums represented in our collection, and to all who have helped us in our pursuit, especially paper collector Virginia Crossley and paper dealer Lucy Hart.

Contents

Value Guide

The children's paper premiums of the Victorian Age are rare and no longer easily found. Cardboard games, puzzles, and playing card sets are seldom found in complete condition, but matching sections together is a part of the collecting experience.

Radio premiums that were offered during the Great Depression time of the 1930s can be found in antique shops and malls, estate tag sales, and auctions, as well as neighborhood garage sales. These pieces will vary in price as to the collectible interest of the radio program. Naturally, the more famous the radio program, the higher the price for its premiums.

Quite a few of these "give-aways," however, do not have prohibitive prices, and because many premiums were issued over the years many interesting and desirable collectibles can still be found. The following prices were based on the authors' personal experiences in searching for these many "finds."

Disclaimer

The current values in this book should be used only as a guide. Prices vary from one section of the country to another and are affected by condition, color of prints, and the completeness of sets or series. Neither the authors nor the publisher assumes responsibility for any losses which might be incurred as a result of using this guide.

Preservation

One very important feature about collecting anything made of paper is the proper storage and preservation of those paper items. The best guidelines to follow in this regard are those set forth in a leaflet issued by the Library of Congress, entitled "Environmental Protection of Books and Related Material."

That leaflet states "...paper is always subject to deterioration if it is improperly made or stored. At the same time, under proper conditions paper may last for hundreds of years."

Furthermore, "Extensive research and a wealth of accumulated evidence show that the lower the temperature at which it is stored, the longer paper will last. ... for every 10°F decrease in temperature, the useful life of paper is approximately doubled. ... For most homes and libraries practical considerations dictate a temperature range of 68° to 75°F."

"Humidity also has a serious effect on ... paper. If too high, it hastens acid deterioration and leads to deterioration by such biological agents as mold and bacteria. If too low, the paper suffers from desiccation" (drying up). Paper "will last longer if kept at a relative humidity of 40 to 50 percent."

Moreover, "There is some evidence that regular changes in temperature and relative humidity (cycling) can lead to a weakening of paper ... Library of Congress scientists do not believe that it results in measurable damage to paper if such changes in temperature and relative humidity can be held to less than 10°F and 15 percent."

Thus, all collectors of paper items, especially items made from pulp paper and cardboard, need to keep their material in a room where both temperature and relative humidity can be regulated within the limitations described by the Library of Congress. This should never be in an attic or basement, but rather a location where the heat duct can be turned off in the winter, and where the effect of air conditioning can be brought to bear during the summer. Also, the use of a humidifier in the winter and a dehumidifier in the summer in the storage area will be of much help.

Equally important in the preservation of paper is the enclosure in which the paper itself is stored. The worst enclosure is anything made of vinyl, because the chemicals in that form of plastic can decompose and emit a vapor after several years that will cause the paper to deteriorate. The best enclosures are those made of either Mylar or polypropylene. If albums are used, only those with acid-free paper should be employed. Safe enclosures and albums can be obtained from library and archival supply houses.

These precautionary measures, which are not difficult to follow, apply to collections of any size. They are much less costly in the long run, and will assure many hours of enjoyment for both contemporary and future collectors.

Introduction

In the last quarter of the 19th century, the United States saw a rapid growth in manufacturing, and companies turned to the advertising industry to promote and capture new markets for their products. A significant part of this effort was the issuance of premiums, such as children's puzzles, games, paper toys, and story booklets.

At this time, printing companies began to use color lithography — a process where the color image is transferred to the paper from inked flat stones or metal plates — to print large quantities of colorful, inexpensive illustrations for their customers. By 1900, advertising had become a large industry, as color lithography became more widely used and the postal service provided more efficient service, including the distribution of mail by the use of Rural Free Delivery.

References

Burdick, J. R. *The American Card Catalog*, New York: Nostalgia Press, Inc., 1967.

Correll, C. J. and Gosden, F. F. *All About Amos 'N' Andy And Their Creators Correll and Gosden*, Rand McNally & Company, 1929.

Csida, Joseph and Csida, June Bunday. *American Entertainment*, A Billboard Book, Watson - Guptill Publications, 1978.

Dennis, Lee. *Antique American Games 1840-1940*, Radnor, PA: Wallace-Homestead Book Co., 1991.

Hechtlinger, Adelaide. *The Great Patent Medicine Era*, New York: Galahad Books.

Margolin, Victor, Ira Brichta, and Vivian Brichta. *The Promise And The Product*, New York: Macmillan Publishing Co., Inc., 1979.

Williams, Anne D. *Jigsaw Puzzles*, Radnor, PA: Wallace-Homestead Book Co., 1990.

Tobacco

The tobacco companies were the first to issue insert cards in their packaged products, but coffee, tea, and other products soon followed. From about 1887, U. S. tobacco cards dominated the market and, after 1900, as the popularity of cigarettes increased, many of these cards were issued in cigarette packages. Usually, these issues were a stock set for two or more brands of tobacco, and today many tobacco collectors are satisfied to obtain a set of the different pictures regardless of the brands.

Pan Handle Scrap/Royal Bengals Little Cigars, "Heroes of History Series," George Washington. $8-10

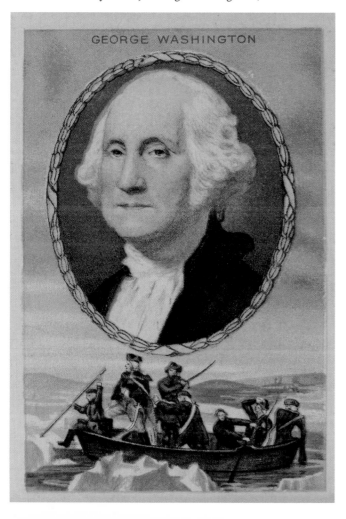

GEORGE WASHINGTON

George Washington, reversed.

Pan Handle Scrap / Royal Bengals Little Cigars

"We honestly believe we have produced in Pan Handle Scrap the finest CHEW that has ever been offered."
10 Little Cigars for 15 Cents

One card from these two series of 50 pictures each, "Heroes of History" and "Men of History," was inserted in each package of Pan Handle Scrap and Royal Bengals Little Cigars. On the back of each card was a short biography of the person pictured. These history issues and the early tobacco sports cards were sought by children of that time just as much as later generations would seek the bubble gum sport cards of the 1930s - 1950s, and the contemporary issues of today.

Other brands of tobacco which distributed history cards were Miner's Extra and Natural Leaf. These tobacco cards are in color lithography and measure 2-1/4" x 3-3/8".

GEORGE WASHINGTON
George Washington, the "Father of Our Country," was born in Westmoreland County, Virginia, February 22, 1732, the son of a Virginia planter. Leaving school at sixteen, he took up surveying; then, at nineteen, was appointed adjutant of the Virginia troops, and served through the French and Indian wars. Received the command of the American army June 15, 1775. In 1787 he was president of the constitutional convention, and was unanimously elected president of the United States in January, 1789, and unanimously re-elected for a second term. He refused the nomination for a third term, thereby establishing a precedent that has descended to this day. He died at Mount Vernon, December 14, 1799. One of Washington's boldest strokes in the Revolution occurred on Christmas night, 1776. The Hessians hired by the British were at Trenton, and Washington set out with a picked force across the icy Delaware River and surprised them at their revels. The prisoners numbered 1,000, and the American loss was only four.

FACTORY Nº 10 - 5 TH DIST OF N.J

HEROES of HISTORY SERIES
FREE WITH

PAN HANDLE
SCRAP

WE HONESTLY BELIEVE WE HAVE PRODUCED IN PAN HANDLE SCRAP THE FINEST CHEW THAT HAS EVER BEEN OFFERED

ONE OF THIS SERIES OF 50 PICTURES IS ALSO INSERTED IN EACH PACKAGE OF

ROYAL BENGALS LITTLE CIGARS
10 for 15 Cents.

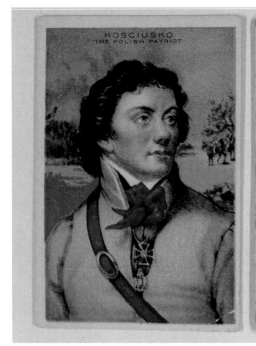
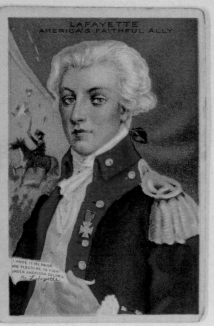
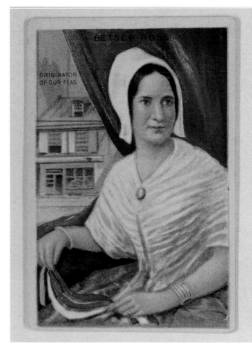
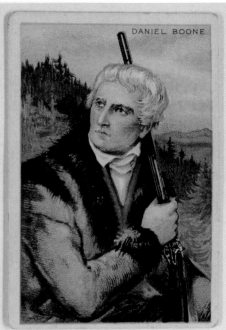

Kosciusko/Lafayette. $8-10 each

Betsey Ross/Daniel Boone. $8-10 each

Ethan Allen/Nathan Hale. $8-10 each

Zebulon Pike/W. H. Harrison. $8-10 each

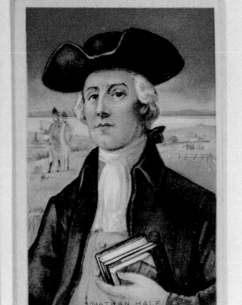
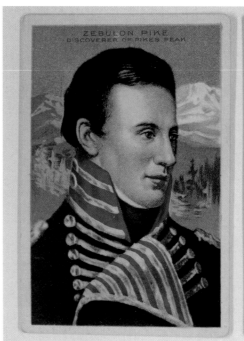
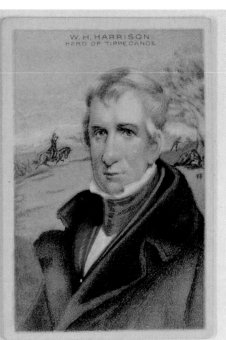

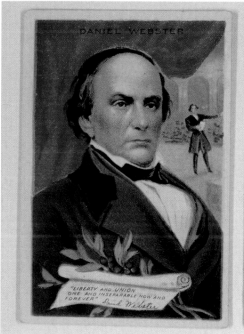
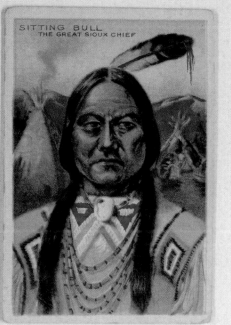
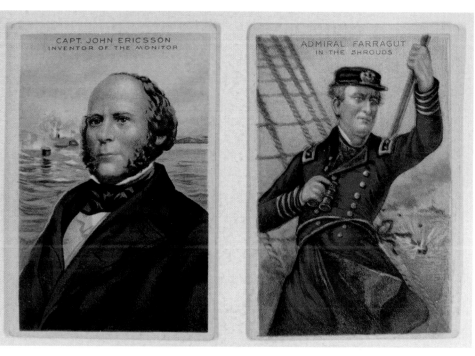

Daniel Webster/Sitting Bull. $8-10 each

Capt. John Ericsson/Admiral Farragut. $8-10 each

Gen. John C. Fremont/Abraham Lincoln. $8-10 each

Gen. Phil. Sheridan/Gen. Wm. T. Sherman. $8-10 each

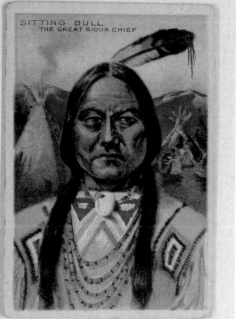
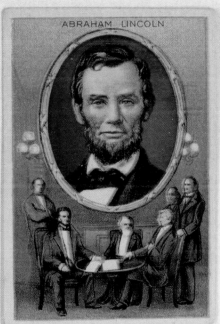
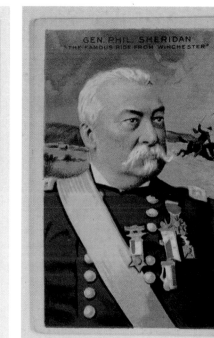
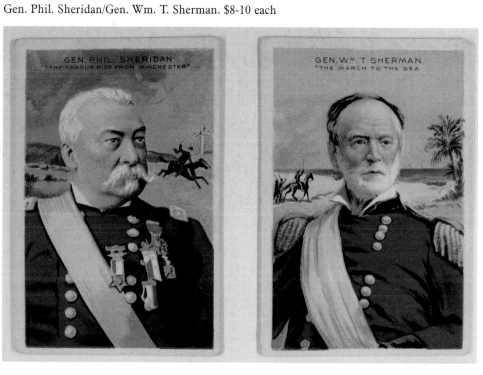

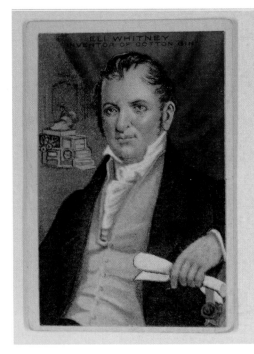 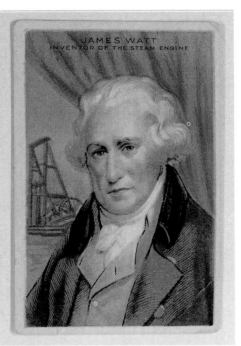 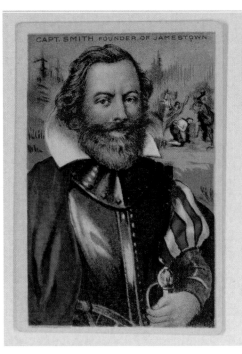 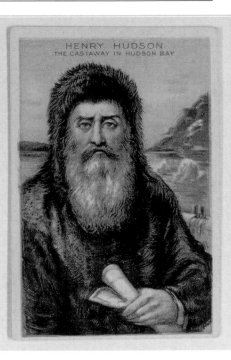

Eli Whitney/James Watt. $8-10 each

Capt. John Smith/Henry Hudson. $8-10 each

Christopher Columbus/Sir Walter Raleigh. $8-10 each

Joan of Arc/Napoleon Bonaparte. $8-10 each

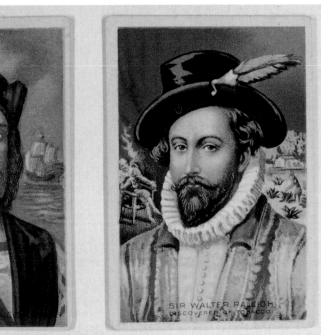 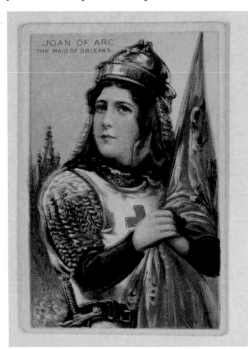 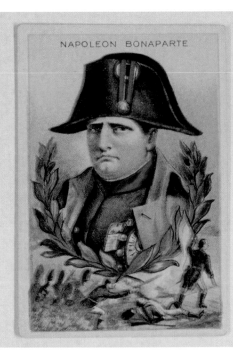

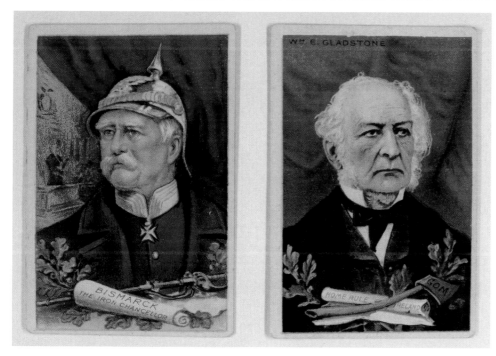

Prince Von Bismarck/Wm. E. Gladstone. $8-10 each

Daniel O'Connell/Li Hung Chang. $8-10 each

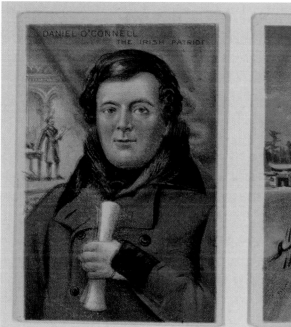 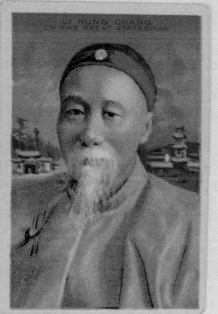

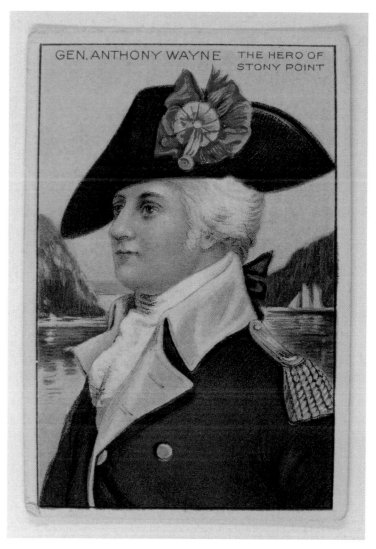

Pan Handle Scrap/Royal Bengals Little Cigars, "Men of History 2nd Series," Gen. Anthony Wayne. $8-10

MAD ANTHONY WAYNE

Anthony Wayne was born January 1, 1745. January 3, 1776, he was commissioned colonel of a Pennsylvania regiment. During the gloomy winter at Valley Forge he made a successful raid and captured a quantity of British supplies. His great feat was the storming of Stony Point, at midnight, July 16, 1779. With 1,200 men he took the fort at the point of the bayonet. He was badly wounded, but commanded his men to carry him in that he might die at their head. Fortunately he lived to become head of the army in 1792. In 1794 he defeated the Indians of the Northwest, and concluded a treaty with them by which the United States got a large area.

On his way home he died at Presque Isle, now Erie, Pennsylvania, December 15, 1796.

FACTORY Nº 10 — 5ᵀᴴ DIST OF N.J.

MEN of HISTORY 2ᴺᴰ SERIES
FREE WITH

PAN HANDLE
SCRAP

WE HONESTLY BELIEVE WE HAVE PRODUCED IN PAN HANDLE SCRAP THE FINEST CHEW THAT HAS EVER BEEN OFFERED

ONE OF THIS SERIES OF 50 PICTURES IS ALSO INSERTED IN EACH PACKAGE OF

ROYAL BENGALS LITTLE CIGARS
10 for 15 Cents.

Gen. Anthony Wayne, reversed.

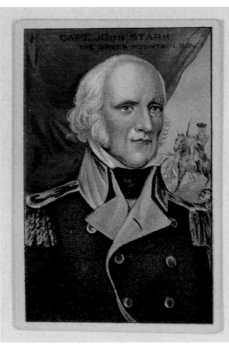
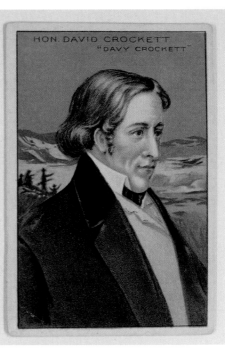

Capt. John Stark/Hon. David Crockett. $8-10 each

Gen. Winfield Scott/Gen."Stonewall" Jackson. $8-10 each

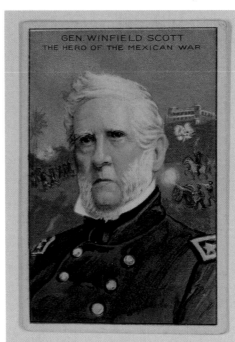
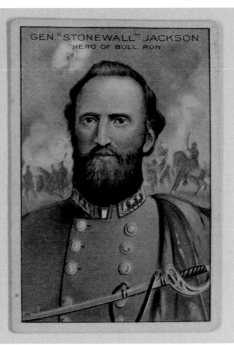

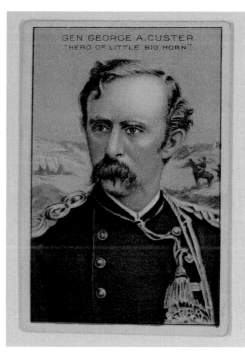
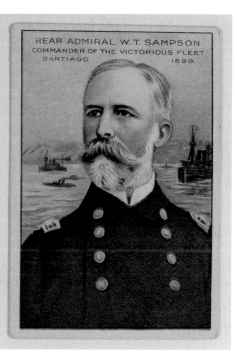
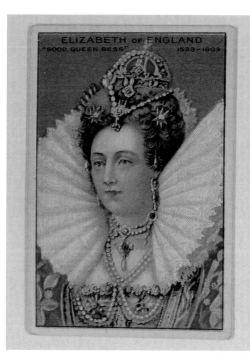
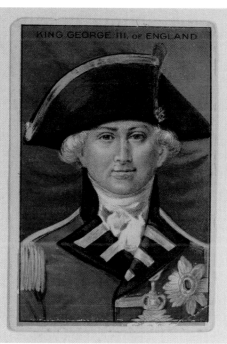

Gen. George A. Custer/Rear Admiral W. T. Sampson. $8-10 each

Elizabeth of England/King George III, of England. $8-10 each

Richard III, of England/Henry VIII, King of England. $8-10 each

Edward VII, of England/Lord Baltimore. $8-10 each

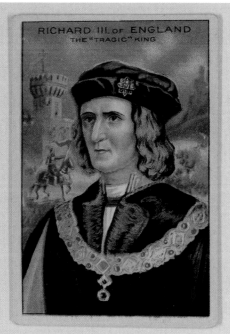
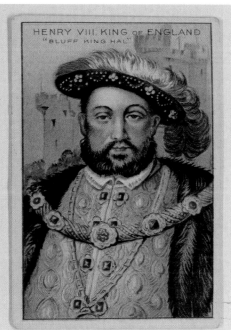
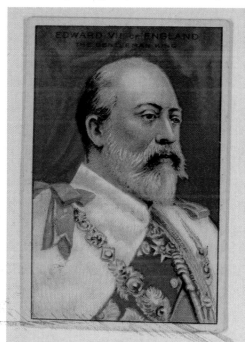
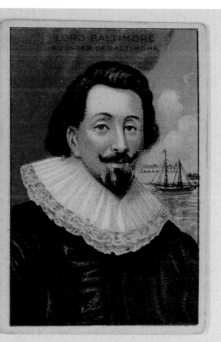

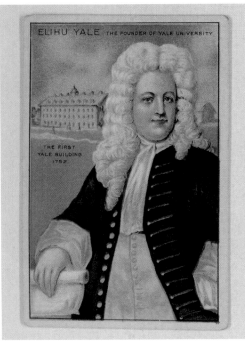
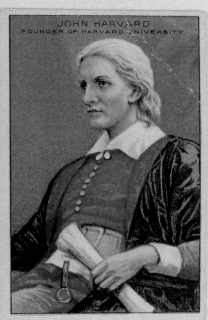
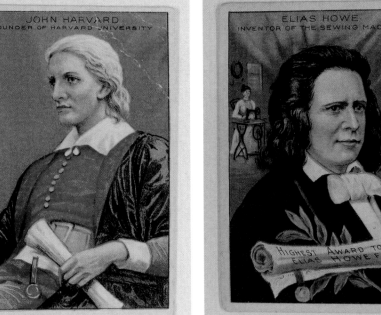
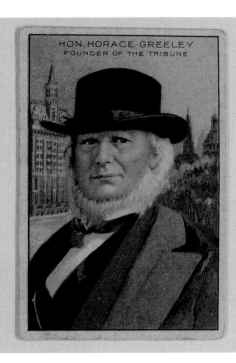

Elihu Yale/John Harvard. $8-10; $5 as shown

Elias Howe/Hon. Horace Greeley. $8-10 each

Edwin Booth/Sir Henry Irving. $8-10 each

Hon. Henry M. Stanley/Hon. Phineas T. Barnum. $8-10 each

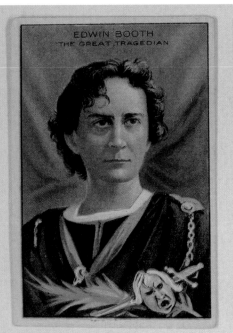
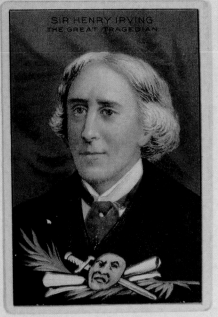
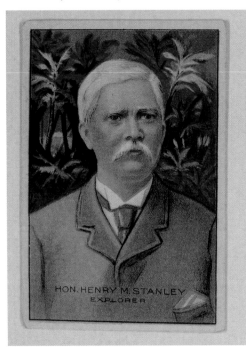
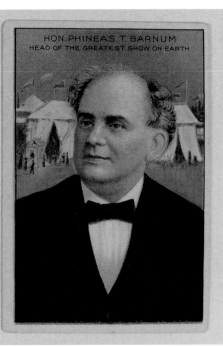

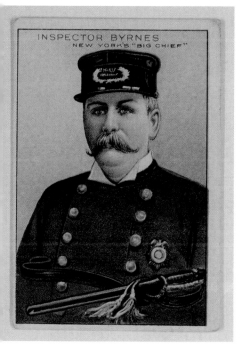

Inspector Byrnes. $8-10

Paper premiums issued for children by tobacco companies are rare, because many companies used trade cards picturing "exotic ladies," to entice smokers to buy their brand. An example of this was Rosina Vokes Cigars, *"Raise the lid and SMOKE UP."* When the Hermann Blatt & Co.'s traveling trunk trade card is turned over, up pops the lid and in the trunk there appears a black- striped, silk-stocking show girl.

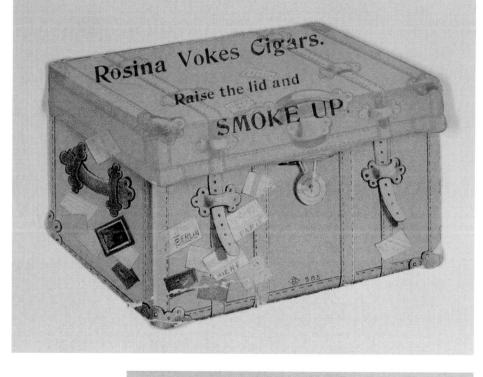

Rosina Vokes Cigars,
trunk. $15 as shown

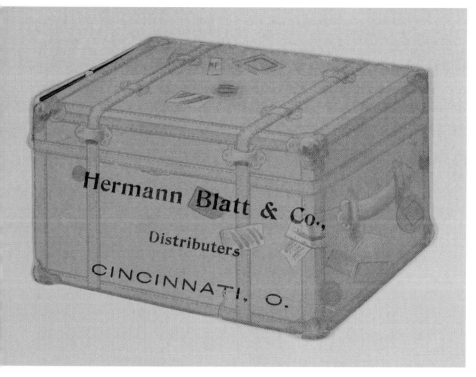

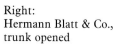

Left:
Hermann Blatt & Co.,
back of trunk

Right:
Hermann Blatt & Co.,
trunk opened

Patent Medicine / Pills / Ointments / Related Products

Beginning about the 1890s, manufacturers of medicine turned to using wild and elaborate claims in their advertising. One example was *"Not sick enough for bed or well enough for the table - Hood's Sarsaparilla Cures."* These messages, together with satisfied customers' testimonials, were printed in newspapers and also as advertisements on premiums, which were given free or mailed to anyone in exchange for a coupon or trade-mark and a few cents' worth of U. S. postage stamps.

These claims continued to be used until 1906, when Congress passed the Pure Food and Drug Act, prohibiting the word "cure" from being used on advertisements for patent medicine. After the passage of the 1906 Act, patent medicine companies began to use words such as "remedy," "harmless," and "relief." As advertising and testimonials became more outrageous, a few businesses started to enforce standards of truth, and later the Pure Food and Drug Act of 1938 broadened the power of the Federal Trade Commission to enforce truth in advertising.

Some of the early advertising premiums were directed toward children, and parents would buy the company's product in order to obtain the necessary coupon. These premiums were greatly appreciated by the children.

C. I. Hood & Co., Lowell, Massachusetts
Hood's Sarsaparilla / Hood's Pills

They Go "Hand In Hand."
"100 Doses One Dollar"

The 1897 Hood's Sarsaparilla Coupon Calendar offered several coupons for children. The company's premium for June was its "Rainy Day Puzzle." This die-cut puzzle was first issued in 1891, and was the first advertising puzzle for children that did not have a moral lesson.

It was a double-sided presentation, showing the "Rainy Day Puzzle" in color lithography on one side, while the "Balloon Puzzle" was on the reverse side, in blue print. The puzzle measured 14-7/8" x 9-7/8".

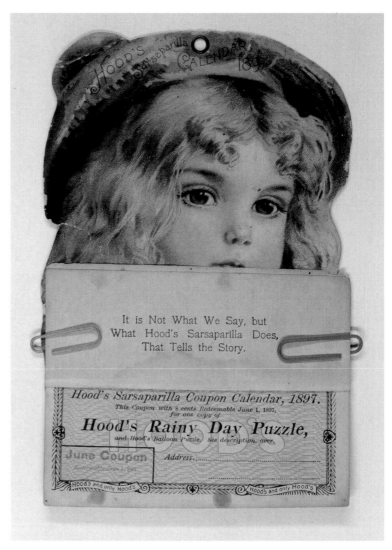

C.I. Hood & Co., 1897 Hood's Sarsaparilla
Coupon Calendar, Rainy Day Puzzle coupon. $25

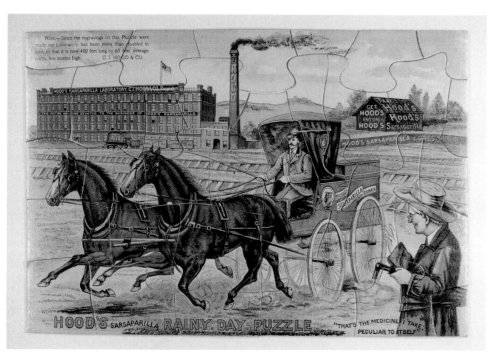

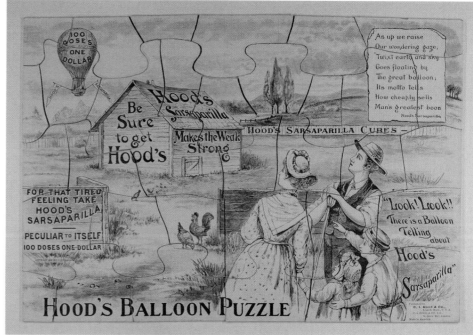

Above:
Hood's Rainy Day Puzzle. $110-125 (box)

Above right:
Hood's Balloon Puzzle, reverse side of Rainy Day Puzzle

In the field of advertising collectibles, much interest is directed to the original packaging. Enclosed in the 1897 Hood's puzzle box was a 16-page booklet containing many testimonials for Hood's products, with a full list of their premiums, "Hood's Photos of the World, Famous Scenes, American and Foreign."

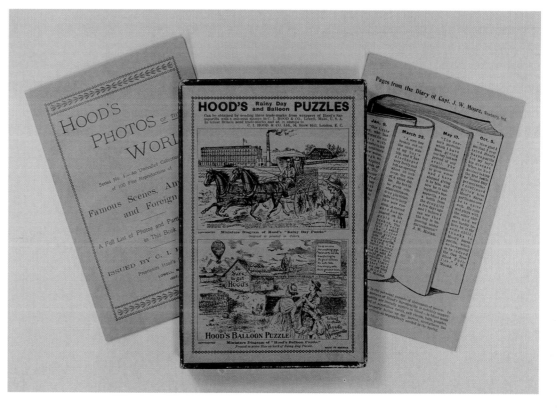

Hood's Puzzle Box, original
advertisements

In addition, there was a four-page leaflet with more testimonials about the "cures" of Hood's Sarsaparilla. The company obtained these testimonials by sending letters to their customers, inquiring if they would favor the company with a statement for their product.

Another monthly coupon from the calendar was for *Hood's Painting Book*. It had 34 large pages of beautiful pictures, partly in color, with full instructions for painting in water colors. Each book had a palette of Hood's Paints, with a brush and blotter.

Hood's memo and envelope. $10

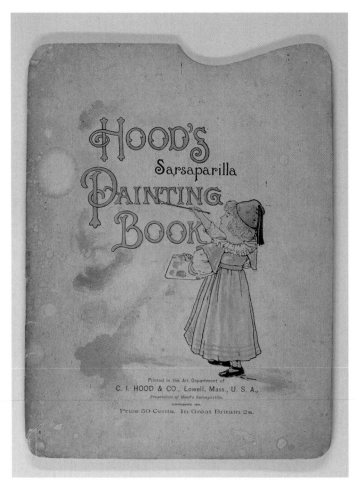

Hood's Painting Book. *Courtesy of Virginia A. Crossley.* $15-20 as shown

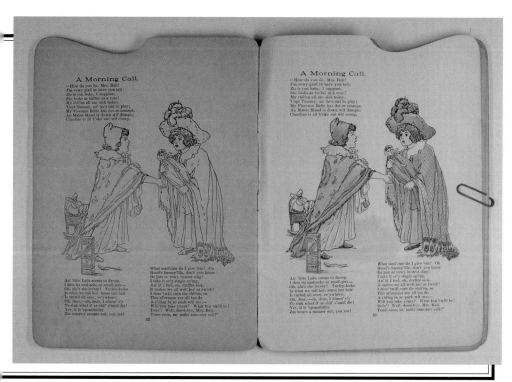

Hood's Painting Book, pages 32-33

The May coupon from the 1897 calendar was for "Hood's Family Paper Dolls," which was a die-cut set of five dolls, in color lithography, with costumes and hats. These were printed in several variations, but in all the sets the dolls are the same.

Envelope and Sample doll. $20 (doll)

Hood's Family Paper Dolls,(costumes, hats and an envelope). Set: $185

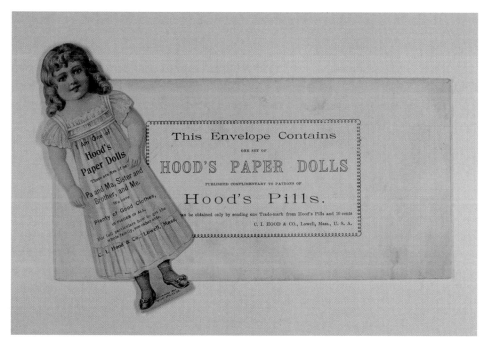

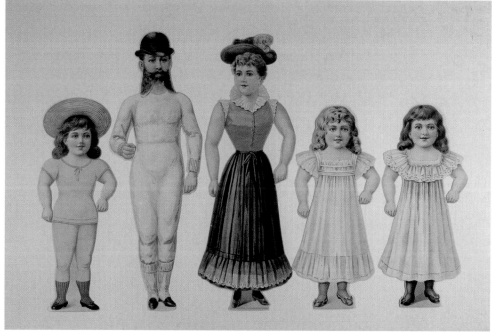

In August, Hood offered another double-sided premium, measuring 11-1/4" x 18-1/2". On one side was "Our Country Puzzle," which was a map of the United States printed in color, mounted on heavy pulp board and cut into pieces of varied sizes and shapes. When the puzzle was assembled all the States in the Union were shown with their boundaries, principal cities, and rivers. In addition, there were the Coat of Arms for each state and portraits of persons who had testified to the "cures" of Hood's Sarsaparilla.

On the reverse side were two other puzzles, Hood's Laboratory Puzzle, in blue print, and Hood's complicated Geometrical Puzzle, in red print.

The October coupon was for "Hood's Spelling School," a game that combined many educational merits. It was neatly packed in a box and sent with full instructions for two to six players. The regular price for the game was twenty-five cents, but it could be had for the coupon and 8 cents in U. S. postage stamps. This premium is not pictured.

Hood's Our Country Puzzle, (reverse side has Hood's Laboratory and Geometrical Puzzles). $25 as shown

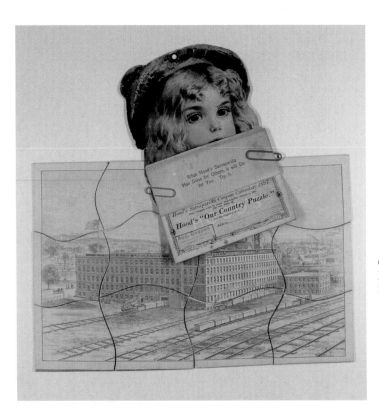
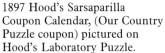

1897 Hood's Sarsaparilla Coupon Calendar, (Our Country Puzzle coupon) pictured on Hood's Laboratory Puzzle.

Hood's Geometrical Puzzle

The premium for November 1897 was a unique and original novelty, consisting of ten well-known animals. All of the die-cut easel-back animals are correct in markings and individuality. The "Hood's Animal Statuettes" consisted of the Newfoundland Dog and Puppies, Mare and Foal, Jersey Cow and Calf, Donkey, Lamb, and Turkey, in color lithography. The Kitten, Rabbit, Squirrel, and Black Leghorn Hen and Chicks are in black-and-white fast-print (a photo chemical-process which puts an image directly onto the printing plate, and through the use of a halftone screen the picture is broken into uniformly sized dots combining photography and lithography). The advertisement on the reverse of the four fast-print statuettes is shown only on the easel, but the 1897 copyright appears on the front.

Hood's Animals. Set: $25-35 (envelope)

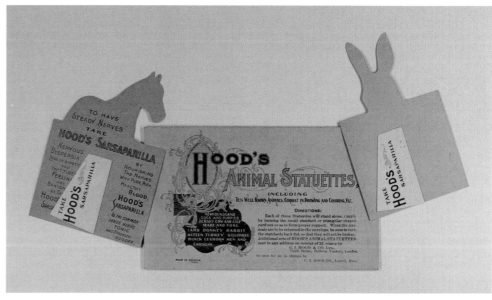

Hood's Animal Statuettes,
envelope and advertisements

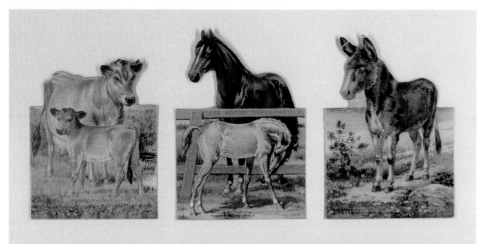

Below and right:
Hood's Animals/Fowl

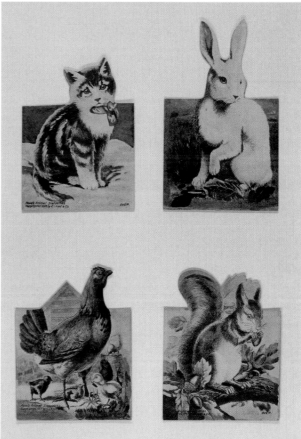

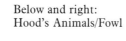

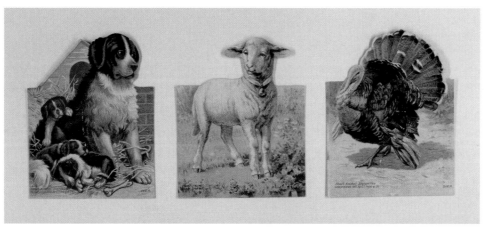

The December coupon was for any of the novelties throughout the year. One or all of those listed were exchanged for the coupon and the appropriate amount in postage stamps.

"Roots, barks and herbs—'like mother used'—are combined in Hood's Sarsaparilla."

The 1914 Hood's Calendar has a coupon for "Hood's Panama Canal Puzzle." Pictured on the coupon is the famous Culebra Cut. This puzzle was sent to any address on receipt of the coupon and 6 cents in stamps.

1914 Hood's Calendar. $25

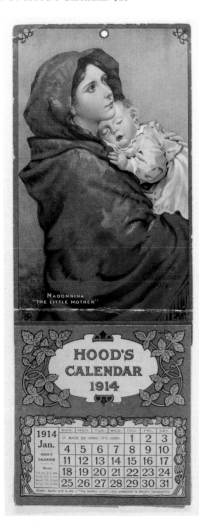

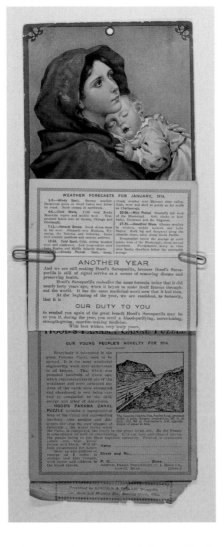

Coupon for "Hood's Panama Canal Puzzle"

Another premium Hood offered was a small "Pansy"-shaped booklet. It measured 4-1/4" x 4", with front and back covers in color lithography. The first page gave information on the planting and growing of the Pansy, while the remaining pages extolled the virtues of Hood's patent medicine.

Two Hoods of style that's rather queer,
Two little maids with naught to fear,
Except that either will rightly guess
What t'other holds behind her dress.

They scan each other's faces fair;
Then, in one voice, they both declare
"Hood's Sarsaparilla! I can tell;
And that's what makes you look so well!"

"Hood's Pills - Keep them in your family medicine closet."

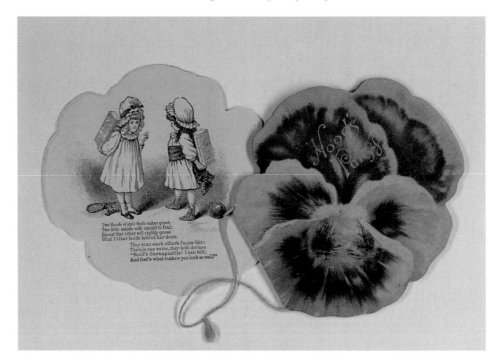

Hood's "Pansy" Book. $20

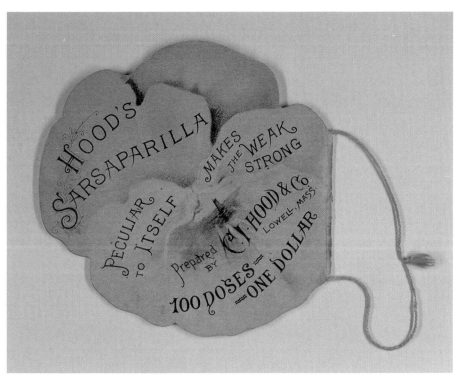

Hood's "Pansy" Book, back cover

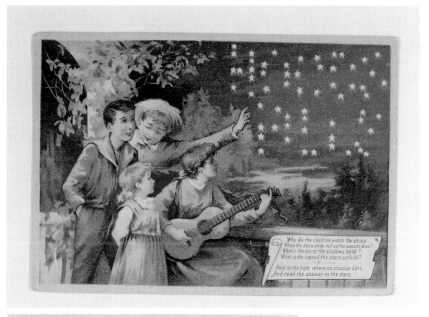

Hood's See-Thru card. $25

The Hood company issued a See-Thru card, on thin paper, and when held to a bright light the picture or words are changed. On one such card the stars spell "Hoods Pills."

> Why do the children watch the skies
> When the stars peep out as the sunset dies?
> What is the secret the shadows hold?
> What is the legend the stars unfold?
>
> Hold to the light where no shadow bars,
> And read the answer in the stars.

In the 1870s, Charles Hires led the way in advertising "soft drinks." During the 1876 National Centennial in Philadelphia he gave away free samples of his soda, "Hires' Root Beer."

Every Family

Should keep some reliable physic in the house, and for this special purpose we have prepared and confidently recommend Hood's Pills. Their constantly increasing sale and the satisfaction they give demonstrate their absolute merit. They are purely vegetable, containing no calomel, mercury, or mineral substance of any kind. Being mild and gentle yet efficient in action, they do not purge, pain or gripe. A cold may be quickly broken up by the prompt use of Hood's Pills, and a fever may be prevented by their timely use. For constipation and costiveness, nothing can be more satisfactory. They act upon the liver, removing obstructions from the alimentary canal, enable the bowels to resume prompt and healthy action, and keep them in natural condition. Biliousness, sour stomach, headache, jaundice, and liver complaint, are cured by Hood's Pills, and persons seriously troubled with constipation find these Pills very valuable to take after dinner. Many testimonials cordially endorsing them might be published if necessary. In fact a single trial is sufficient to secure for them your commendation. Keep them in your family medicine closet.

Rev. James P. Stone, of Dalton, N. H., after using Hood's Sarsaparilla, Olive Ointment, and Vegetable Pills, writes: "Your preparations are all they profess to be. Mrs. S. says your Pills are the best she has ever known."

HOOD'S TRADE MARK **Vegetable PILLS**

Registered trademark adopted April 1, 1888.

Invigorate the Liver

Regulate the Bowels

Cure Sick Headache

Hood's Pills

Are sold by all druggists, or will be sent by mail on receipt of price, by C. I. HOOD & CO., Lowell, Mass. Price 25 cents; five boxes $1.

Hood's See-Thru, reversed

"Hires' Cough Cure / Hires' Root Beer Syrup"

Hires also issued a See-Thru card showing a young girl restfully asleep in bed after taking a teaspoon of "Hires' Cough Cure." When the card is tilted back and forth before a bright light, her eyes will miraculously flutter open because she is feeling so much better.

Nichols' Bark & Iron, Billings, Clapp & Co., Boston

"In presenting this little book to the public, we have a twofold object: first, to call the attention of its readers to the virtues...of the most reliable tonic NICHOLS' BARK AND IRON; second, to afford parents a medium by which they may instruct as well as amuse their children, in reproducing the sketches in the outline squares..."

Hires' See-Thru, reversed

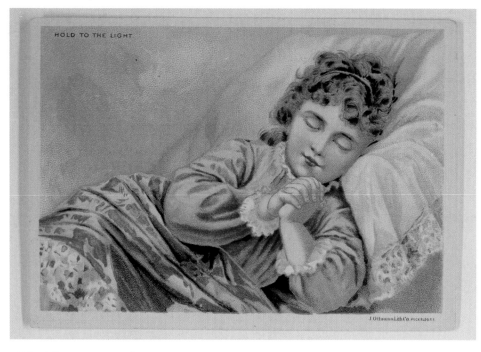

Hires' See-Thru card. $25

This company offered the *Young Folks' Drawing Book*, measuring 4-3/4" x 6-5/16", with front and back covers in color lithography. The book has 6 black-and-white drawings with ruled grids for reproducing sketches, plus pages of additional advertising and testimonials for their tonic. The printers were Trautmann, Bailey & Blampey, N. Y.

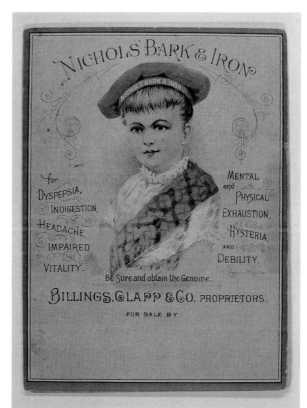

Nichols' Bark & Iron, "Young Folks' Drawing Book," back cover

Nichols' Bark & Iron, "Young Folks' Drawing Book," double page

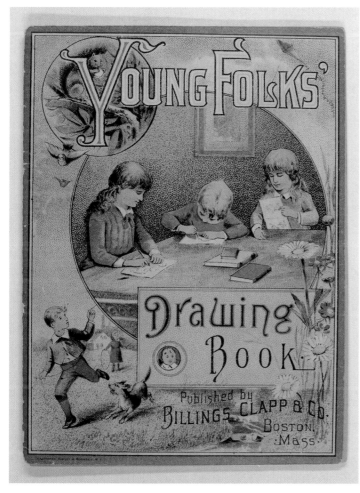

Nichols' Bark & Iron, "Young Folks' Drawing Book." $20-25

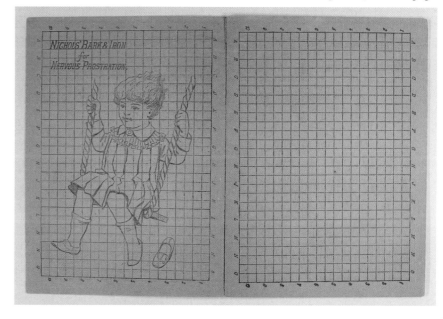

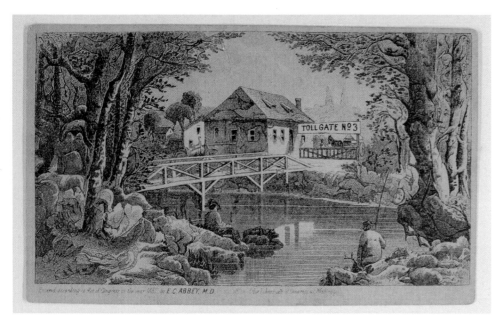

E.C. Abbey, Toll Gate #3 puzzle card. $6-8

E. C. Abbey, M. D., Buffalo, N. Y.

CUTAVACO! Dr. Abbey's Great Specific
for Skin Diseases
"From two to ten applications cure"

There were four Toll Gate puzzle cards designed to "find the hidden objects." These cards were black-and-white etchings with a one-color over-print. The Toll Gate #3 puzzle card, c. 1880, contained many hidden pictures in its background, and these hidden objects were listed on the back of the card. The cards were mailed upon receipt of postage. This technique of finding a hidden animal or object is still used today in children's puzzles.

The circus affords entertainment for both children and adults. In 1871, P. T. Barnum, the great showman, exclaimed his circus "As the Greatest Show on Earth."

California Fig Syrup Company, San Francisco
California Syrup of Figs and Elixir of Senna

"On the market for over 40 years"
"The very best family laxative, always ready for use..."

The California Fig Syrup Company was part of Sterling Products, Inc., Wheeling, West Virginia. At this time the company issued a 12 page booklet, *Circus Animals*, for boys and girls, with puzzles and articles on each animal represented. These nine animals are the giraffe, lion, buffalo, leopard, elephant, camel, kangaroo, hippopotamus, and polar bear. Each puzzle has a hidden animal pictured in its background.

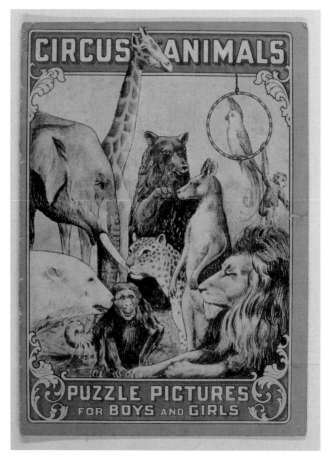

California Fig Syrup Co., "Circus Animals." $20-25

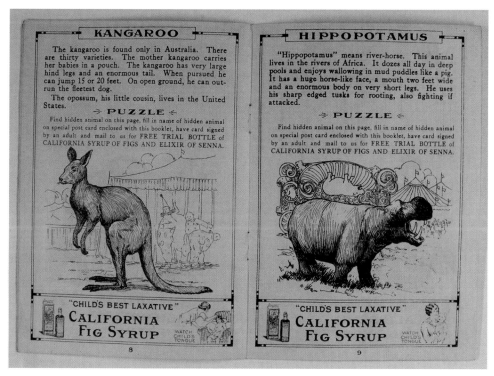

California Fig Syrup Co., "Circus Animals," pages 8-9

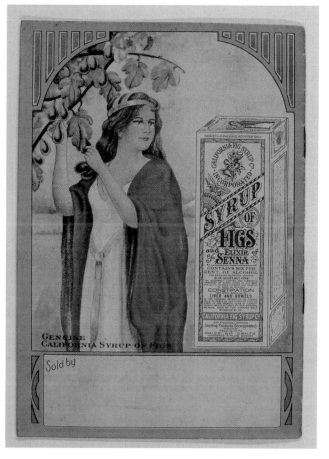

California Fig Syrup Co., "Circus Animals," back cover

This booklet measures 4-1/4" x 6", and has colorful front and back covers. The pages are printed in blue ink, with advertising throughout. The printer was Edwards & Deutsch Litho., Co., Milwaukee - Chicago.

After a child found and named a hidden animal in the booklet, a special enclosed post card would be signed by an adult and returned to the company for a Free Trial Bottle of California Syrup of Figs. This 5 fluid ounce bottle contained 6% alcohol, and was the reason why an adult's signature was requested.

Many medical compounds of the time contained alcohol. Two examples are Lydia E. Pinkham's Vegetable Compound - 21%, and Dr. Hostellers Bitters - 44%.

E. T. Hazeltine, Warren, Pa.
Piso's Cure for Consumption / Piso's Remedy for Catarrh

"Is free from Opium in any form, therefore perfectly safe."

The Company issued a small advertising booklet, 2" x 3", entitled *The Merchant's Lesson*, c. 1887. Even today, children and adults are great collectors of tiny books.

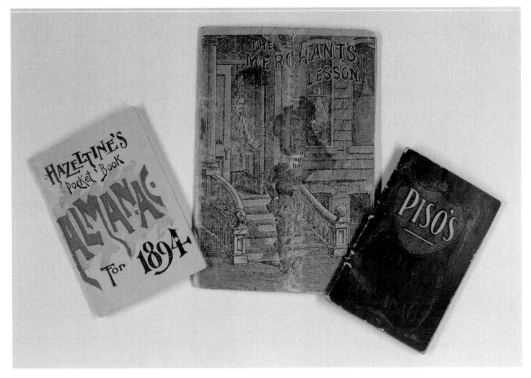

Hazeltine/Piso's booklets. $10-12 as shown

Another tiny book issued yearly was *Hazeltine's Pocket Book Almanac*. The small almanac for 1894 measured 1-3/8" x 2", and advertised Piso's Cure and Piso's Remedy.

The Piso's 1913 Pocket Book Almanac measured 1-1/4" x 2", and advertised the following items under Piso's Trade Mark: Piso's Remedy, Piso's Catarrh Balm, Piso's Tablets (a treatment of the diseases of women) and Piso's Antiseptic Tooth Powder. The Piso medicines were sold by all druggists in the United States, Canada, and Great Britain.

Malena Stomach & Liver Pills, Malena Co., Warriorsmark, Pa.

"MA-LE-NA, Cures All Common Skin Diseases"
"Guaranteed to Cure or Money Refunded"

With the purchase of any Malena product the company gave away a booklet for children. These booklets measure 5" x 6-1/4", and are illustrated in color lithography, with additional sketches in black-and-white. Some examples are *Little Red Riding*

Hood, Old Mother Hubbard, The Three Bears, Playmates, Farm Friends, Wild Animals, Jack the Giant Killer, and *Family Friends.*

The "Fatal Telegram"

"Uneedum-Igotum"

In 1903, the "G-S-E Gavitt's Stock Exchange" card game was invented by Harry E. Gavitt, of the W. W. Gavitt Medical Company, manufacturing chemists, of Topeka, Kansas. The first lot of games was distributed among their 6,000 medical agents, who were to give the games to their customers. The demand became so great that the company decided to make a small charge for them.

As the demand increased further, Gavitt decided to remove the medical advertising from the cards, increase the price, and use better brands of stocks.

Malena Stomach & Liver Pills, "Little Red Riding-Hood." $20-25

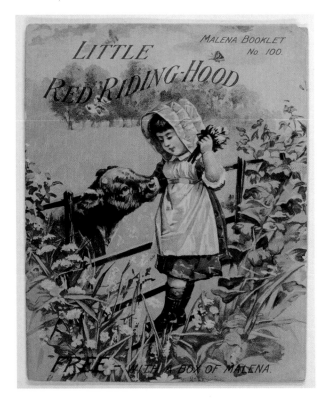

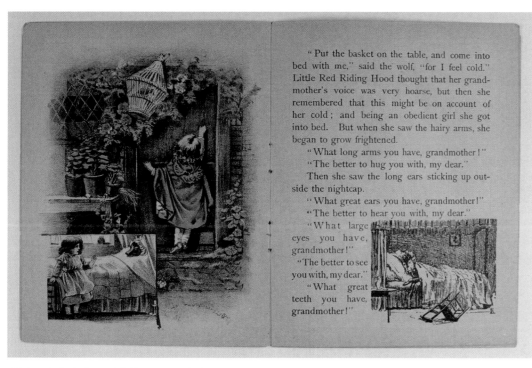

"Put the basket on the table, and come into bed with me," said the wolf, "for I feel cold." Little Red Riding Hood thought that her grandmother's voice was very hoarse, but then she remembered that this might be on account of her cold; and being an obedient girl she got into bed. But when she saw the hairy arms, she began to grow frightened.

"What long arms you have, grandmother!"

"The better to hug you with, my dear."

Then she saw the long ears sticking up outside the nightcap.

"What great ears you have, grandmother!"

"The better to hear you with, my dear."

"What large eyes you have, grandmother!"

"The better to see you with, my dear."

"What great teeth you have, grandmother!"

Malena's "Little Red Riding-Hood," double page

Malena's "Little Red Riding-Hood," back cover

Malena's "Old Mother Hubbard," double page

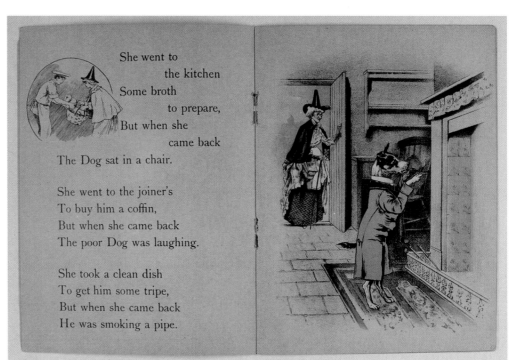

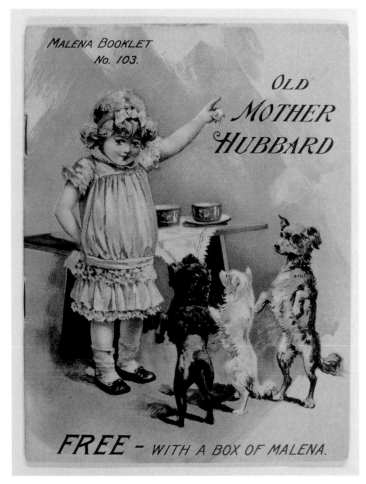

Malena Stomach & Liver Pills, "Old Mother Hubbard." $20-25

Malena's "The Three Bears," page/
inside back cover advertisement

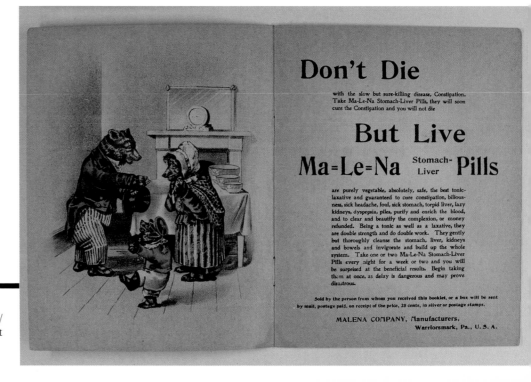

Malena's "Playmates,"
double page

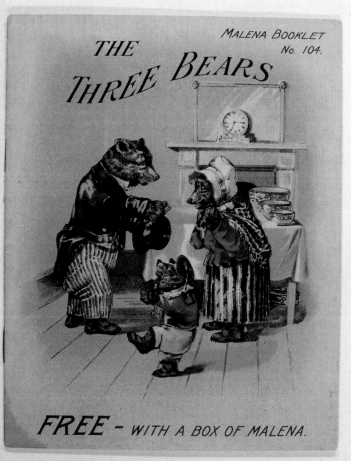

Malena Stomach & Liver Pills, "The
Three Bears." $20-25

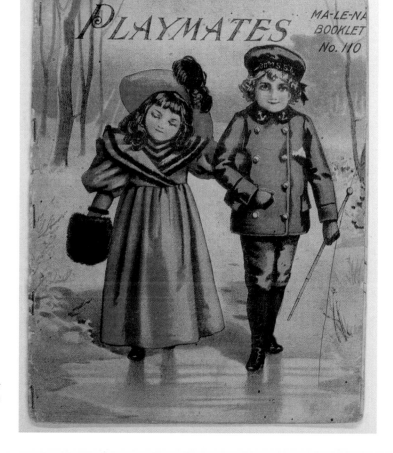

Malena Stomach & Liver
Pills, "Playmates." $20

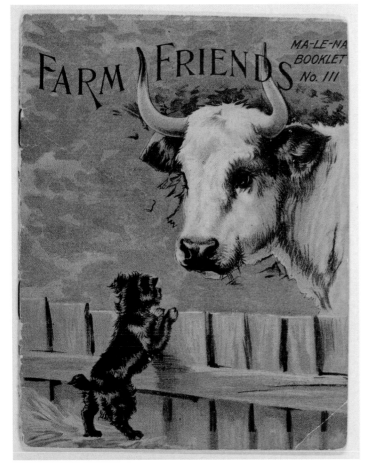

Above:
Malena Stomach & Liver Pills, "Farm Friends." $20

Above right:
Malena's "Farm Friends," double page

Malena's "Wild Animals," double page

Dorothy and Fido.

Fido was the name of a dog that lived on the farm where Baby Dorothy was spending the summer with Aunt Gertie. Fido and Dorothy were great playmates, because Fido was so gentle and seemed to know that Dorothy was only a little bit of a girl and could not run like the older girls and boys, so she and Fido would roll over and over on the grass and play together in the woods.

One morning when Baby went out to have her usual romp with Fido, she found three little puppies running around and having a glorious time chasing one another across the grass. She hurried back to the house and told Aunt Gertie what she had discovered and asked for a biscuit for a breakfast for the puppies, but one little fellow only smelled of the biscuit and would not eat it. Aunt Gertie explained that the puppies were too young to eat biscuits, so Dorothy gave the biscuit to Fido, who finished it in short order.

Dorothy thought the puppies the most beautiful things in the whole world, and after they began to eat she would slip out of the house to feed them with candy, and sometimes she would leave a part of her dinner to take out to the dear little puppies.

Dorothy and Fido.

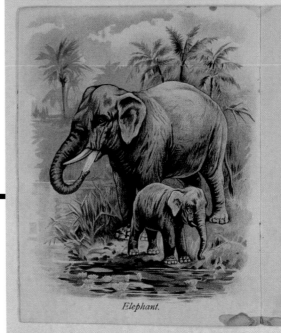

THE ELEPHANT.

The elephants are the largest of all the animals that walk about on the land, and they live in Asia and Africa, where they are captured and taught to do all sorts of things to help the people in their daily work. Sometimes they are used in warfare and frequently in hunting wild animals.

There are two kinds of elephants, and it is not difficult to distinguish them. The elephant with small ears and a forehead which curves in comes from Asia, and the one with big ears and a bulging forehead comes from Africa.

The elephant has a long nose called a trunk, and it is so delicate and the elephant knows so well how to use it that he can pick up from the ground so small a thing as a wisp of hay. The elephant does almost everything with his trunk. With it he puts his food and water into his mouth, and when he wishes to wash himself he fills his trunk full of water and squirts it out all over his back.

Elephant.

Right:
Malena's "Jack the Giant Killer," page/
inside back cover advertisement

Below right:
Malena Stomach & Liver Pills, "Jack
the Giant Killer." $20-25

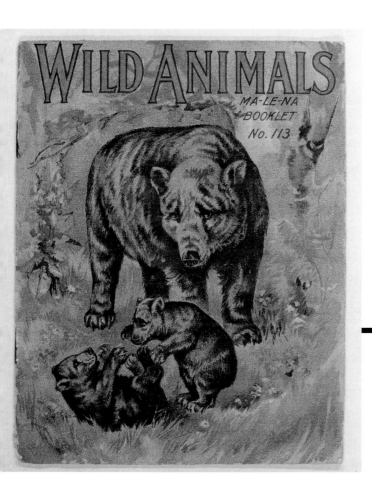

Malena Stomach & Liver Pills,
"Wild Animals." $20

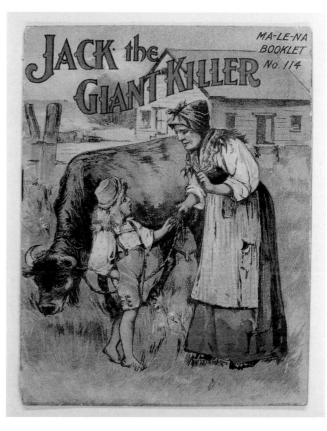

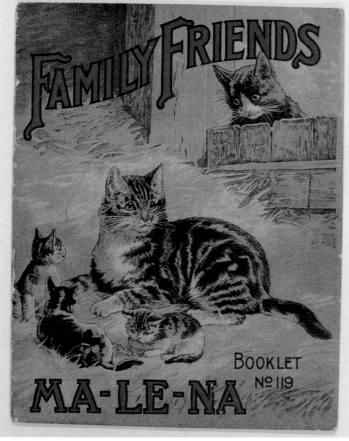

Malena Stomach & Liver Pills, "Family Friends." $20

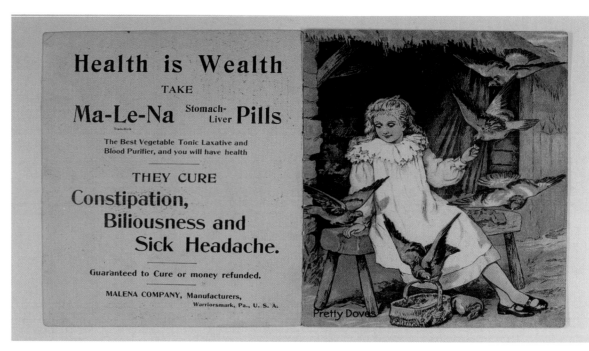

Malena's "Family Friends," inside front cover advertisement/page

G-S-E Gavitt's Stock Exchange, $35-40(box)

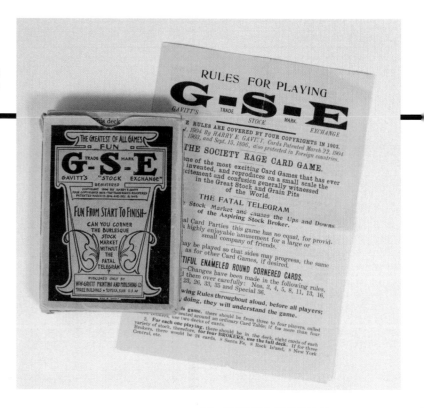

The 1904 "G-S-E Gavitt's Stock Exchange" game was a railroad card game. It included the names of Pennsylvania, Rock Island, Santa Fe, and New York Central Railroads. The Fatal Telegram card is the joker card. It was published only by W. W. Gavitt Printing and Publishing Co., Topeka, Kansas.

VICKS VapoRub, The Vick Chemical Co., Philadelphia

The Story of BLIX and BLEE

Two little elves named Blix and Blee,
Lived in the shade of the jub-jub tree
In a little glass house as round as a pie,
As clean as a whistle and blue as the sky;
For they made their home by the old jub-jub
In an empty jar of Vicks VapoRub.

This colorful 15-page booklet, 5" x 7", was copyrighted in 1928. The advertising premium was obtained by sending four cents in stamps to the Vick Chemical Company, Greensboro, N. C.

G-S-E Gavitt's Stock Exchange, cards

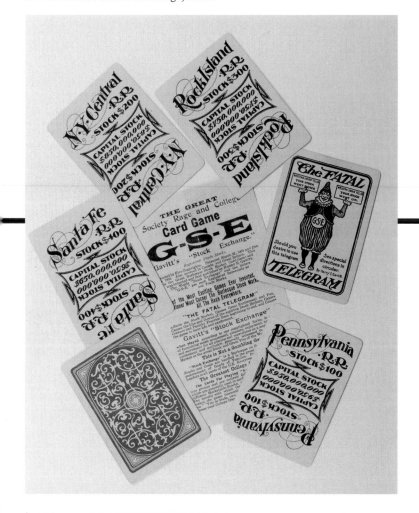

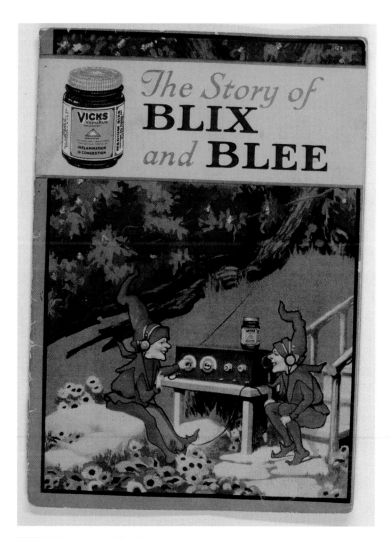

VICKS Vapo Rub, The Vick Chemical Co., "The Story of Blix and Blee." $15-20

VICKS Vapo Rub, "The Story of
Blix and Blee," back cover

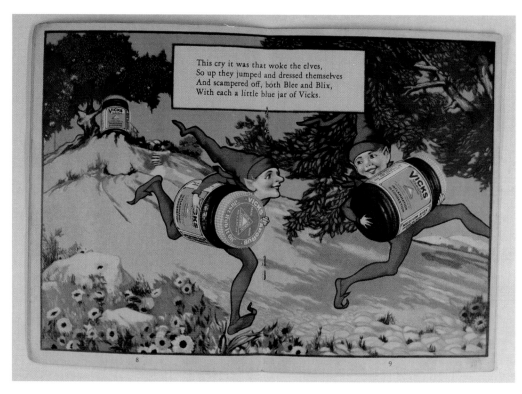

VICKS Vapo Rub, "The Story of Blix and Blee," inside illustration

McKesson's Products, McKesson & Robbins, Inc., Bridgeport, Conn.

"Quality For Over 100 Years"

McKesson's Jig-Saw / Cross-Word Puzzle package was issued on their 100th anniversary in 1933, and was given with each 39-cent purchase of the drug company's products. Official entry blanks and rules were included for the company's contest, and each returned entry blank was to be accompanied by an empty carton of any McKesson Product.

The colorful 150-piece jig-saw puzzle measured 10-1/2" x 14". The 361-Space Cross-Word Puzzle was designed by F. Gregory Hartswick, Editor of *The Cross-Word Magazine*.

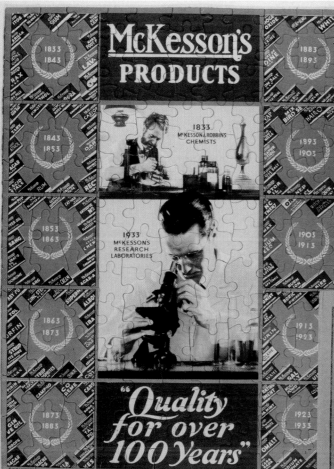

McKesson's Products, McKesson &
Robbins, Inc., Jig-Saw Puzzle

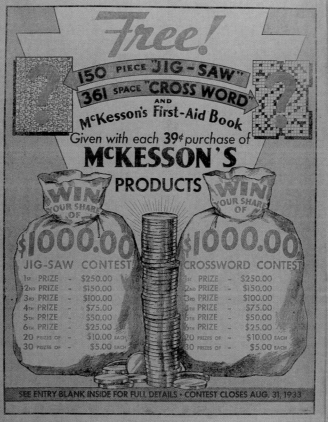

McKesson's Products, Jig-Saw Puzzle/
Crossword. Set: $45-50 (envelope)

McKesson's Products, envelope

Pond's Extract, Pond's Extract Co., N. Y. & London

"DEMAND the GENUINE"

Pond's Extract Company produced such items as Pond's lip salve, toilet cream, and toilet soap. In 1889 this company offered a free premium booklet, 5-1/8" x 4-5/8", in blue print. It was entitled *Choice Selections From Mother Goose's Melodies*, with some additional lines.

There was an old woman
 lived under the hill.
And if she's not gone, she
 lives there still.
Baked apples she sold,
 and cranberry pies.
And she's the old woman
 who never told lies.
"As good as Pond's Extract,"
 so she was told.
This thing is a humbug, such
 frauds I despise;
"Give me none but the genuine
 and don't tell such lies."

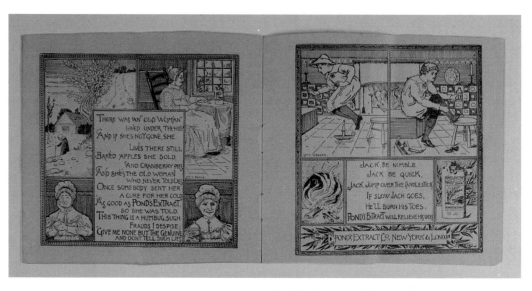

Pond's Extract, "Choice Selections From Mother Goose's Melodies," double page

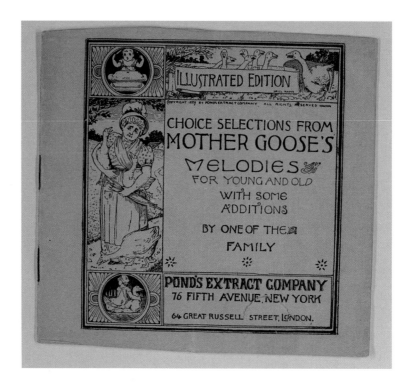

Pond's Extract, "Choice Selections From Mother Goose's Melodies." $12-15

PALMER COX'S
"Brownies"

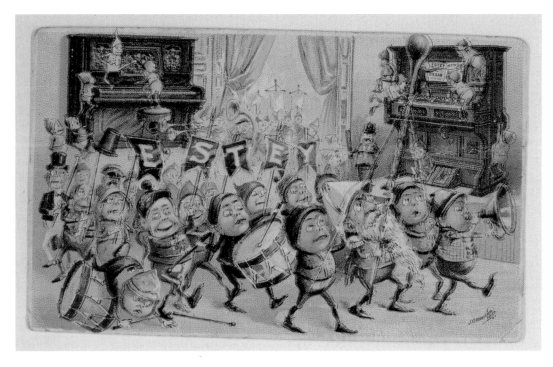

Palmer Cox, "Estey"
trade card. $15-20

"Your grandmother used Pond's Extract in 1846."
"Pond's Extract controls pain, stops bleeding and reduces inflammation."

In 1901 the company gave out a small booklet entitled *Wisdom In Fable*, which was illustrated by Palmer Cox (1840-1924). He was an author and illustrator, famous for his children's classic "Brownie" books. His clever drawings in this booklet pictured animals of the forest extolling the virtues of Pond's Extract.

 The baby bears that thought to steal
From watchful bees a toothsome meal,
Received a dose that closed their eyes
But, through the kind and tender care
Of cunning-minded mother bear,
POND'S EXTRACT promptly was applied

Till "pain" and "swelling" did subside.
Said one, "No person e'er should buy
Diluted stuff that draws the eye
Because of quantity or scent
POND'S EXTRACT, only, brings content.
When it we use, we surely know
Our ailments take the hint and go."

 The advertising booklet measured 4" x 4-7/8", with illustrations in color lithography, and was mailed by the company to any address.
 In addition, the advertising industry printed many reading booklets for children that used Palmer Cox's illustrated stories of his quaintly dressed "Brownies" and other animals. These booklets were used by businesses as premiums to give to their customers.

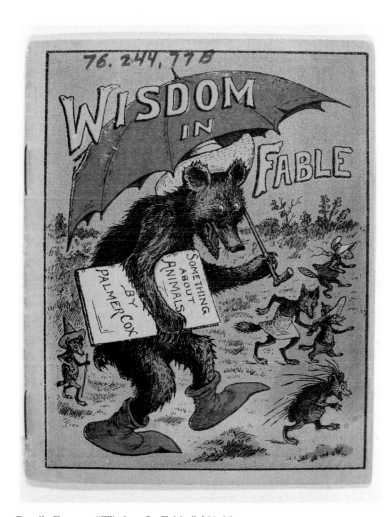

Pond's Extract, "Wisdom In Fable." $30-35

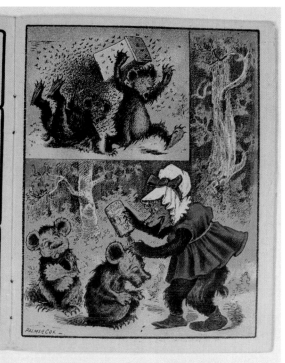

Pond's Extract, "Wisdom In Fable," double page

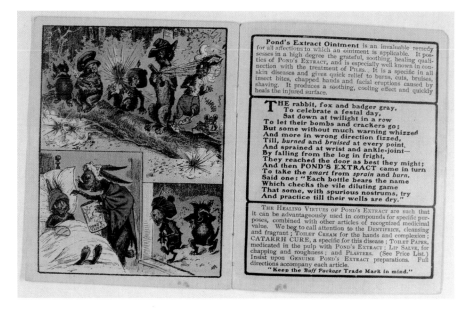

Pond's Extract, "Wisdom In Fable," double page

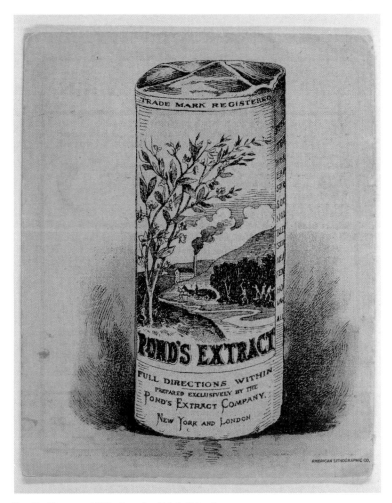

Pond's Extract, "Wisdom In Fable," back cover

Frank Miller's Crown Shoe Dressing, N.Y.C.

*"The Celebrated Set of 12 Palmer Cox Primers,
None Like Them in the World."*

This shoe polish company issued one of the primers for two coupons - one coupon with every bottle or save twenty coupons for the set of 12 books. The books were *Busy Brownies, Cock Robin, Merry Mice, Bonny Birds, Monkey's Trick, First Trousers, Funny Foxes, Birds' Wedding, Fox's Story, Olly Chinee, Jack The Giant,* and *Rival Babies.* The first 6 books listed are pictured.

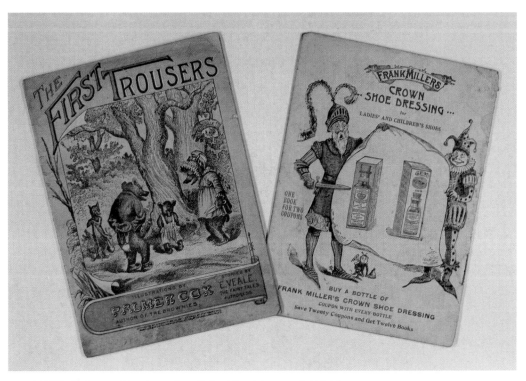

Frank Miller's Crown Shoe Dressing, "The First Trousers." $30-35

THE MAGPIE'S REVENGE.

IT was all due to the treatment which Madame

Magpie had received at the time of the great ball in the early spring. Invitations had been sent far

Frank Miller's Crown Shoe Dressing, "The First Trousers," double page

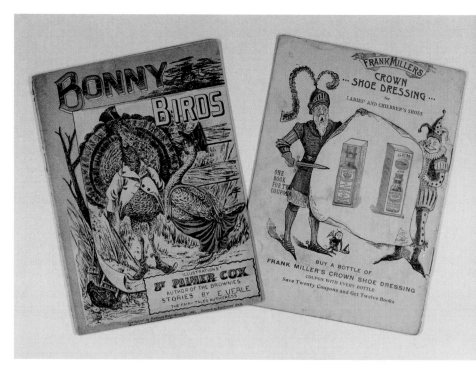

Frank Miller's Crown Shoe Dressing, "Bonny Birds." $30-35

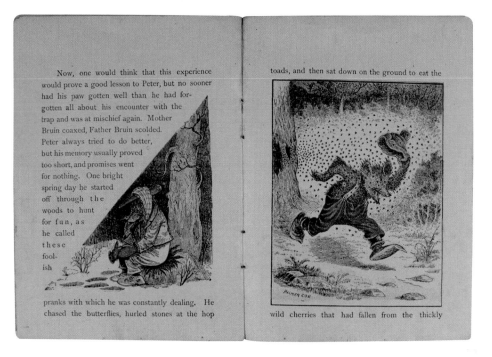

Now, one would think that this experience would prove a good lesson to Peter, but no sooner had his paw gotten well than he had forgotten all about his encounter with the trap and was at mischief again. Mother Bruin coaxed, Father Bruin scolded. Peter always tried to do better, but his memory usually proved too short, and promises went for nothing. One bright spring day he started off through the woods to hunt for fun, as he called these foolish pranks with which he was constantly dealing. He chased the butterflies, hurled stones at the hop

toads, and then sat down on the ground to eat the

wild cherries that had fallen from the thickly

Frank Miller's Crown Shoe Dressing, "Bonny Birds," double page

Jersey Coffee, Dayton Spice Mills Co.

*"All lovers of a delicious cup of coffee,
Use Jersey Coffee"*

The company issued a set of 6 books, *Cock Robin, Funny Foxes, Birds' Wedding, Merry Mice, Bonny Birds,* and *Busy Brownies.*
A short story from the book, *Busy Brownies,* is "The Brownies Christmas Pudding."

Somewhere in the woods nobody knew where, for the Brownies kept the secret all to themselves, was a great big Christmas Pudding full of plums and citron, raisins and spices, and the Brownies wanted to bring that pudding home.

It was so big and heavy that they had built something that made one think of a raft or perhaps a ladder with the sides very far apart. How they put the pudding on it would be hard to tell, but they managed it and bravely they struggled with their burden perched on their little shoulders. They took turns so that no one got too tired. But all were glad when they were safely out of the woods, and had landed the pudding in the hollow of the old tree, back of the school house, for this had been the spot chosen for the great feast. What a treat they had. The pudding was so good, and the day was so merry that the Brownies wished that Christmas came more than once a year. They vowed they would never have a Christmas without a Plum Pudding.

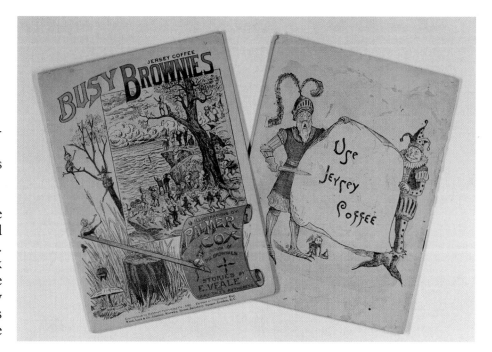

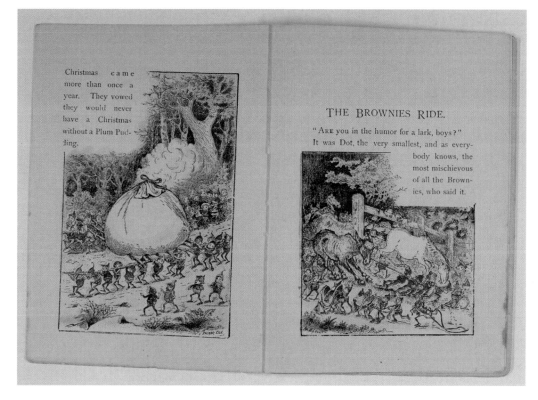

Top right:
Jersey Coffee, "Busy Brownies." $30-35

Right:
Jersey Coffee, "Busy Brownies," double page

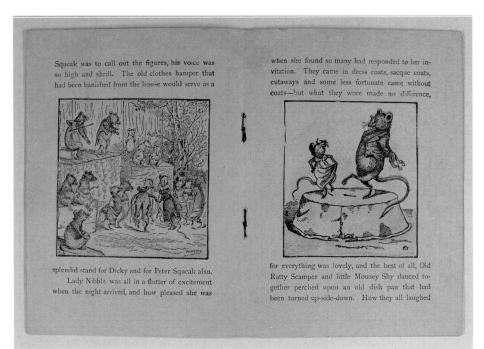

Squeak was to call out the figures, his voice was so high and shrill. The old clothes hamper that had been banished from the house would serve as a

splendid stand for Dicky and for Peter Squeak also.

Lady Nibble was all in a flutter of excitement when the night arrived, and how pleased she was

when she found so many had responded to her invitation. They came in dress coats, sacque coats, cutaways and some less fortunate came without coats—but what they wore made no difference,

for everything was lovely, and the best of all, Old Ratty Scamper and little Mousey Shy danced together perched upon an old dish pan that had been turned up-side-down. How they all laughed

Jersey Coffee, "Merry Mice," double page

Jersey Coffee, "Merry Mice." $30-35

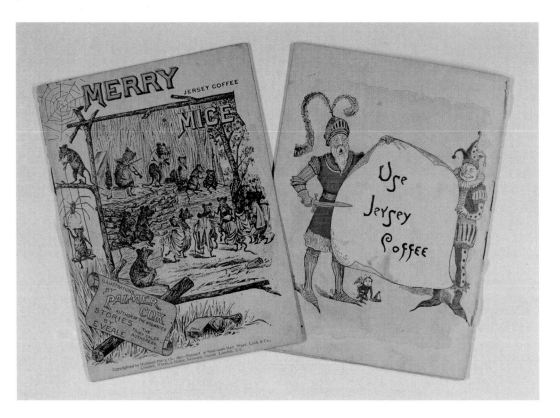

Another company, The Boston Shoe Co., *"Right In Style! Right In Price!"* of Louisville, Ky., issued a set of 8 books which were *Busy Brownies, Cock Robin, Birds' Wedding, Bonny Birds, Monkey's Trick, Jack The Giant, Rival Babies,* and *First Trousers.*

All of these books measured 4-3/8" x 5-3/4", and were published in 1897 by Hubbard Publishing Company, London. The illustrations were printed in color lithography.

Boston Shoe Co., "Cock Robin," double page

Boston Shoe Co., "Cock Robin." $30-35

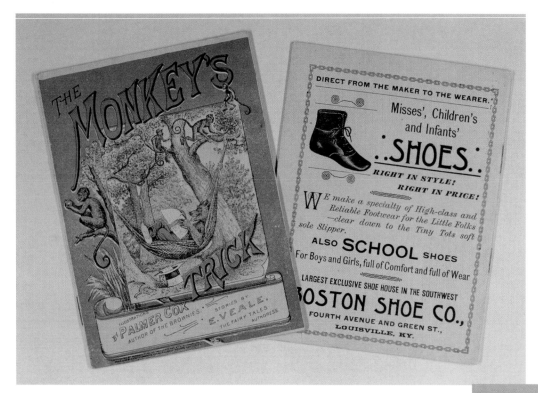

Boston Shoe Co., "Monkey's Trick." $30-35

Boston Shoe Co., "Monkey's Trick," double page

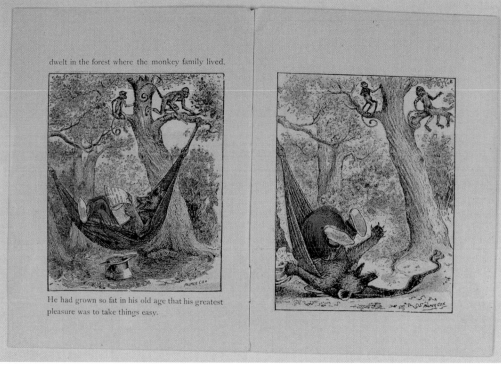

Beverages

The popularity of coffee, tea and cocoa is due to the fact that they contain the stimulant known as caffeine. Many large coffee producers are found in South and Central America, and regions of Africa. Tea is grown chiefly throughout eastern and southern Asia. The cacao bean, from which come chocolate and cocoa, is grown in South and Central America, and the East Indies (primarily Indonesia).

Coffee

The Woolson Spice Company, Toledo, Ohio

This company was founded in August 1882. In the early days, Lion Coffee was its principal brand and, in fact, represented its entire business. The company eventually handled many grades of coffee and all kinds of spices.

"COMRADE—When you go home, don't forget to take this War Song Book with you. It will be a gentle reminder that you should drink Lion Coffee—a mixture of Mocha, Java and Rio. Ask your grocer for Woolson Spice & Lion Coffee."

Earlier in life, Alvin M. Woolson, the founder, had joined the 1st Regiment of the Ohio Volunteers and served in the Civil War. Years later, the Woolson Spice Company published two booklets on war songs. In the first booklet, *War Songs*, Dedicated to the G. A. R. (Grand Army of the Republic), The Woman's Relief Corps, and the Sons of Veterans, there appears a print of the Woolson Spice Company's factories and storehouses.

"COMRADE—please remember that the issue of this book of war songs cost thousands of dollars, and as a partial reimbursement we will ask you to buy one package of Lion Coffee. It is for sale by all grocers."

The second booklet, *War Songs*, dedicated to the United Confederate Veterans, was published during that organization's Second Annual Convention, at Jackson, Miss., in 1891. In this booklet there is a print of the Woolson Spice Company's coffee cabinet, which was placed in stores, and could hold 120 one-pound packages.

The company also distributed paper toys that were printed in series of 30 different die-cuts, in color lithography. These were made to stand up so that they could be played with by children. The words LION COFFEE always appeared on the front of the toy, while on the reverse side were different advertising messages.

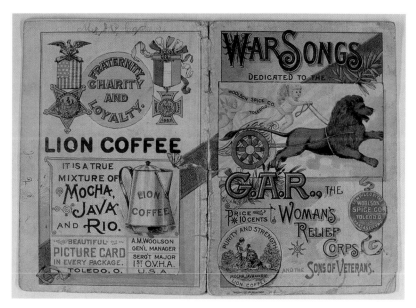

Woolson Spice Co., Lion Coffee, "War Songs." $45-85 as shown

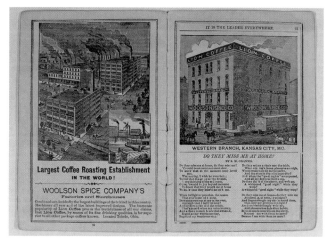

Woolson Spice Co., factories/storehouses, "War Songs," G.A.R.

"Lion Coffee, It's Popular Because It's Good."
"Lion Coffee, The Cup Which Satisfies."

The different toy railroad cars of LION Railroad can be coupled together to make a train set. There is the LION Locomotive, LION R. R. Baggage Car, WOOLSON FAST FREIGHT LINE Freight Car, and the LION R. R. Caboose. To make the toy stand up, a child would bend back the bottom strip until the figure (1) fitted inside of the flap marked (2) on the back. Then flaps (3) and (4) would be bent back, and the toy would stand up perfectly.

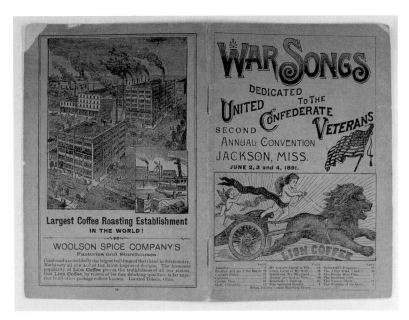

Woolson Spice Co., Lion Coffee, "War Songs," (1891). $45-85 as shown

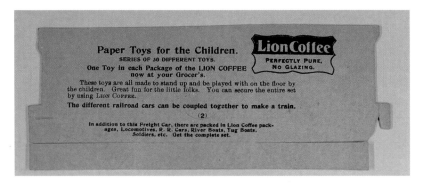

Lion Coffee, Lion Railroad, reversed for advertisement

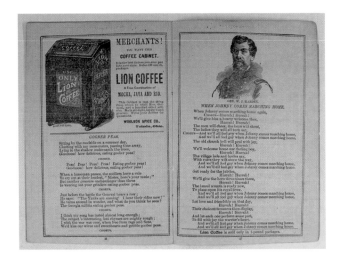

Woolson Spice Co., coffee cabinet/"When Johnny Comes Marching Home", "War Songs," Confederate Convention

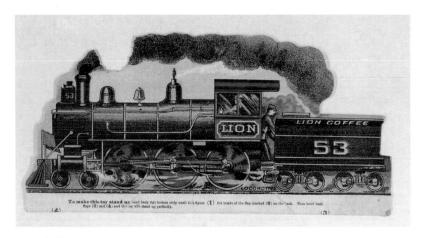

Lion Coffee, Locomotive. $15-25 as shown

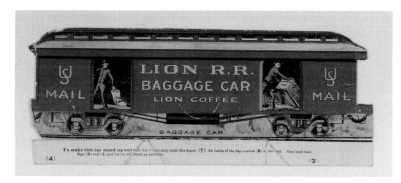

Lion Coffee, Baggage Car. $15-25 as shown

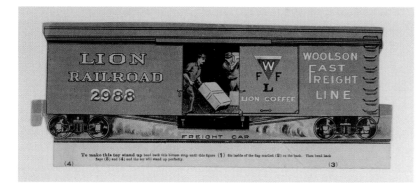

Lion Coffee, Freight Car. $25-30

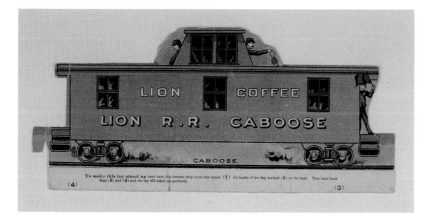

Lion Coffee, Caboose. $25-30

Some of the other paper toys are Fire Engine, Hose Cart, and Hook & Ladder which form a group set. Another group set was comprised of the Battleship in Action, Ocean Liner, River Steamboat, Tug Boat, and Launch. Other pieces were Soldiers Marching, Cannon, Automobile, and Doll Carriage.

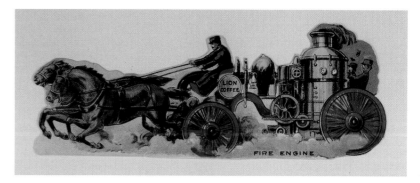

Lion Coffee, Fire Engine. $15-25 as shown

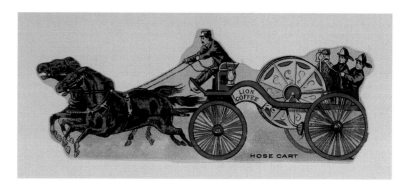

Lion Coffee, Hose Cart. $15-25 as shown

Lion Coffee, Hook & Ladder. $15-25 as shown

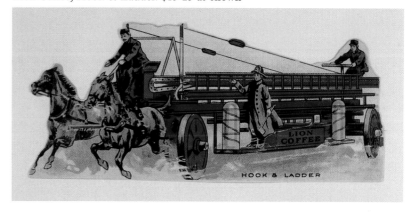

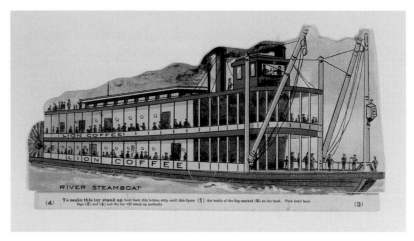

Lion Coffee, River Steamboat. $15-20

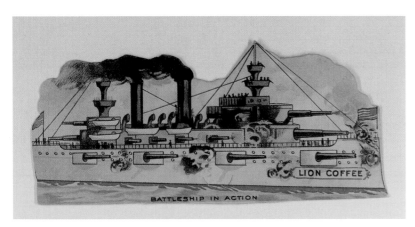

Lion Coffee, Battleship In Action. $10-12 as shown

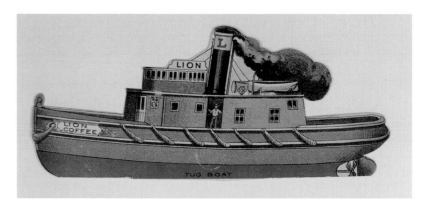

Lion Coffee, Tug Boat. $10-12 as shown

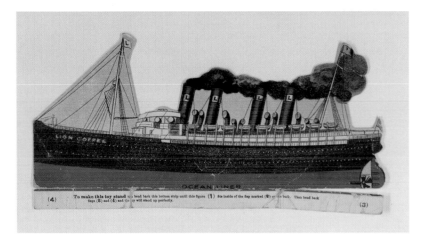

Lion Coffee, Ocean Liner. $15-20

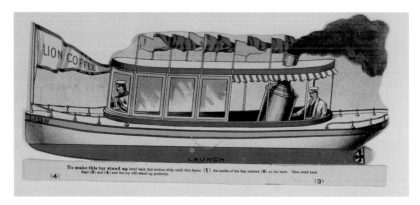

Lion Coffee, Launch. $15-20

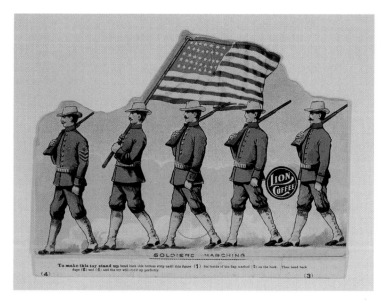

Lion Coffee, Soldiers Marching. $15-20

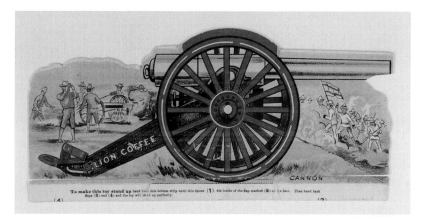

Lion Coffee, Cannon. $15-20

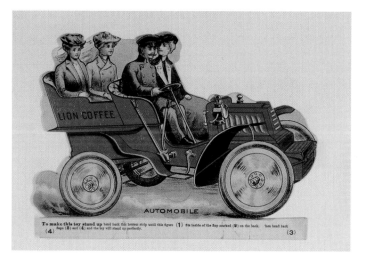

Lion Coffee, Automobile. $15-20

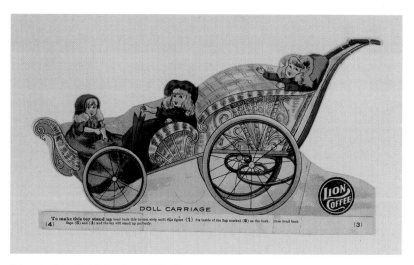

Lion Coffee, Doll Carriage. $15-20

The directions for folding the animal/cart paper toys to create a standard were somewhat involved. The Dog & Cart toy had to be bent on dotted lines until the tongue (A) fit into the slot (B). The wheels then would stand up perfectly along the bottom edge line of the pulling animal. All the pull toys have LION COFFEE printed on the wagons, and include The Billy Goat and Cart, Pony & Cart, and Dorothy & Her Cart.

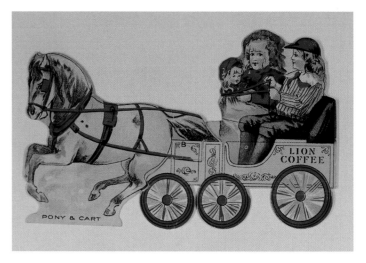

Lion Coffee, Pony & Cart. $10-15

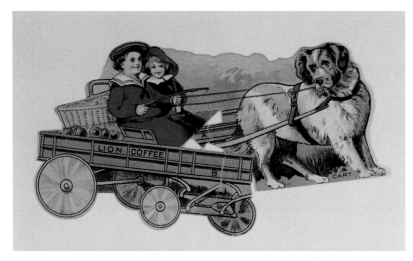

Lion Coffee, Dog & Cart. $10-15

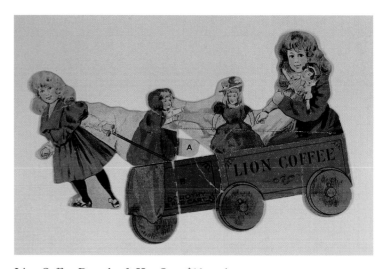

Lion Coffee, Dorothy & Her Cart. $10 as shown

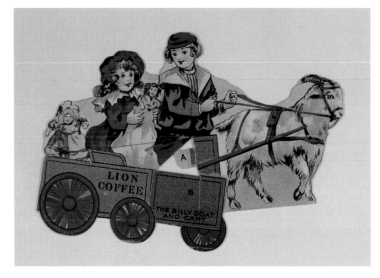

Lion Coffee, The Billy Goat and Cart. $10-25

Other toys have their folding directions printed on the back side. The dotted lines were to be folded back, and a pre-cut section would pop out for a perfect stand-up. Some of these pieces were LION COFFEE LINE Trolley Car, LION COFFEE Yacht, Indian On Pony, and Indians On The War-Path.

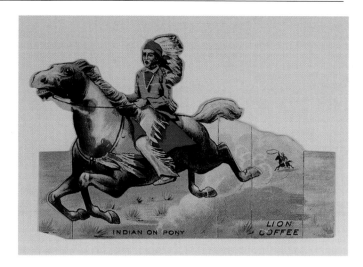

Lion Coffee, Indian On Pony. $10 as shown

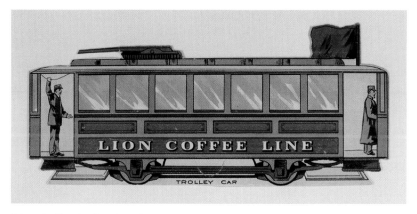

Lion Coffee, Trolley Car. $10-12 as shown

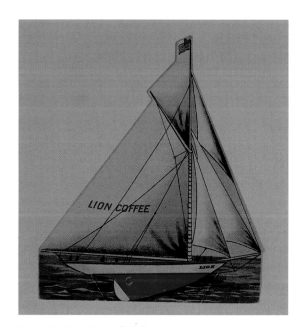

Lion Coffee, Yacht. $10-15

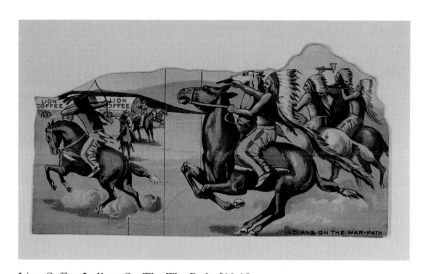

Lion Coffee, Indians On The War-Path. $10-15

"GAMES FREE! An amusing game will be found in each package of LION COFFEE. Fifty Different Kinds. At your grocer's."
"60 Games are given Free in Lion Coffee Packages. At your Grocer's."

The game, "Pinning Tusks On The Elephant," was for a large company of players. The directions are the same as the well-known game of "Pinning The Tail On The Donkey." Lion Coffee also had a game called "Pinning Tails on the Donkey." Another game was "Polly Wants a Cracker," which was copyrighted in 1903 by Woolson Spice Co. The player who pinned a cracker nearest the parrot's mouth was the winner.

Lion Coffee, Tusks for Elephant

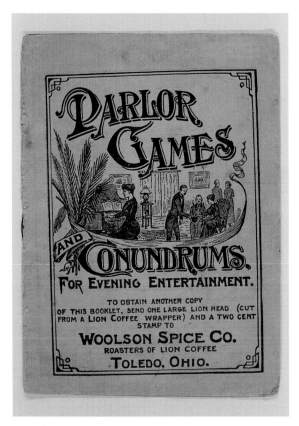
Lion Coffee, "Parlor Games and Conundrums." $15

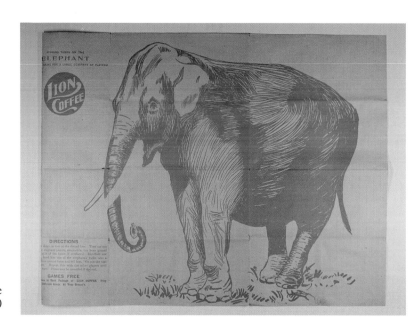
Lion Coffee, Pinning Tusks On The Elephant, (14" x 30") uncut. $25-50

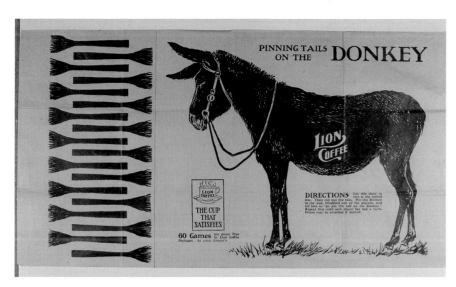

Lion Coffee, Pinning Tails On The Donkey, (13" x 24") uncut. $25-50

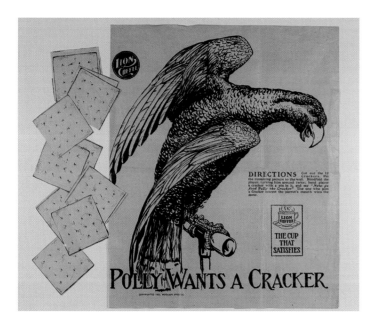

Lion Coffee, Polly Wants A Cracker. $50 as shown

The directions of the question-and-answer games, such as "Game of NOTED PEOPLE," state that each player was to hold a number of forfeits (about 6 apiece), with "Lion Coffee" beans being used as the forfeits. The director read the questions aloud, stopping after each question to await the answer. The player holding the answer should, of course, be the first to respond, but if another player answered the question first then he received a forfeit from the person who should have answered. The person holding the most forfeits won the game. Some other question-and-answer games were "Game of WHO AM I ?," "Game of BIBLE QUESTIONS," "AMERICAN HISTORY," "Cross Questions and Silly Answers," "JUMBLE," and "REBUS GAME."

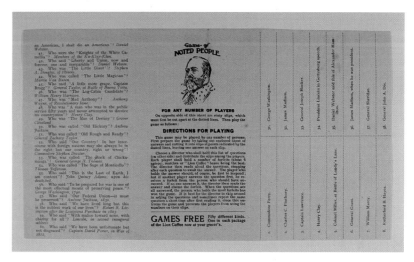

Lion Coffee, Noted People, (6" x 22") uncut. $15-20

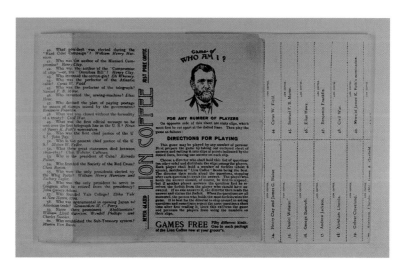

Lion Coffee, Who Am I?, uncut. $15 as shown

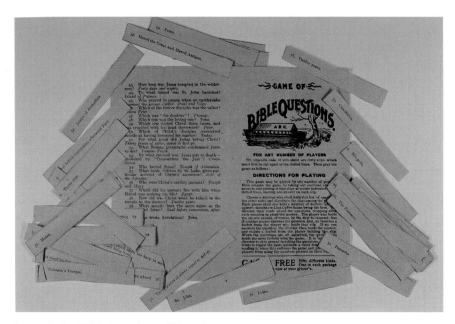

Lion Coffee, Bible Questions. $15 as shown

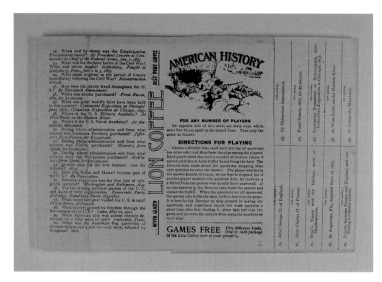

Lion Coffee, American History. $15 as shown

Lion Coffee, Cross
Questions and Silly
Answers, uncut. $15-20

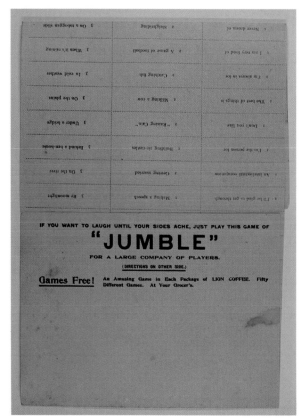

Lion Coffee, Jumble, uncut.
$15-20

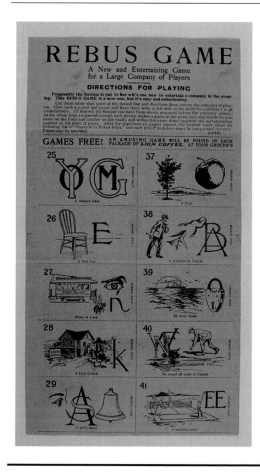

Lion Coffee, Rebus Game, uncut. $15-20

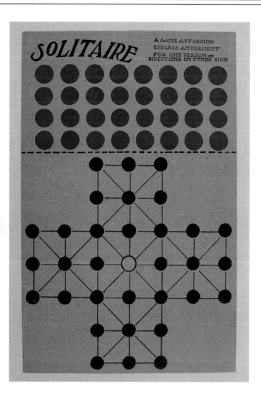

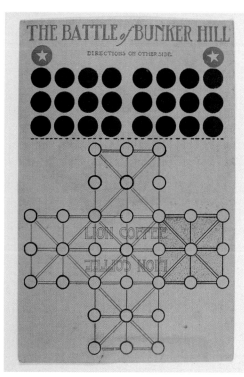

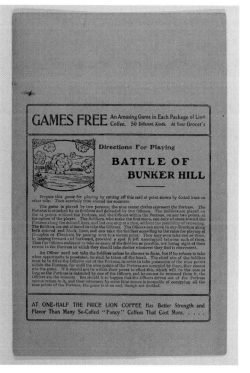

Top center:
Lion Coffee, Solitaire, uncut. $15-20

Above:
Lion Coffee, Battle of Bunker Hill, uncut. $15-20

Left:
Lion Coffee, Battle of Bunker Hill, reversed

The board games were of cardboard, and were adapted to one or more players. The "Solitaire" board game afforded endless amusement for one player. The "Battle of Bunker Hill" was played by two persons, as in checkers. "Fox and Geese" has fifteen black counters for the geese and a red counter for the fox.

The board game, "Game of FISH POND," is an example of many games that were "borrowed" from popular common games in a period when copyright laws were not highly enforced, and companies plagiarized from one another. This game had been published by the famous toy manufacture, McLoughlin Brothers, New York City, 1890, with a colorful, lithograph board and numerous slits in which to stand fish.

Other board games included "THE TEN LITTLE SOLDIERS," "Game of TWELVE MEN MORRIS," "Game of MAYPOLE," "PACHESI," "Game of CROSS BOARD," "TIT-TAT-TOE," "How to Tell Her Age," "Fortune Telling," "Odd or Even," "Game of EUREKA," and a puzzle game called "LION COFFEE with a NUMBER PUZZLE" on the reverse side.

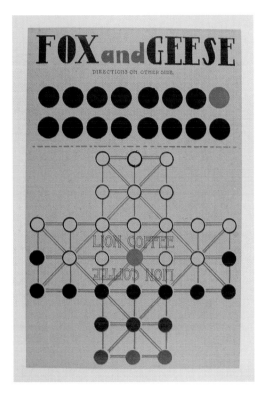

Lion Coffee, Fox and Geese, uncut. $15-20

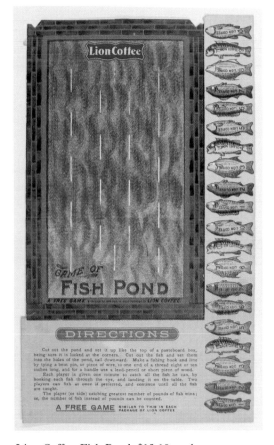

Lion Coffee, Fish Pond. $15-18 as shown

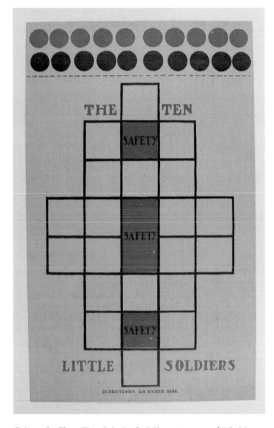

Lion Coffee, Ten Little Soldiers, uncut. $15-20

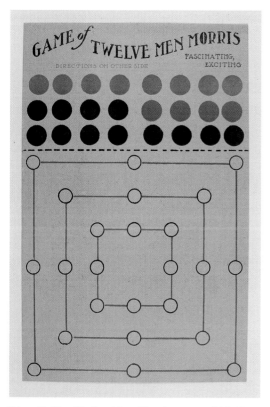

Lion Coffee, Twelve Men Morris, uncut. $15-20

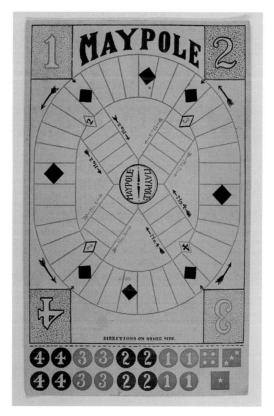

Lion Coffee, Maypole, uncut. $15-20

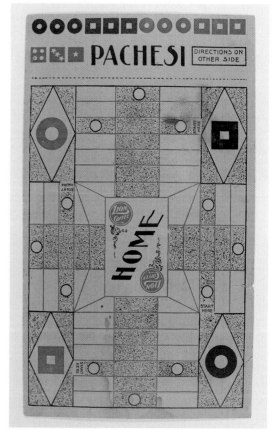

Lion Coffee, Pachesi, uncut. $15-18 as shown

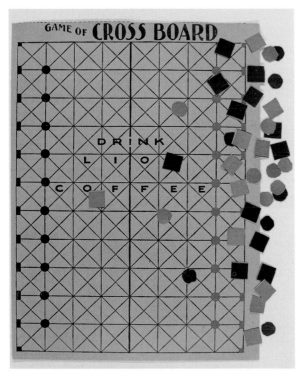

Lion Coffee, Cross Board. $12-15 as shown

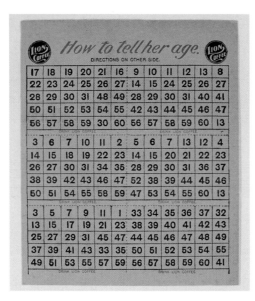

Lion Coffee, How To Tell Her Age, uncut. $15-20

Lion Coffee, Fortune Telling, uncut. $15-20

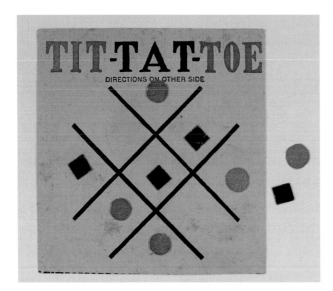

Lion Coffee, Tit-Tat-Toe. $12-15 as shown

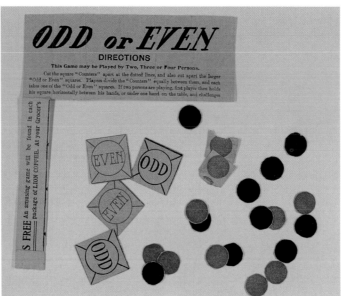

Lion Coffee, Odd or Even. $10 as shown

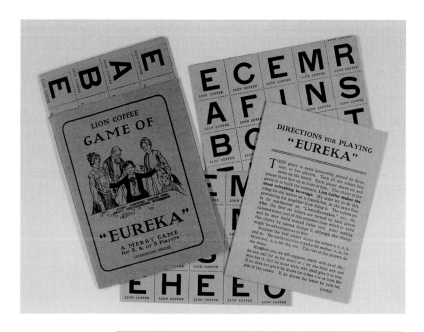

Lion Coffee, Eureka, uncut.
$25-30 (wrapper)

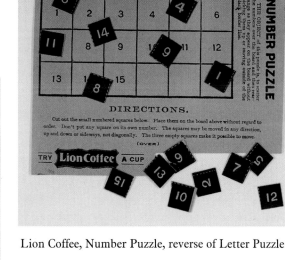

Lion Coffee, Number Puzzle, reverse of Letter Puzzle

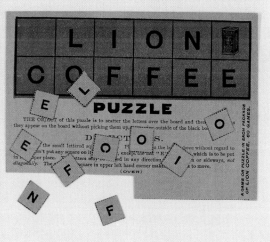

Lion Coffee, Letter Puzzle. $10 as shown

"CHRISTMAS GAMES FREE! A numerous and varied assortment. One game in every package of Lion Coffee from Oct. 15 until Christmas Day."

Many of the Woolson Spice Company's varied assortment of envelope games have copyright dates of 1894 and 1895. "Jeremiah Judkin's Trip to the Fair," copyright 1894, shows a picture on the envelope of the family in front of the Administration Building of the World's Columbian Exposition, held in Chicago, 1893. The Reader of the printed story, "The Truthful Account of A Most Extraordinary Occurrence," had to distribute small printed slips among the players, and these were read aloud to fill in the blank lines that appear in the story. The game grew funnier the longer it was played.

Some of these games were "BOBBY'S FIRST DAY AT THE CIRCUS," "SIMON PURE'S VISIT, or How a City Boy Spent The Summer with Country Relatives," "SPELLING GAMES" of anagrams, syllabus, and orthography, and, of course, "JACK STRAWS!" with colorful, wooden sticks.

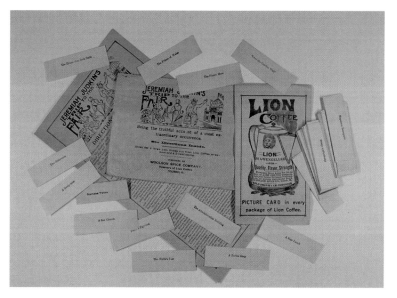

Lion Coffee, Jeremiah Judkin's Trip to the Fair. $20-25 as shown

Lion Coffee, Bobby's First Day at the Circus. $15-20 as shown

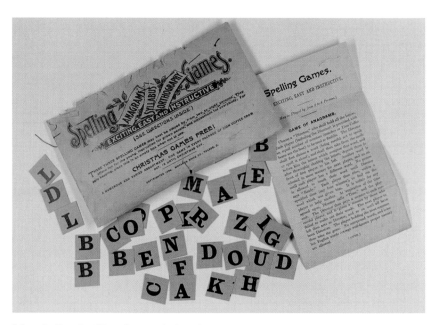

Lion Coffee, Spelling Games. $15 as shown

Lion Coffee, Simon Pure's Visit. $15-20 as shown

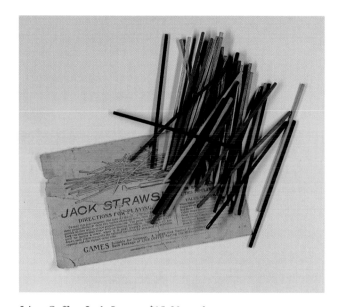

Lion Coffee, Jack Straws. $15-20 as shown

"LION COFFEE is used in every State and Territory of the U. S."

"If Mother Goose were alive to-day she would surely drink LION COFFEE."

The children's playing card games are both interesting and instructive. "OUR UNION" can be played by any number of players. The cards are divided among the players. Player No. 1 takes up his top card, such as Indian Territory, and reads the first of six descriptive lines. Eventually, someone guesses the name of the card, and it is given to that player. Player No. 2 reads his first card, and so on, until all the cards have been read. The player holding the greatest number of cards is declared the winner.

The game "MOTHER GOOSE" is played like the Milton Bradley Company's game called "OLD MAID." The card pairs are of nursery rhymes and fairy tales. The 13th pair reads as SILVER LOCKS AND THREE BEARS, and the 14th pair shows a young Chinese boy as Aladdin in the fairy tale called ALADDIN AND HIS WONDERFUL LAMP.

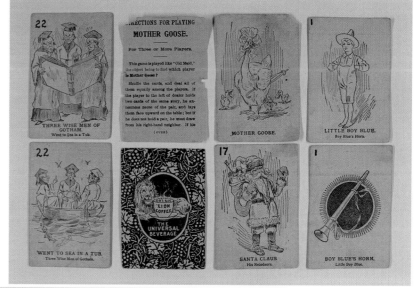

Lion Coffee, Mother Goose, (22 pairs/Mother Goose). 18-20 as shown

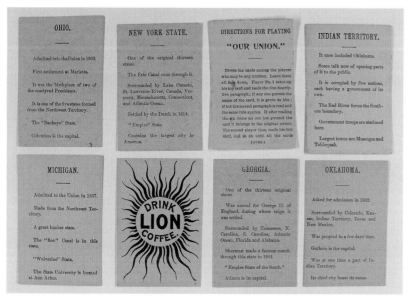

Lion Coffee, Our Union, (49). $18-22

The "GAME OF CHINK," copyrighted in 1903 by The Woolson Spice Company, is one that would not have been produced even half a century later. The object of the card game was to avoid taking tricks which contain a Chinese man or, less complimentary, a "Chink." When the game appeared, the United States had had a Congressionally-approved policy for 23 years that restricted the Chinese from entering the country. Well into the 20th century, unfortunately, the Chinese and a few other nationalities were made the object of amusement in some American games. The Chinese Exclusion Acts were finally repealed in 1943, after the Chinese had become this nation's ally in World War II. We must always remember that America then, as today, is a country of immigrants.

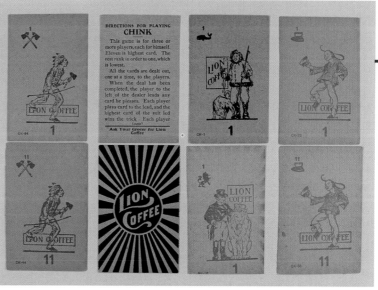

Lion Coffee, Chink, (4 groups/11 cards each) violet wrapper. $25-30

Some of the other card games were "OUR COUNTRY," "Wars of the World," "Game of POLITICS," "THE SPY," "Game of AUTHORS," "Game of COLOR CASINO," "Game of ASTRONOMY," "Game of KNOWLEDGE," "New Game of STOP," and a much smaller deck known as the "Game of PIG."

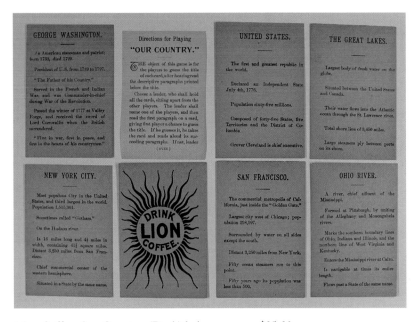

Lion Coffee, Our Country, (Deck) beige wrapper. $25-30

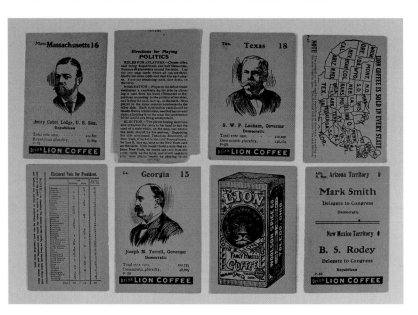

Lion Coffee, Politics, (Deck) green wrapper. $25-30

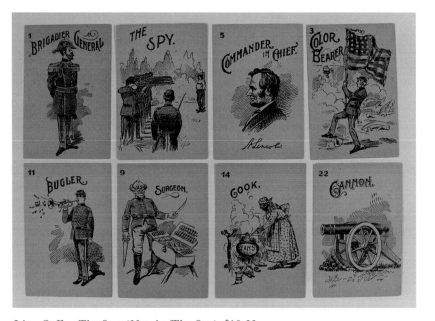

Lion Coffee, The Spy, (22 pairs/The Spy). $18-22

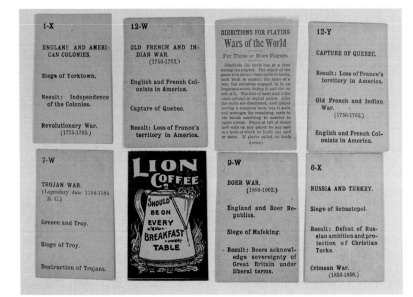

Lion Coffee, Wars of the World, (WXYZ groups/11 cards each). $18-22

Lion Coffee, Authors, (4 groups/12 cards each) green wrapper. $25-30

Lion Coffee, Astronomy, (4 groups/11 cards each) green wrapper. Similar to Chinese "Pfan Tan". $25-30

Lion Coffee, Color Casino, (4 groups/11 cards each) violet wrapper. $25-30

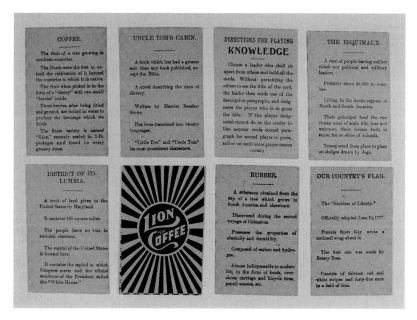

Lion Coffee, Knowledge, (Deck) beige wrapper. $25-30

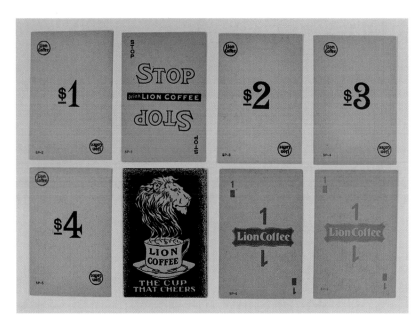

Lion Coffee, Stop, (Deck) green wrapper. $25-30

Lion Coffee, Stop, (BRBG groups/9 cards each)

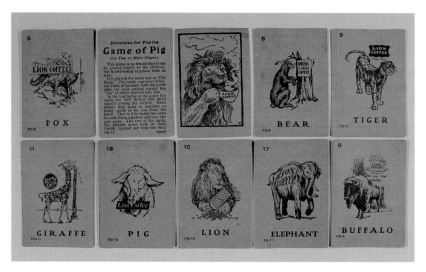

Lion Coffee, Pig, (17 pairs/Pig) pink wrapper. $25-30

LION COFFEE / TRANSFER PICTURES / LOTS OF FUN

The pictures of the transfer activity sets were to be cut apart and placed in water for two or three minutes. Each, then, was to be held against an article that was to be decorated, and afterwards it was carefully drawn away, leaving the transfer picture sticking to the article. It was great fun for children.

Lion Coffee, Transfer Pictures. $25-30

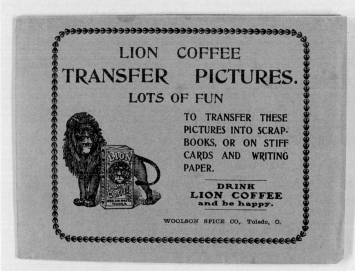

"MAGIC PICTURES" brought about invisible designed pictures after a lead pencil had been drawn back and forth across the paper. Also, "The Lion Coffee Painting Sheet" directions called for a moistened brush to be applied to a set of colors on the sheet.

Lion Coffee, "Little Artist's Painting Book." $15-20

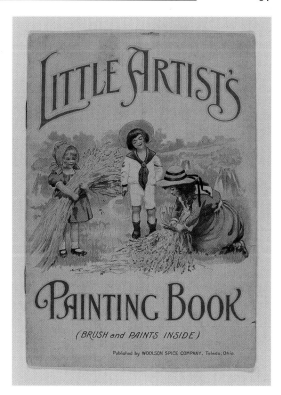

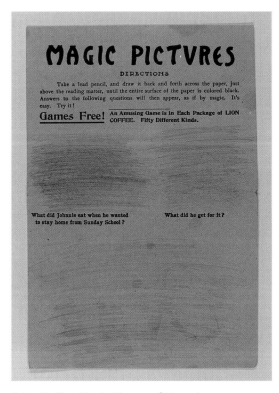

Lion Coffee, Magic Pictures. $10 as shown

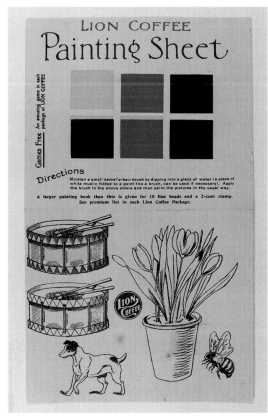

Lion Coffee, Painting Sheet. $15-25

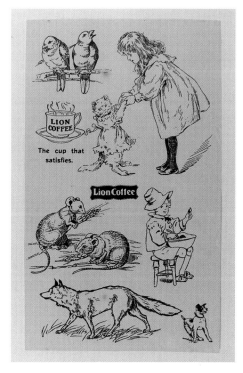

Lion Coffee, "Little Artist's Painting Book," inside page

The cards for pricking and sewing helped to educate children to use their hands. With a pointed instrument, holes were pricked into the card at points indicated by small black dots. A needle with embroidery yarn was used to sew through the holes. Some pattern designs were a sunflower, a rooster, and a Victorian girl on a bench, looking at a book.

Lion Coffee, Sunflower. $10-15

Lion Coffee, Rooster. $10-15

Lion Coffee, Victorian girl. $10-15

Small booklets were given out by the Woolson Spice Company for the reading enjoyment of children. These had short stories, poems, and pictures. Some of these were *FAIRY LAND*, *BABY HOOD*, and *THREE LITTLE GOSSIPS*. These three were copyrighted in 1885 by Baker & Hayes and printed by The Pictorial Publishing Co., Phila. & Baltimore.

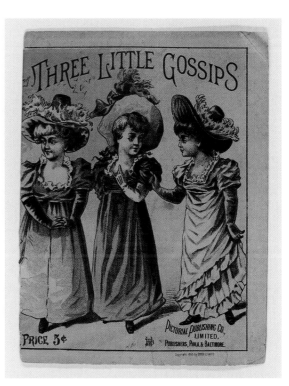

Lion Coffee, "Three Little Gossips." $10-20

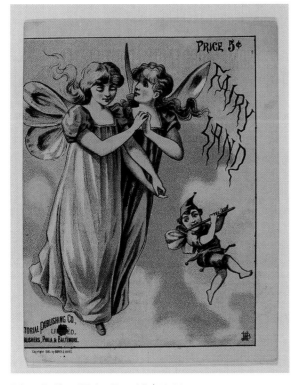

Lion Coffee, "Fairy Land." $10-20

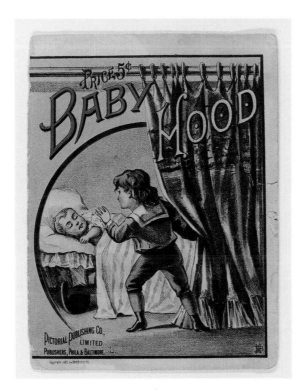

Lion Coffee, "Baby Hood." $10-20

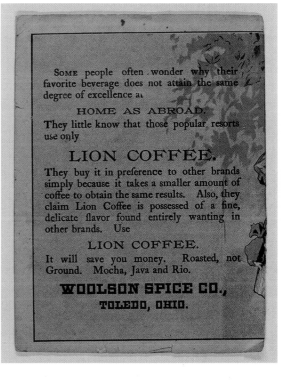

Lion Coffee, "Three Little Gossips," back cover

70

"CUT OUT YOUR LION HEADS FOR VALUABLE PREMIUMS"
"PICTURE BOOKS 'Given Free' To The Children Who Drink LION COFFEE"

The booklet, *Lion Coffee Premium List*, featured premiums the company gave in exchange for large (round) lion heads cut from their coffee wrappers. In addition, as stated on the back of a Woolson Spice trade card, three books entitled *Jack and the Bean Stalk*, *My First Alphabet*, and *The Three Little Pigs* were given in exchange for 6 large lion heads cut from coffee packages and a two-cent postage stamp.

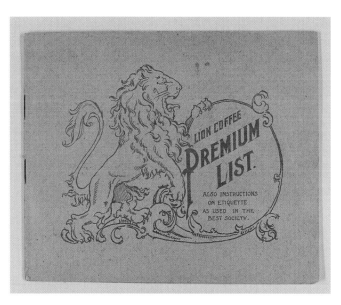

Lion Coffee, Premium List, (booklet). $20-30

Lion Coffee, Lion Heads. $2 each as shown

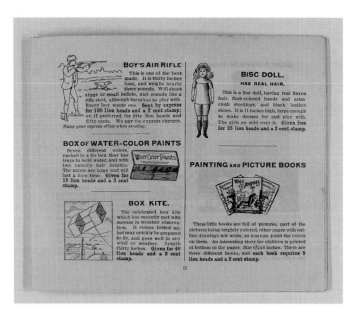

Lion Coffee, Premium List, inside page

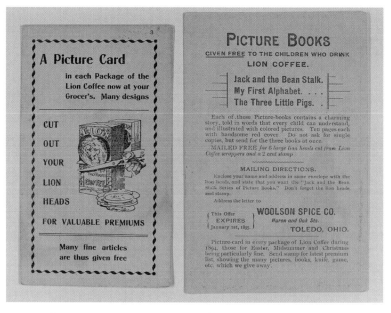

Lion Coffee, Picture Books (premiums) $15-20; $3-6

Here are some more "Lion Coffee" premium games that were welcomed by the children: "The Game of LITERATURE," "Reuben Rubberneck's Visit To Chicago," "Game of JAIL," "Quotations," "COUNTRIES AND TERRITORIES OF THE WORLD," "Game of Bottles," "Game of TWELVE MONTHS," "Sir Hinkum Funnyduster," "Game of MONKEY," "Game of Inventions," "BUY AND SELL," "Progressive Words," and "Snap."

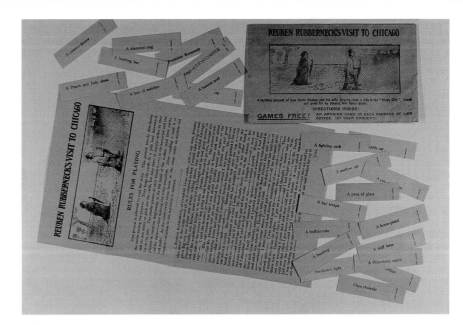

Lion Coffee, Reuben Rubberneck's Visit To Chicago. $15-20 as shown

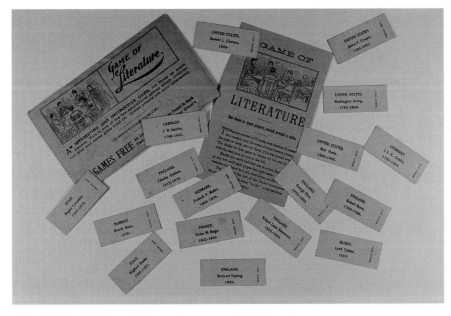

Lion Coffee, Additional Games: Literature. $15-20 as shown

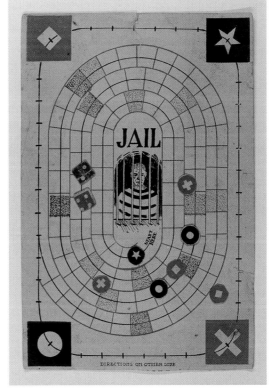

Lion Coffee, Game of Jail. $15 as shown

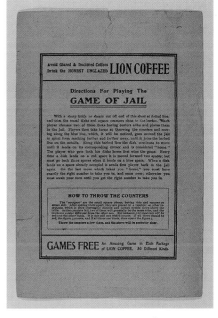

Lion Coffee, Game of Jail, reversed

72

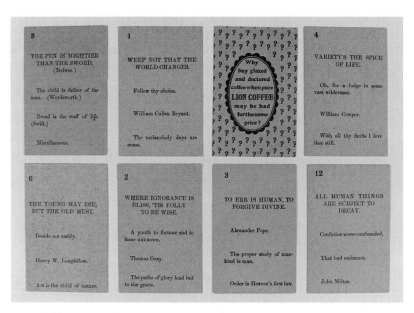

Lion Coffee, Game of Quotations, (Deck) $10-12

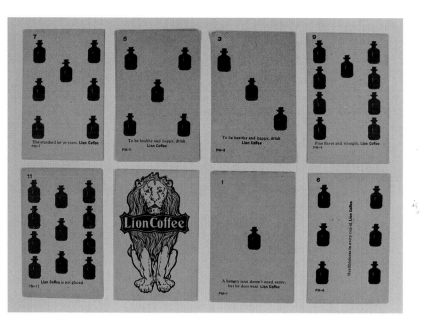

Lion Coffee, Bottles, (11 groups/4 cards each). $10-12

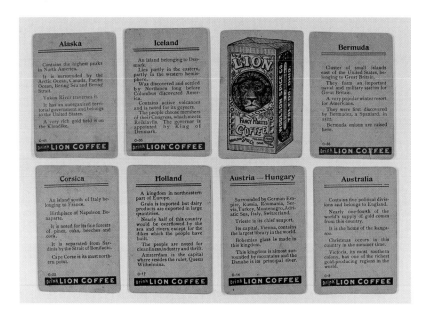

Lion Coffee, Countries and Territories of the World, (Deck) $10-12

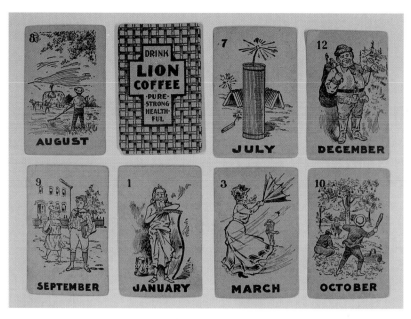

Lion Coffee, Twelve Months, (4 cards each). $10-12

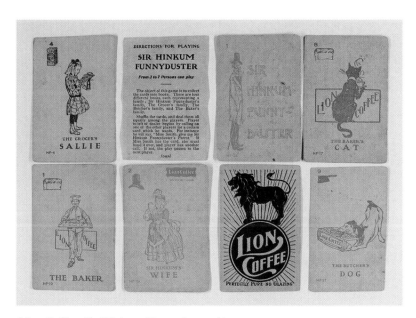

Lion Coffee, Sir Hinkum Funnyduster, (4 groups/9 cards each) violet wrapper. $25-30

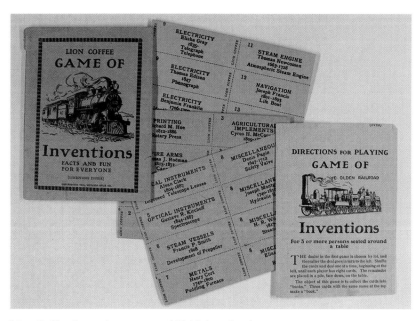

Lion Coffee, Inventions, uncut. $25-30 (envelope)

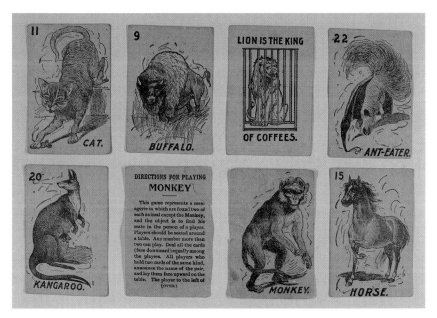

Lion Coffee, Monkey, (22 pairs/Monkey) red wrapper. $25-30

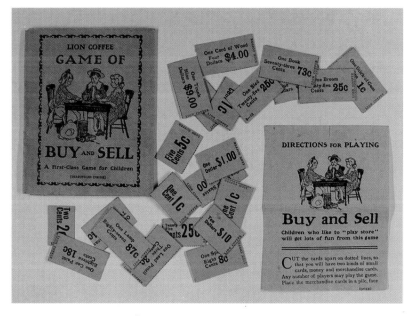

Lion Coffee, Buy & Sell. $20 as shown

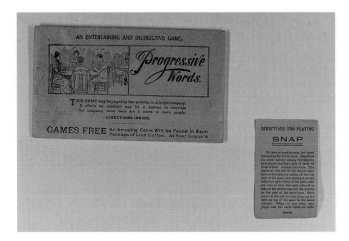

Lion Coffee, Progressive Words,
(envelope) and directions for Snap

W. F. McLaughlin & Co., Chicago

This company was the producer of the coffee brand known as "McLaughlin's XXXX Coffee." It was a glazed, roasted coffee. This glazing was made from corn starch and reclarified sugar. The company's chief competitor was the Woolson Spice Company, whose "Lion Coffee" was advertised as an honest coffee, entirely free from all coloring or glazing. The McLaughlin Company, throughout its free premium paper items, was always explaining the following two questions: Why is McLaughlin's XXXX Coffee Glazed? What is glazing composed of?

All of the company's Novelty folding booklets contain five stand-up paper toys. In each booklet, the directions state that the player is to break the little catches holding the cutout in position, then bend up the picture scene on the line indicated until it stands perfectly straight. Then the player was to tie these different processions together by putting a hole in the back margin and tying another on to it.

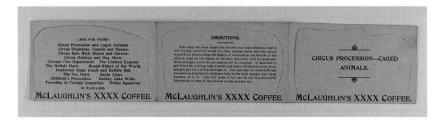

McLaughlin Coffee, Novelty Booklet, "Circus Processions and Caged Animals," (3 of 5 sections for advertisements)

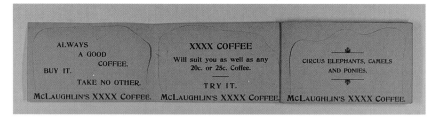

McLaughlin Coffee, Novelty Booklet, "Circus Elephants, Camels and Ponies," (3 of 5 sections for advertisements)

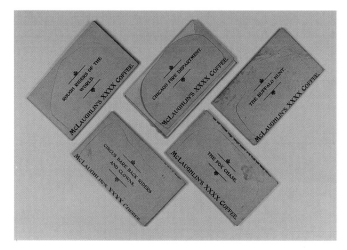

McLaughlin Coffee, Novelty Booklets,
(5 sections unfolded 2-1/2" x 20")

McLaughlin Coffee, "Circus Processions and Caged Animals," Coach/Band. Set:(5) $25-30

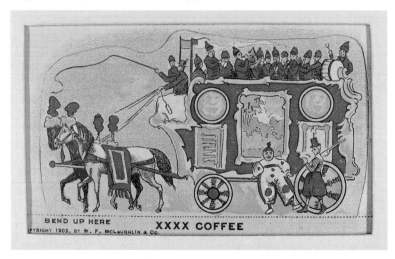

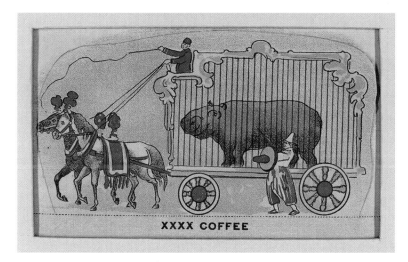

McLaughlin Coffee, "Circus Processions and Caged Animals," Hippopotamus

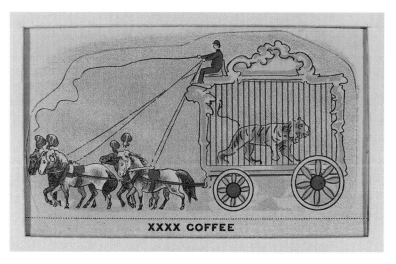

McLaughlin Coffee, "Circus Processions and Caged Animals," Tiger

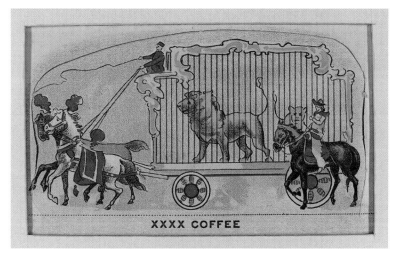

McLaughlin Coffee, "Circus Processions and Caged Animals," Lions

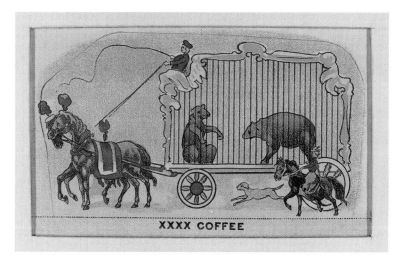

McLaughlin Coffee, "Circus Processions and Caged Animals," Bears

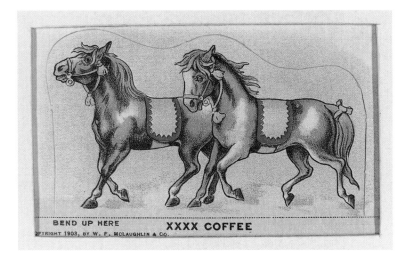

McLaughlin Coffee, "Circus Elephants,
Camels and Ponies," Ponies. Set:(5) $25-30

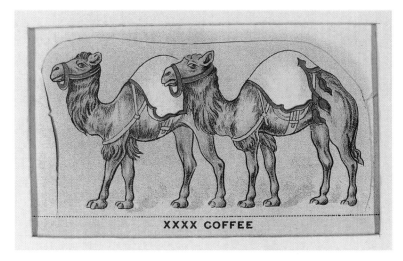

McLaughlin Coffee, "Circus Elephants, Camels and Ponies," Camels

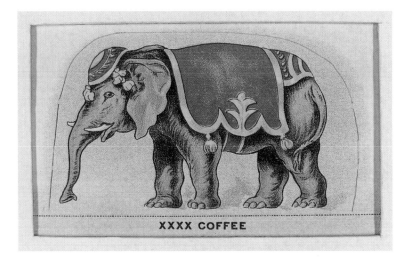

McLaughlin Coffee, "Circus Elephants, Camels and Ponies," Elephant

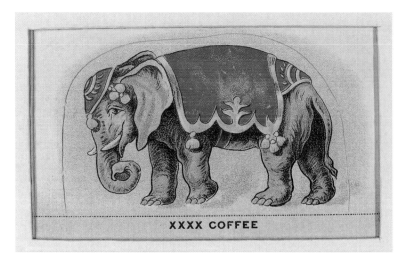

McLaughlin Coffee, "Circus Elephants, Camels and Ponies," Elephant

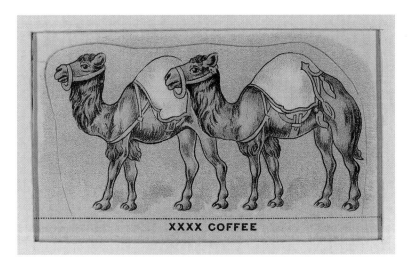

McLaughlin Coffee, "Circus Elephants, Camels and Ponies," Camels

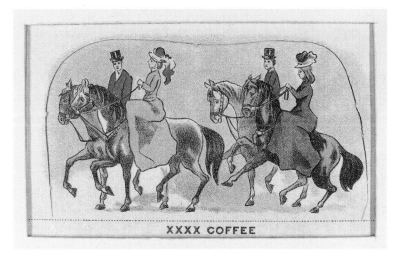

McLaughlin Coffee, "Circus Bare Back Riders and Clowns," Show Horses/Riders

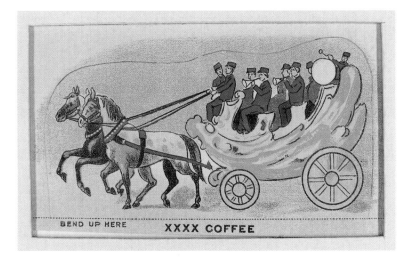

McLaughlin Coffee, "Circus Bare Back Riders and Clowns," Coach/Band. Set:(5) $25-30

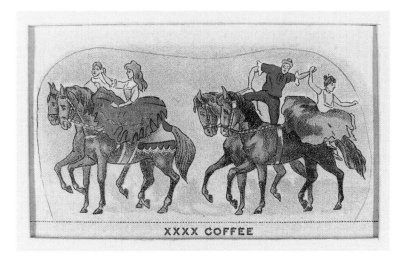

McLaughlin Coffee, "Circus Bare Back Riders and Clowns," Bare Back Riders

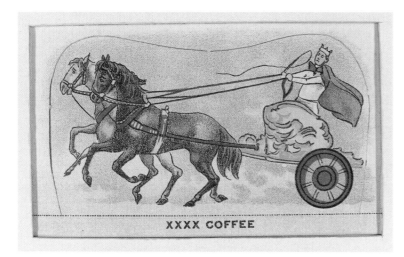

McLaughlin Coffee, "Circus Bare Back Riders and Clowns," Chariot

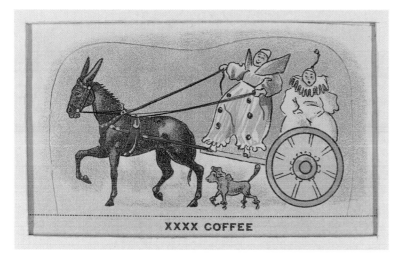

McLaughlin Coffee, "Circus Bare Back Riders and Clowns," Clowns

"LOOK FOR THESE!
Circus Procession and Caged Animals
Circus Elephants, Camels and Ponies
Circus Bare Back Riders and Clowns
Circus Monkey and Dog Show
IN PACKAGES. McLAUGHLIN'S XXXX Coffee"

Other Novelty booklets were Chicago Fire Department, The Limited Express, The Buffalo Hunt, Rough Riders of the World, Deadwood Stage Coach and Buffalo Bill, The Fox Hunt/Chase, Santa Claus, Children's Procession, Traveling in Foreign Countries, and White Squadron.

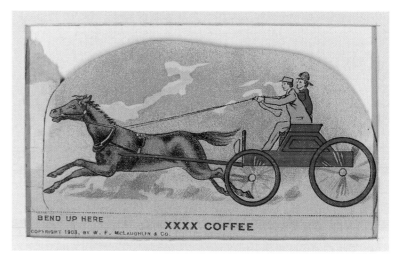

McLaughlin Coffee, "Chicago Fire Department,"
One Horse Fire Wagon.(4) $10-12 as shown

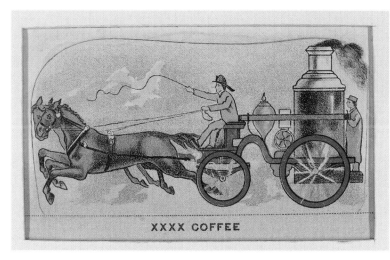

McLaughlin Coffee, "Chicago Fire Department," Fireman's Steam Pump

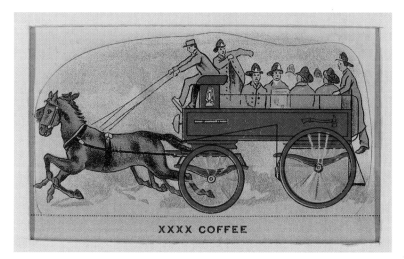

McLaughlin Coffee, "Chicago Fire Department," Firemen on Wagon

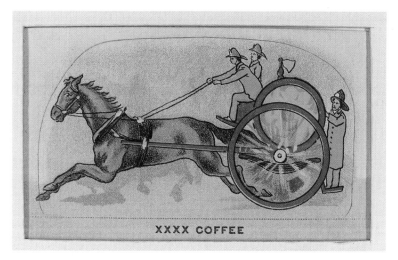

McLaughlin Coffee, "Chicago Fire Department," Hose Wagon

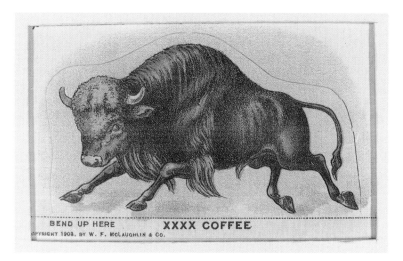

McLaughlin Coffee, "The Buffalo Hunt," First Buffalo. Set:(5) $20

McLaughlin Coffee, "The Buffalo Hunt," Indian with Pistol

McLaughlin Coffee, "The Buffalo Hunt," Second Buffalo

McLaughlin Coffee, "The Buffalo Hunt," Indian with Rifle

McLaughlin Coffee, "The Buffalo Hunt," Third Buffalo

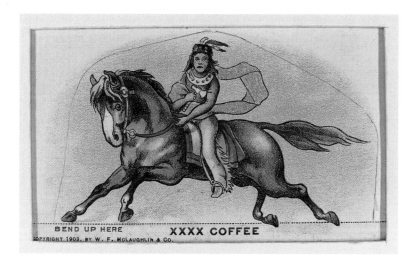

McLaughlin Coffee, "Rough Riders of the
World," Indian with Tomahawk. Set:(5) $20

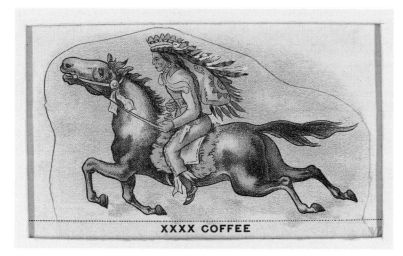

McLaughlin Coffee, "Rough Riders of
the World," Indian wearing headdress

McLaughlin Coffee, "Rough Riders of
the World," Indian wearing a skin cape

McLaughlin Coffee, "Rough Riders of the World," Rider with shield

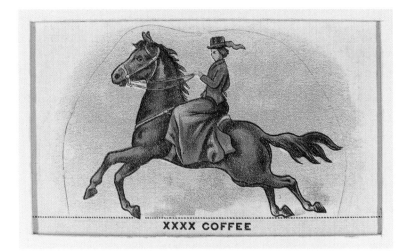

McLaughlin Coffee, "Rough Riders of the World," Lady Rider

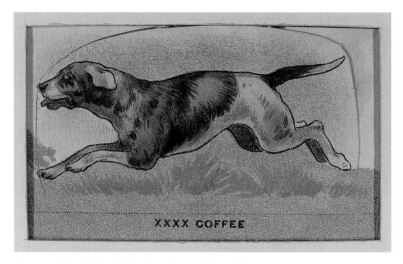

McLaughlin Coffee, "The Fox Chase," First Hound

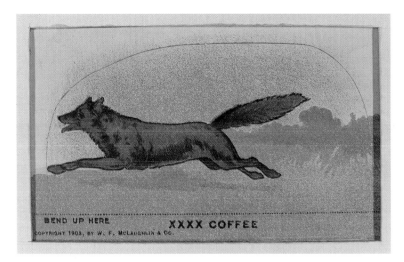

McLaughlin Coffee, "The Fox Chase," Fox.(4) $15 as shown

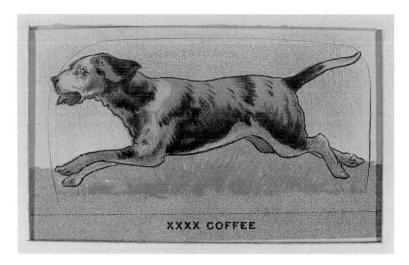

McLaughlin Coffee, "The Fox Chase," Second Hound

McLaughlin Coffee, "The Fox Chase," Third Hound

The paper toys of animals and fowls were offered to help identify different groups of species. One of the largest homogenous groups of animals offered was the domestic dog. Many of these stand-up dogs were prize-winning show dogs with their name below the breed name. The dog, "Sir Bedivere," was for the St. Bernard breed. The pug with his many prize-winning medals hanging around his neck has the name "Mayor of Leeds."

McLaughlin Coffee, Sir Bedivere/Mayor of Leeds. $3-4 each

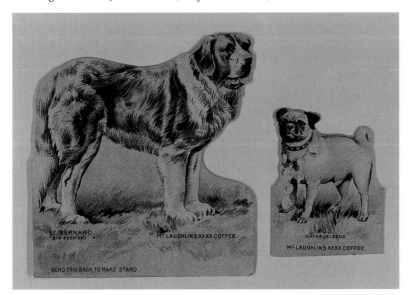

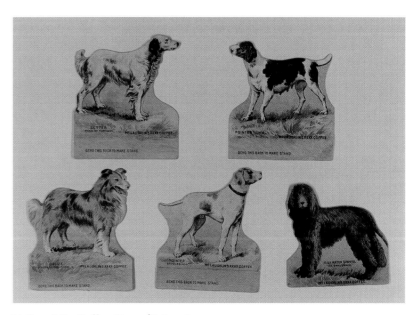

McLaughlin Coffee, Dogs. $3-4 each

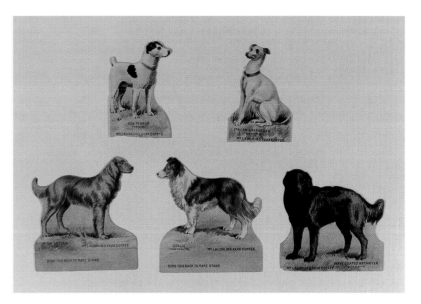

McLaughlin Coffee, Dogs. $3-4 each

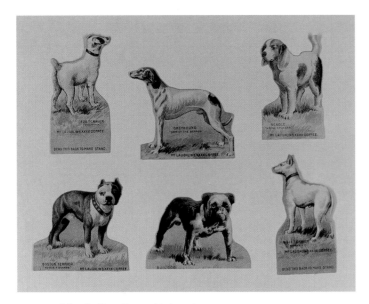

McLaughlin Coffee, Dogs. $3-4 each

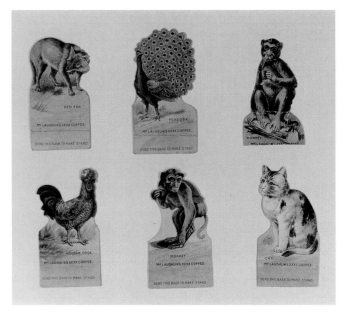

McLaughlin Coffee, Animals/fowl. $3-4 each

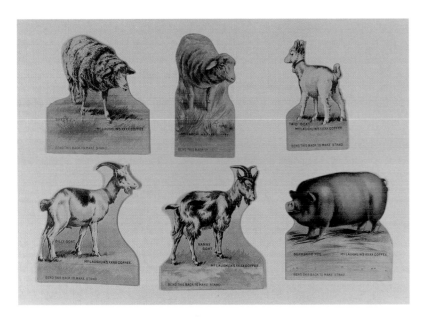

McLaughlin Coffee, Farm animals. $3-4 each

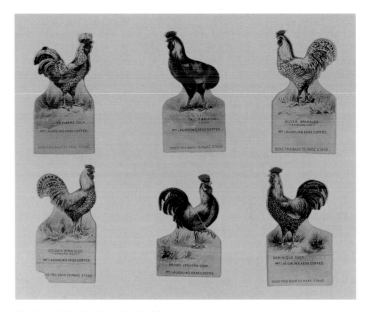

McLaughlin Coffee, Fowl. $3-4 each

*"McLaughlin's XXXX Coffee
is Better Quality than any other Coffee on the Market.
This is the reason of its enormous sale."*

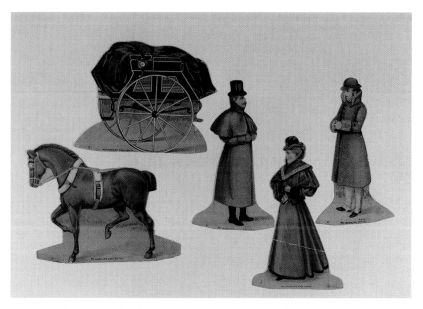

McLaughlin Coffee, Novelty Push Toys, #2. $25-30 as shown

The Novelty push toys that were offered by McLaughlin are similar to the Woolson Spice Company's animal/cart paper toys, although McLaughlin included in its five section pieces an advertising paper doll. In set No. 3, the advertising paper doll has an extra outfit. The other pieces are the St. Bernard dog that would pull the two-wheel cart by attaching the cart handle to a slit in the dog's harness. Flaps on the side of the main pieces were to be bent back as standards.

The Novelty push toy in set No. 15 is a baby buggy, and it has two advertising paper dolls. One is the baby and the other an older sister with a muff as an extra piece of clothing. The sets are numbered and each piece has a set number.

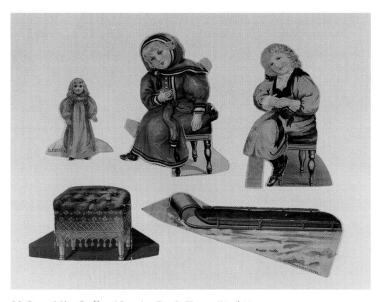

McLaughlin Coffee, Novelty Push Toys, #1. $40

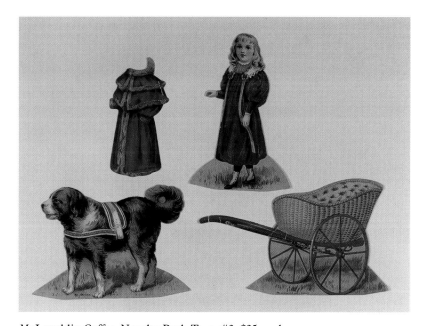

McLaughlin Coffee, Novelty Push Toys, #3. $35 as shown

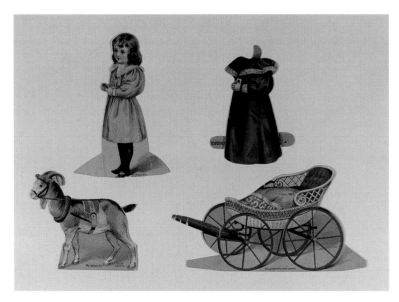

McLaughlin Coffee, Novelty Push Toys, #4. $30 as shown

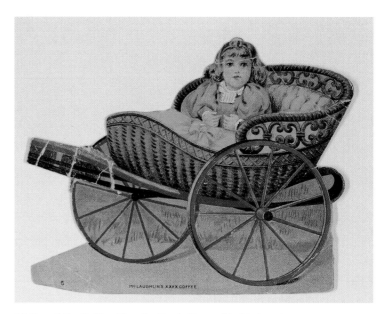

McLaughlin Coffee, Novelty Push Toys, #6. $4-6 as shown

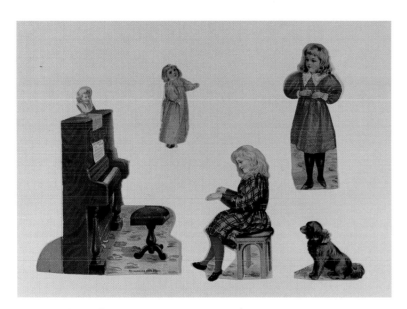

McLaughlin Coffee, Novelty Push Toys, #5. $30-35 as shown

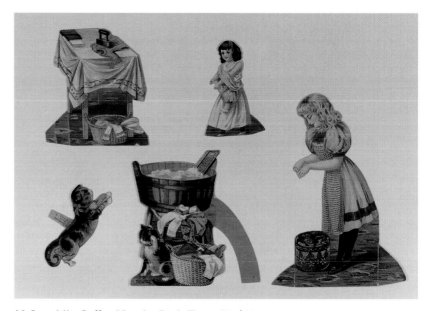

McLaughlin Coffee, Novelty Push Toys, #7. $40

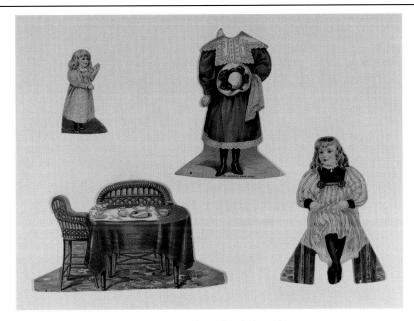

McLaughlin Coffee, Novelty Push Toys, #8. $30 as shown

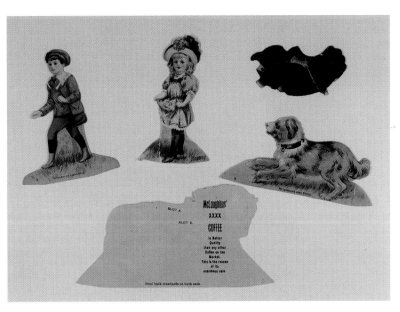

McLaughlin Coffee, Novelty Push Toys, #9. reversed (advertisement)

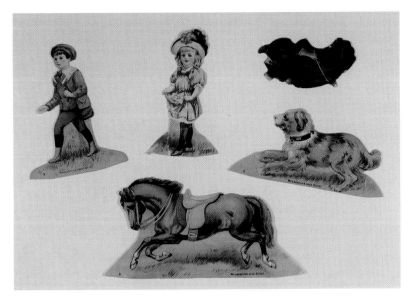

McLaughlin Coffee, Novelty Push Toys, #9. $40

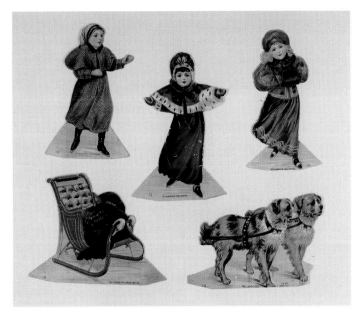

McLaughlin Coffee, Novelty Push Toys, #10. $30-35 as shown

McLaughlin Coffee, Novelty Push Toys, #11. $30-35 as shown

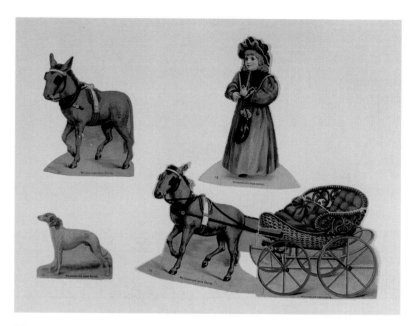

McLaughlin Coffee, Novelty Push Toys, #13. $30 as shown

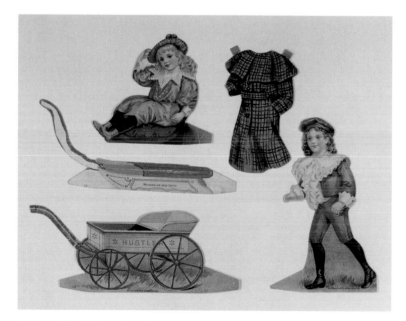

McLaughlin Coffee, Novelty Push Toys, #12. $40

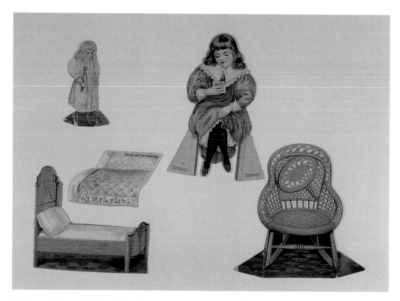

McLaughlin Coffee, Novelty Push Toys, #14. $40

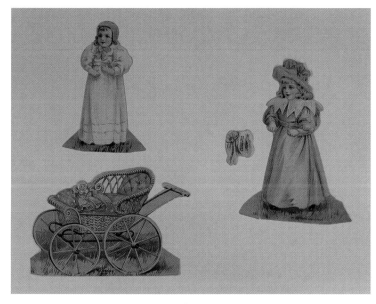

McLaughlin Coffee, Novelty Push Toys, #15. $30-35 as shown

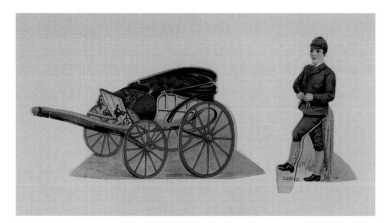

McLaughlin Coffee, Novelty Push Toys, #16. $20 as shown

"Get all these Wonderful Animal Books, Hundreds of Marvelous Changes."

These changeable (transformable or metamorphic) booklets open up to a full-page animal, with the pages being divided into halves. In one booklet the first picture is a beaver. Turning over one of the page-halves reveals a new animal, which is half beaver and half leopard. Sometimes the half-pages open up to a complete animal. The surprise is always there.

McLaughlin Coffee, Animal Book, metamorphic. $12 as shown

McLaughlin Coffee, Animal Book, inside page

McLaughlin Coffee, Animal Book, flipped page

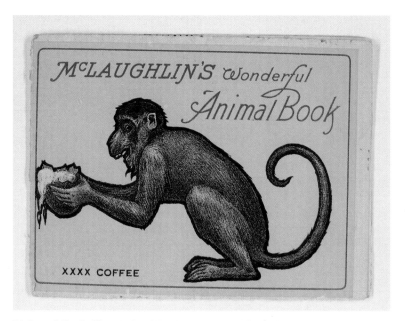

McLaughlin Coffee, Animal Book, metamorphic. $15

McLaughlin Coffee, Animal Book, back cover

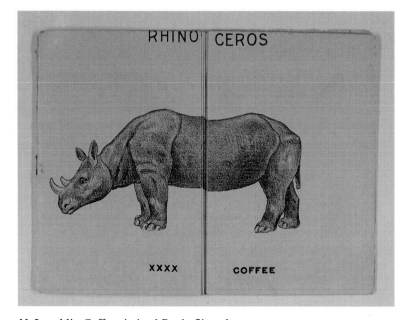

McLaughlin Coffee, Animal Book, flipped page

*"This Drawing Book is one of a series
of ten different designs.
You will find them in the
BEST PACKAGE COFFEE ON EARTH."*

The *McLaughlin's XXXX Drawing Book* is a small booklet that has tracing paper over each printed drawing. Opposite of the tracing paper is a plain page. By tracing the drawing and again on the opposite side of the tracing paper, an impression will appear on the plain page. Now the child has a right and left view of the drawing to color.

The small story booklets containing beautiful lithograph pictures were attractive art items for children. In the center section, the booklets have a double-page picture. In the booklet, A BUFFALO HUNT, the double-page scene shows two Indians on horseback bearing down on three buffaloes during a hunt. Two other booklets are THE SKIRT DANCE and I DONT WANT TO PLAY IN YOUR YARD. The printer was Geo. S. Harris & Sons, N. Y.

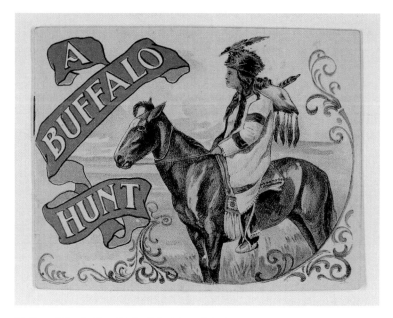

McLaughlin Coffee, "A Buffalo Hunt." $15

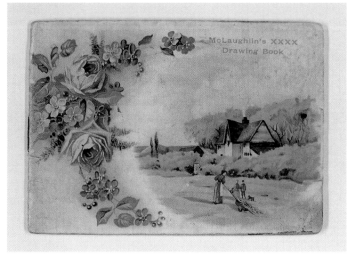

McLaughlin Coffee, Drawing Book. $10 as shown

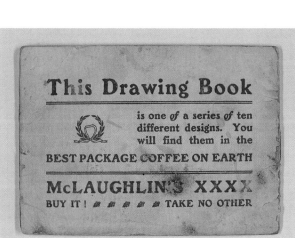

McLaughlin Coffee, Drawing Book, back cover

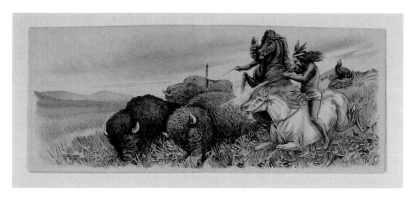

McLaughlin Coffee, "A Buffalo Hunt," double page

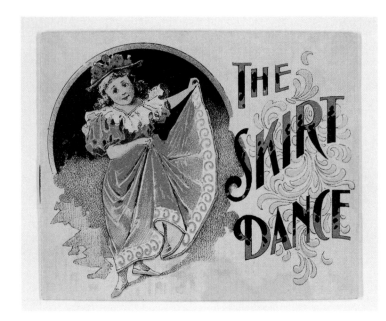

McLaughlin Coffee, "The Skirt Dance." $15

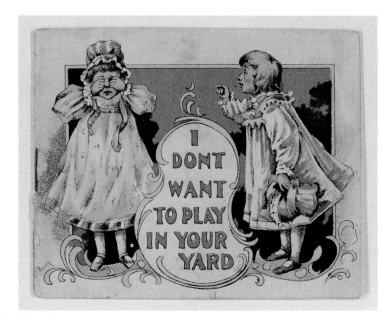

McLaughlin Coffee, "I Dont Want To Play In Your Yard." $15

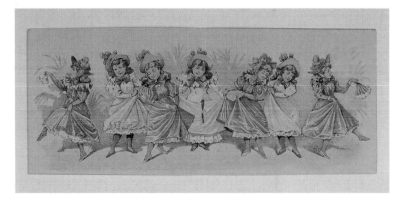

McLaughlin Coffee, "The Skirt Dance," double page

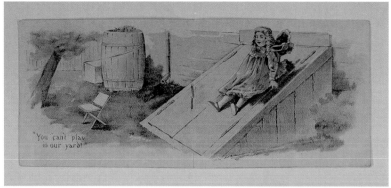

McLaughlin Coffee, "I Dont Want To Play In Your Yard," double page

McLaughlin Coffee, "I Dont Want To Play In Your Yard," back cover

McLaughlin's XXXX Coffee
"There she goes a sleigh-ridin' with Billy Wilkins, and only
Chewsdy night she asked me for my fortograf."
"SAY OLD MAN, IF YOU FORGET TO BRING
HOME SOME McLAUGHLIN'S XXXX COFFEE I
SHALL BE A WIDOW
TO-MORROW, DE YE HEAR?"

The small, palm-fitting trade cards were attractive collectible pieces for children. Billy Wilkins' sleigh is pulled by a goat. Another trade card shows a toy train engine with a wooden McLaughlin's XXXX Roasted Coffee box and a rocking chair behind it, with both being used as passenger cars by the children.

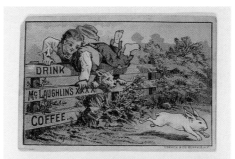

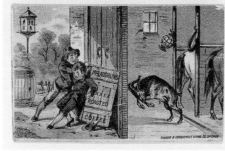

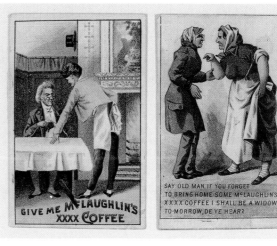

McLaughlin Coffee, Small trade cards. $4 each

McLaughlin Coffee, Small trade cards. $4 each

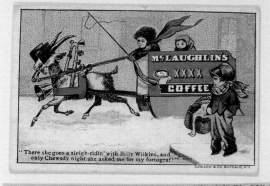

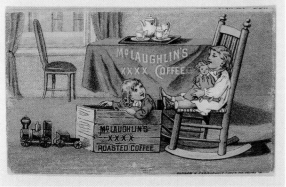

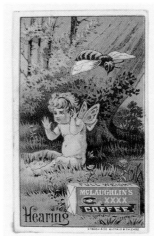

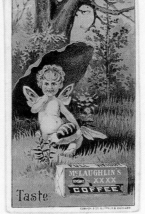

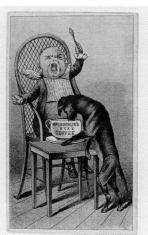

McLaughlin Coffee, Small trade cards. $4 each

McLaughlin Coffee, Small trade cards. $4 each

McLaughlin Coffee, Small trade cards. $4 each

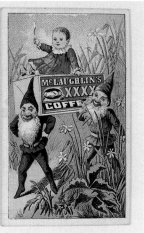
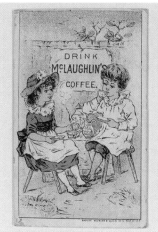
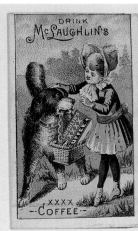

McLaughlin Coffee, Small trade cards. $4 each

McLaughlin Coffee, Small trade cards. $4 each

Above left:
McLaughlin Coffee, Small trade cards. $4 each

Left:
McLaughlin Coffee, Small trade cards. $4 each

Below left:
McLaughlin Coffee, Small trade cards. $4 each

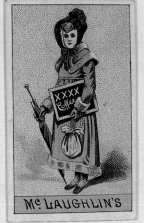

McLaughlin Coffee, Small trade cards. $4 each

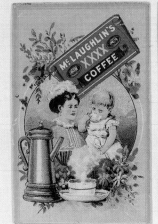
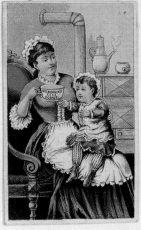

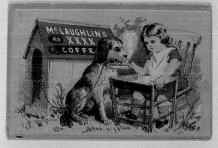
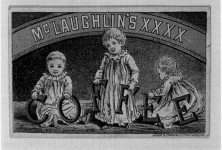

McLaughlin Coffee, Small
trade cards. $4 each

Another type of trade card, LAKE STEAMER, "SUSQUEHANNAH," of the Anchor Line steamers, shows the ship unloading a cargo of coffee at a McLaughlin's warehouse in Chicago. It announces on the opposite side that a beautiful colored picture of the "Battle of the Monitor and Merrimac," 16 inches high and 20 inches long, was a new premium offer. It was given in exchange for 15 wrappers of the XXXX Coffee, and a two-cent stamp to pay postage.

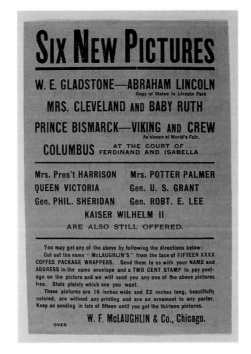

McLaughlin Coffee, Advertisement/English. $5

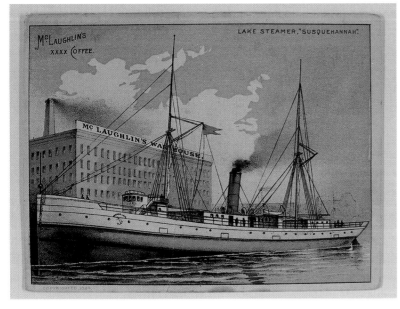

McLaughlin Coffee, "Susquehannah." $15

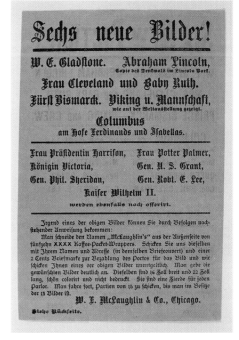

McLaughlin Coffee, Advertisement reversed, German

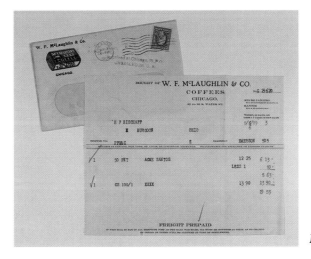

McLaughlin Coffee, Bill/Envelope. $10

Tea / Cocoa

Chase & Sanborn

"Ceylon Girl Picking Tea"

In the early 1900s this coffee, tea and spice company issued a series of four puzzle pictures. The puzzle of the girl picking tea, c. 1910, measures 6-1/8" x 8", and is printed in color lithography.

This company also offered a "front and back" trade card. Such cards are cleverly designed to attract one's curiosity.

A COMPROMISE

This trade card shows a couple leaning out of their windows, drinking a cup of Royal Gem Tea or Seal Brand Coffee. On the opposite side they are exchanging their cups and saucers. Both of these brands were Chase and Sanborn imports.

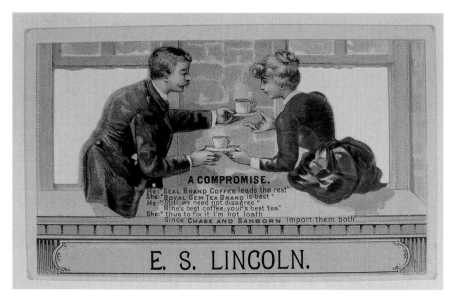

Royal Gem Tea/Seal Brand Coffee, trade card. $15

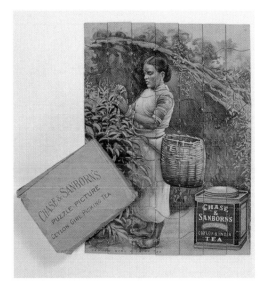

Chase & Sanborn, "Ceylon Girl Picking Tea." $30-35 (box)

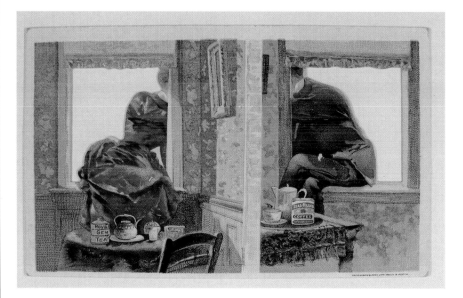

Royal Gem Tea/Seal Brand Coffee, reversed

Lipton Tea and Coffee, Thos. J. Lipton Inc.

"Finest Blend of Ceylon & India Orange Pekoe & Pekoe Tea"

This company was founded by the British merchant, Thomas J. Lipton (1850-1931), who was born in Glasgow, Scotland, of Irish parentage. He began his business in Glasgow, in a small grocery store which later developed into a huge chain store from which supplies of tea and coffee were received from the company's own plantations.

In 1933, the company offered a jig-saw puzzle. It was a color fast-print, measuring 12" x 9", and entitled, "One of Lipton's Ceylon Tea Estates."

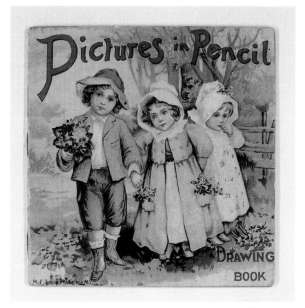

C.D. Kenny Co., "Pictures in Pencil." $10-15

KENNY'S FINE TEAS
"Moyune" Gunpowder
Formosa Oolong
English Breakfast

The *Picture in Pencil* was a drawing book issued by C. D. Kenny Co. The company serviced importers, jobbers, and retailers, and in addition had 50 branch stores offering tea, coffee, and sugar. The drawing book, with its colorful cover, measures 5" x 5".

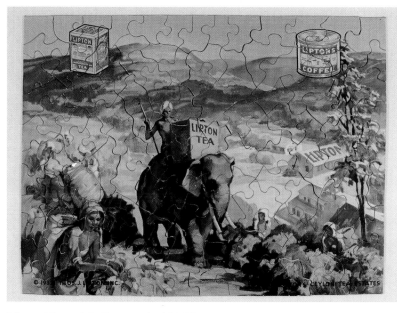

Lipton Tea and Coffee, puzzle. $30-35

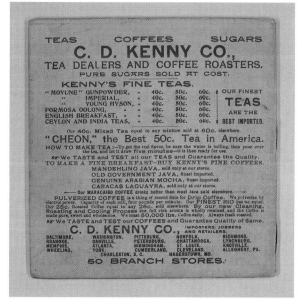

C.D. Kenny Co., "Pictures in Pencil," back cover (advertisement)

The cocoa company of Hawley & Hoops, New York, offered two game cards similar in rhyme to the "Five Little Pigs Went To Market." The company used the Five Little Mice and the Five Little Frogs for their rhymes.

Five Little Mice
This Little Mouse Got Caught In A Trap.
This Little Mouse He Heard It Go Snap.
This Little Mouse Did Loudly Squeak Out.
And This Little Mouse He Ran All About.
This Little Mouse Said, "Do Not Bewail
　　But Come Let Us Pull Him Right Out
　　By The Tail."

These trade cards were copyrighted in 1884. They were handed out by dealers to their customers.

Hawley & Hoops, "Five Little Mice," trade card. $12

Hawley & Hoops, "Five Little Frogs," trade card. $12

Food

The early cereal manufacturers promoted their ready-to-eat boxed corn and wheat flakes as a labor-saver for the housewife. Later, the packages became an effective advertising medium for their premium coupons. A few of these premiums were mechanical items with a moving part. The revolving disc and the pull-out are the most frequently used means of operating them.

W. W. Kellogg, Battle Creek, Michigan.

*"Here We Go, All three in step,
Shopping for Corn Flakes, Rice Krispies, and
Pep."*

In 1931, the company offered a revolving disc chart, "Kellogg's Wheel of Knowledge, Interesting Facts About The United States." The company mailed the mechanical chart, 6-1/2" x 6-1/2", in exchange for 2 package tops of Kellogg's Corn Flakes.

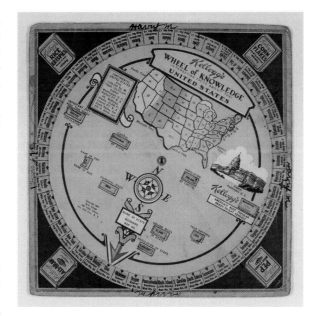

Kellogg's Wheel of Knowledge. $15-20

A year later, the company gave a fold-out booklet entitled *Kellogg's Funny Jungleland - Moving Pictures*. This story booklet, 4-3/8" x 6-1/2", in color fast-print, has three changing sections for any three animals, thus creating many different pictures as sections are flipped over. An earlier version, *Jungleland Moving-Pictures*, measuring 7" x 9", had been issued in 1907.

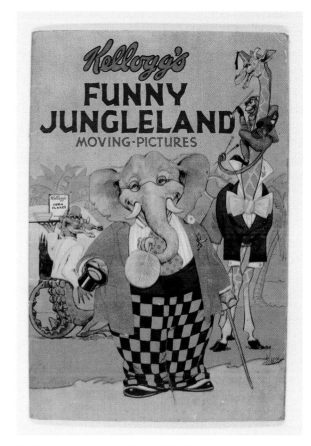

Kellogg's Funny Jungleland. $20-35

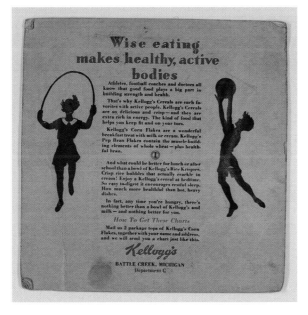

Kellogg's Wheel of Knowledge, reversed

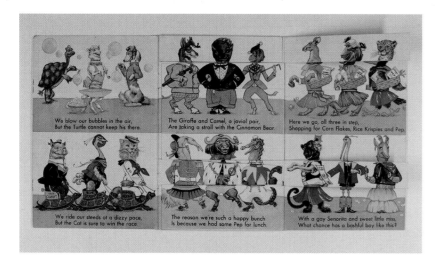

Kellogg's Funny Jungleland, 3 sections

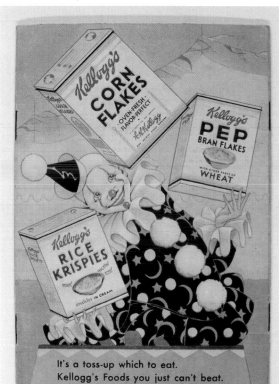

Kellogg's Funny
Jungleland, back cover

"Keep going with Kellogg's"

Baseball has long been the national game of the United States. "The Little Slugger," a jig-saw puzzle in fast-print, showing a little pitcher, was offered by the Kellogg Company in 1933. The puzzle measured 6" x 8", and came in a cellophane envelope.

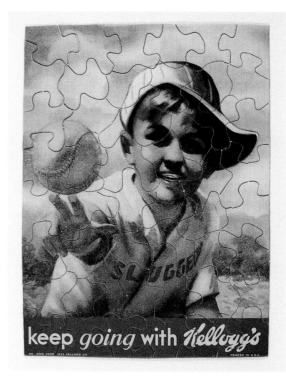

Kellogg's Little Slugger. $45 (cellophane envelope)

Kellogg's Kaffee Hag - 97% caffeine free Rice Krispies, Corn Flakes, Wheat Krumbles, All-Bran and Shredded Whole Wheat Biscuit

The Kellogg Company offered a colorful cutout paper doll named Dolly with four dresses and bonnets. This set advertised their five ready-to-eat dry cereals and their 97% caffeine-free coffee.

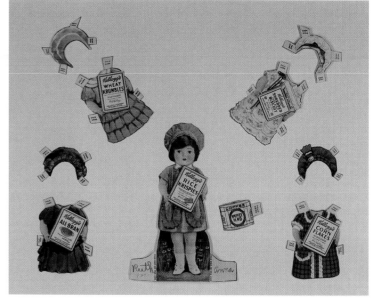

Kellogg's "Dolly." $30

In 1978, the Kellogg Company gave colorful jig-saw puzzles which were fitted into cardboard frames designed for easy assembling. Examples include a map of the United States, constellations, and two puzzles of a tropical bird and his friends. These puzzles each measured 8-7/8" x 11-7/8".

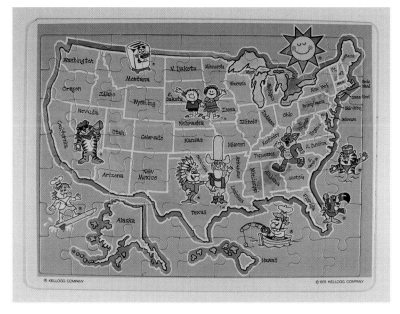

Kellogg's puzzle, Map of U.S.A., (1978). $6-8

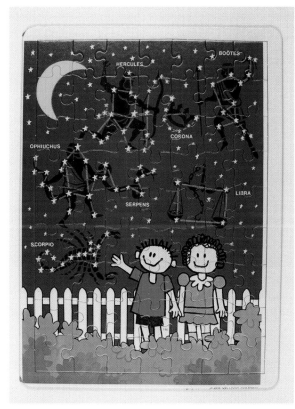

Kellogg's puzzle, Constellations, (1978). $6-8

Kellogg's puzzle, Tropical Bird and Friend, (1978). $6-8

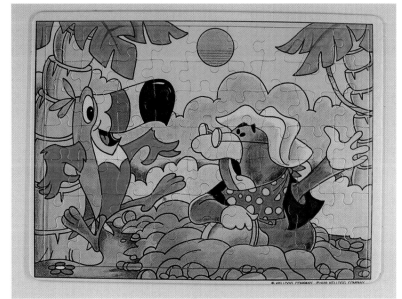

Kellogg's puzzle, Tropical Bird and Friend, (1978). $6-8

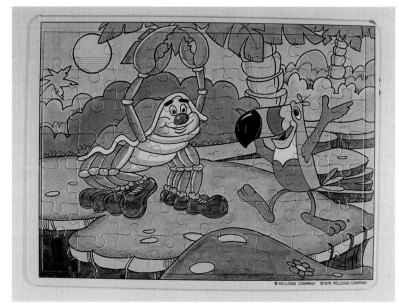

Skippy Says, "Wheaties Taste Eleganter Than Elegant."

General Mills issued a series of Skippy Cards with its breakfast cereal, Wheaties, one card per box. "Skippy" first appeared in a magazine, the old Life, after World War I. Skippy's creator, the artist Percy Crosby, had a long collaboration with the magazine. The comic character card #3 of Skippy, in color fast-print, is one of 12 cards, 2-3/8" x 3-1/4". They were packed in boxes of Wheaties in 1933 by permission of Percy Crosby - Skippy, Inc.

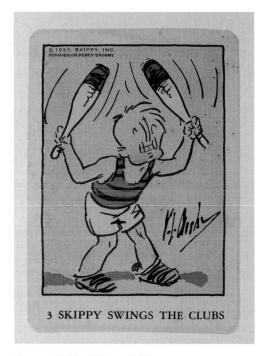

General Mills, "Skippy." $5

CHEEKO The Dancing Monkey
ZIPPY The Polka Dot Clown

The Muffets' SHREDDED WHEAT puppet's package each contained five cards. The cardboard puppets were colorful "punch out" pieces. They were to be assembled in alphabetical order as marked on each piece. These were copyrighted in 1951.

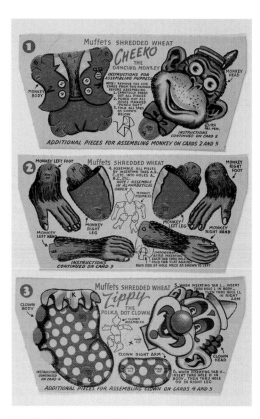

Muffets' Shredded Wheat,
Cheeko/Zippy. $18-20

*Enriched TIP-TOP Is Better Bread
The loaf in the red, star-end wrapper.*

Tip-Top Sports Game of Questions and Answers is on a revolving disc, 3" x 3-3/8", with the correct answer covered by a pull-tab. WHO HOLDS THE WORLD AND OLYMPIC RECORDS FOR RUNNING BROADJUMP? The pull-tab answer was JESSE OWENS. No copyright date.

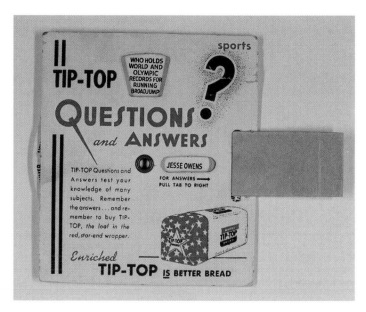

Tip-Top Bread, Sports Game of Question and Answers. $8-10

Another revolving disc chart this company offered was Know Your STATES of the United States of America, and measured 4-1/4" x 5-1/4". The chart was issued by the makers of Tip-Top bread before Alaska's statehood in 1959.

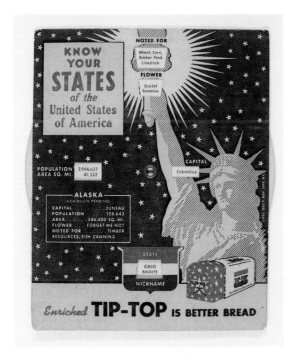

Tip-Top Bread, Know Your States. $8-10

Fleischmann & Co.'s Compressed Yeast

"None Genuine without our Facsimile Signature"

This company issued a small tracing booklet for young children. On the inside back cover of the booklet a premium list was printed, naming the silverware which the company gave in exchange for yellow labels.

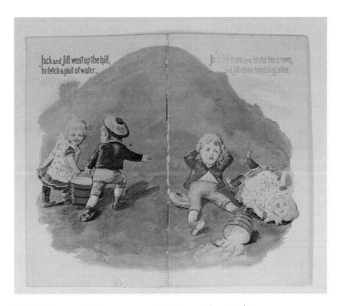

Fleischmann & Co., covers, (back and front). $8

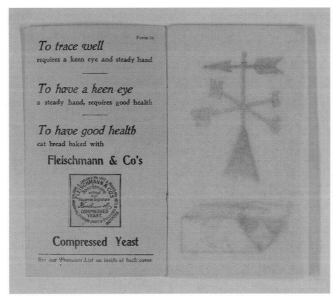

Fleischmann & Co., inside cover and page

Sunshine Biscuits, Loose-Wiles Biscuit Co.

"Sunshine Biscuits from the thousand window bakeries"

Sunshine Auto Truck, build it yourself. These cardboard sheets with cardboard pieces are about 18" x 12-1/2", c. 1920-1930s.

Since the Crystal Palace Exhibition in London, 1851, World's Fairs and Expositions have featured exhibits from nations around the world. Each nation represented displayed the best of its products.

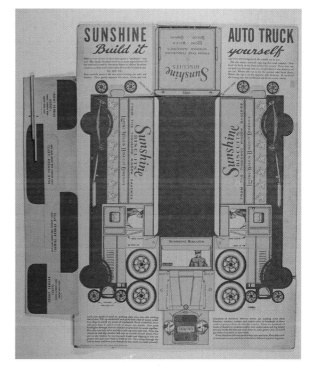

Loose-Wiles Biscuit Co., "Sunshine Auto Truck," *Courtesy of Virginia A. Crossley.* $30

K C and I C Baking Powder, Jaques Mfg. Company, Chicago

"Gold Medal (Highest Award) at the Trans-Mississippi & International Exposition, 1898, Omaha, Nebraska"

These die-cut, wrap-a-round dolls are in color lithography, and the reverse advertisement on each displays the gold medal which was received at the Omaha Exposition. They were printed by The Gugler Litho., Co., Milwaukee.

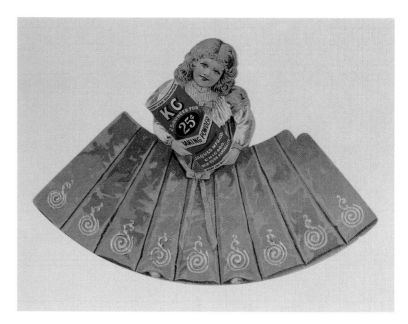

KC Baking Powder, 1898 Trans-Mississippi & International Exposition. $40

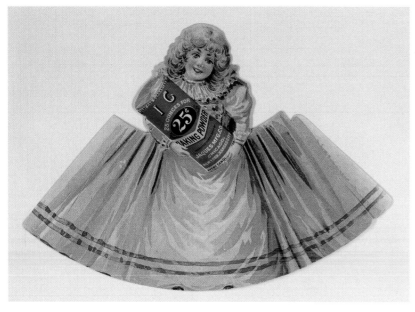

IC Baking Powder, 1898 Trans-Mississippi & International Exposition. $40

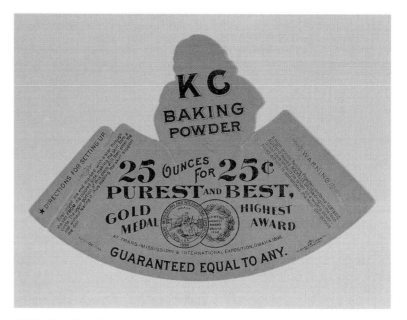

KC Baking Powder, reversed

Libby's Apple Butter

"A Century of Progress 1933"

When this exposition opened at Chicago, Libby offered a jig-saw puzzle in color fast-print of the aerial view of the fair in the "art deco" style. The puzzle measures 8" x 9-3/4".

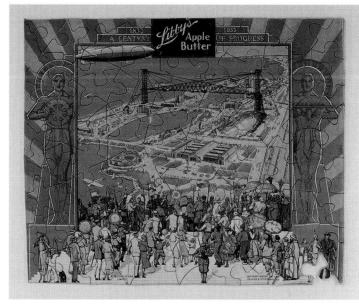

Libby's Apple Butter, 1933 Century of Progress. $25 as shown

"Ask your Grocer for Fort Bedford P-Nut Butter"

By 1896, many companies sought the immigrant trade, and thus the advertising industry began to recognize the different nationalities of Americans by using ethnic-slanted premiums in advertisements. *Little Miss Muffet in Different Lands*, a booklet 3-1/2" x 5", has the Mother Goose rhyme "Little Miss Muffet" set in different situations throughout the world.

Little Tradja of Norway, she sat in the door way
 Eating her reindeer broth,
 Then came a big badger,
 And little Miss Tradja
 Soon carried her meal farther North.

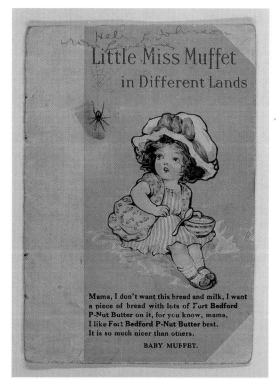

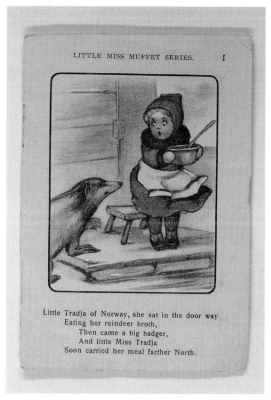

Fort Bedford P-Nut Butter, "Little Miss Muffet in Different Lands," page 1.

Fort Bedford P-Nut Butter, "Little Miss Muffet in Different Lands." $10 as shown

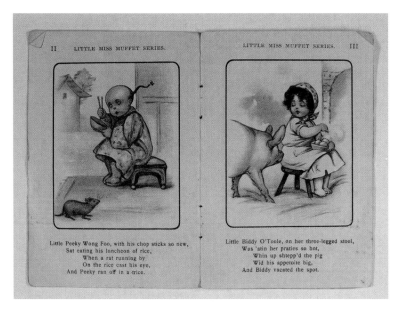

Fort Bedford P-Nut Butter, "Little Miss
Muffet in Different Lands," double page

Fort Bedford P-Nut Butter, "Little Miss
Muffet in Different Lands," back cover

"Look For The U.S.P."

ZIPP'S U.S.P. Flavoring Extracts issued a booklet in chromolithography entitled, *The Three Bears.* The booklet measured 4-1/4" x 6-1/4".

The letters U.S.P. guaranteed the product was prepared according to a formula approved by the United States Pharmacopoea, a recognized authority on formulas and prescriptions. This label was on ZIPP'S Best Flavoring Extracts, such as vanilla, ginger, wintergreen, and peppermint.

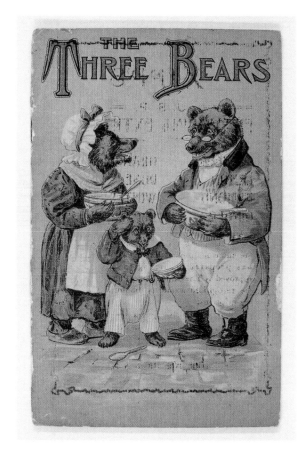

Zipp's U.S.P. Flavoring Extracts,
"The Three Bears." $20 as shown

Zipp's U.S.P. Flavoring Extracts, "The Three
Bears," double page (advertisement)

Zipp's U.S.P. Flavoring Extracts,
"The Three Bears," back cover

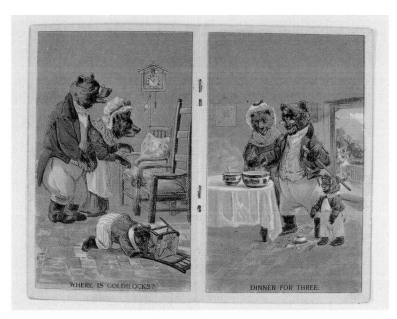

Zipp's U.S.P. Flavoring Extracts, "The Three Bears," double page

Thread / Clothing / Personal Accessories

Many sewing items were advertised through the use of free premiums. Numerous makers of these products used Mother Goose rhymes in their booklets and on trade cards to attract the attention of children in family households, so that parents would purchase the products and obtain the premiums for their children.

Two of these companies were J. & P. Coats and Clark's O.N.T. Spool Cotton. The O.N.T. stands for "Our New Thread."

"Patronize American Industries!"

The Clark's O.N.T. Spool Cotton Company offered a trade card entitled, "The Thread that binds the Union—North to South." This card has on the reverse side a print of the factory located in Newark, New Jersey.

Clark's O.N.T., Union—North to South, reversed

Clark's O.N.T. Trade Card,
Union—North to South. $20

"AHEAD OF ALL OF THEM"
For Hand and Machine Sewing

The Mother Goose booklet, *Rock-A-Bye Baby And Other Rhymes,* was printed for Clark's O.N.T. Spool Cotton and Milward's Helix Needles. These rhymes were pictured in verse with a few additional lines about their product.

Pease-porridge hot,
Pease-porridge cold,
Pease-porridge in the pot,
Nine days old.
Spell me Cotton without a C
Why that's not difficult—
O.N.T.

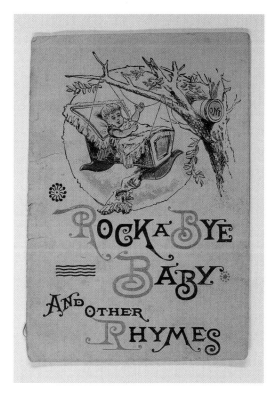

Clark's O.N.T., "Rock-A-Bye Baby And Other Rhymes." $10-15

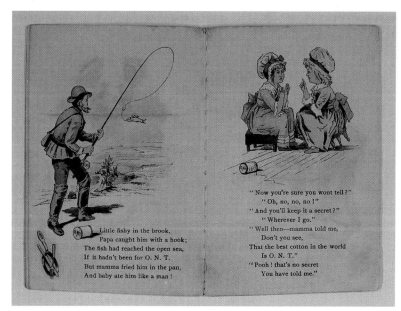

Clark's O.N.T., "Rock-A-Bye Baby And Other Rhymes," double page

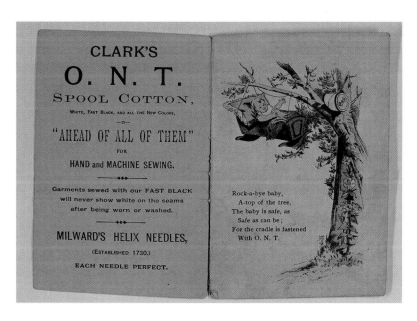

Clark's O.N.T., "Rock-A-Bye Baby And Other Rhymes," inside cover/page 1

Clark's O.N.T., "Rock-A-Bye Baby And Other Rhymes," back cover

In another of their premium booklets, *THE HUNTERS THREE and O★N★T★*, a rhyming tale, tells how all the nations of the earth rejoice in O.N.T. What are named, however, are not nations but racial groupings throughout the world. The groups are three white children, Zulu braves, Hottentots, Chinaman, Esquimau (Eskimo), and an Indian brave.

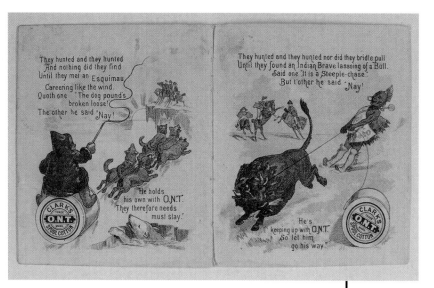

Clark's O.N.T., "The Hunters Three and O★N★T," double page

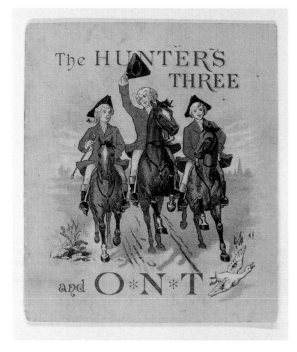

Clark's O.N.T., "The Hunters Three and O★N★T." $15-20

Clark's O.N.T., "The Hunters Three and O★N★T," back cover

J. & P. Coats · Clark's O.N.T.
Spool Pets / Spool Zoo

"Fun With Spools"

In 1930 and 1931, The Spool Cotton Company offered two sets of John Martin's spool cutouts. The first set was Spool Pets, a set of six cards, which was sent out on request by simply sending four cents in stamps to the company. These paper toy cards were the heads and tails of animals which could be cut out and glued to the end of a J. & P. Coats or Clark's O.N.T. wooden spool. The set included Kitty Cat, Puppy Dog, Bob Bunny, Hal Horse, Clara Cow and Pete Pig.

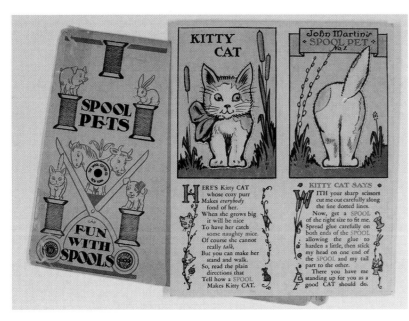

J. & P. Coats & Clark's O.N.T., "Spool Pets," envelope, (Kitty Cat)

"Spool Pets," 1930, Kitty Cat/Puppy Dog. $4 each

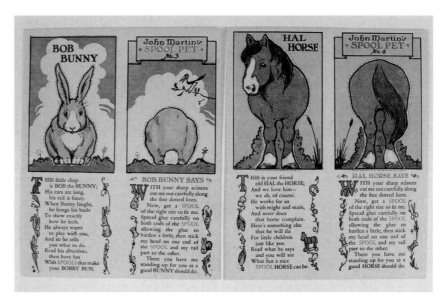

"Spool Pets," Bob Bunny/Hal Horse. $4 each

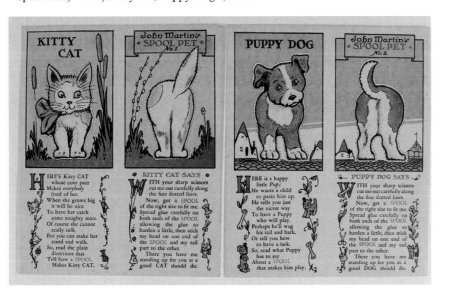

"Spool Pets," Clara Cow/Pete Pig. $4 each

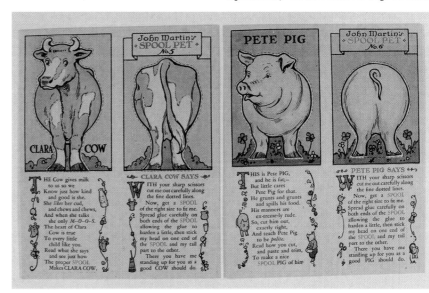

The Spool Zoo cards were mailed for five cents in stamps or one card in each J. & P. Coats BIAS TRIM packages. The Spool Zoo set included Fox, Bear, Zebra, Lion, Elephant and Hippo.

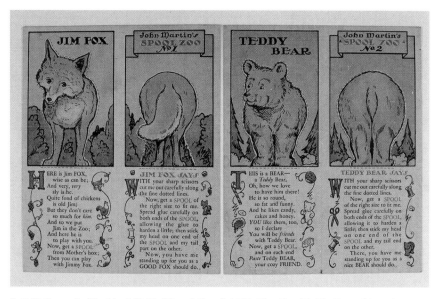

J. & P. Coats & Clark's O.N.T., "Spool Zoo," 1931, Jim Fox/Teddy Bear. $4 each

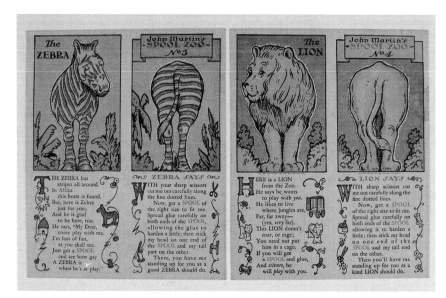

"Spool Zoo," The Zebra/The Lion. $4 each

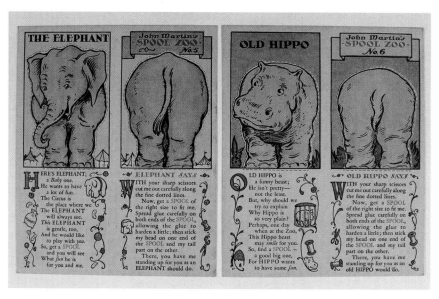

"Spool Zoo," The Elephant/Old Hippo. $4 each

Clark's Mile-End

THE ORIGINAL THREAD OF AMERICA

A paper toy set of twelve animals could be obtained by sending three two-cent postage stamps to The Clark Mile-End Spool Cotton Company, N. Y. These two-piece animal toys were made to stand up by attaching the legs of the smaller piece to the larger piece. Some of the animals were an elephant, hippopotamus, lion, tiger, zebra, buffalo, polar bear, and a domestic cow. The set was copyrighted in 1896.

Clark Mile-End Spool Cotton, animals. $4 each

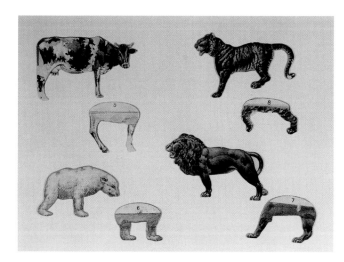

Clark Mile-End Spool Cotton, animals. $4 each

The Willimantic Thread Co.

"Highest Awards at New Orleans Exhibition 1885"
"Highest Awards at Columbian Exposition 1893"

This company issued four sheets (5-3/4" x 6-1/4") of cutout dolls in color lithography. Advertisements for New Orleans Exhibition of 1885 are on the reverse of the sheets of the girl with the doll, and the boy with the hobbyhorse. The Columbian Exposition of 1893 at Chicago is on the reverse of the sheets of the girl with the lamb and the boy with the horn.

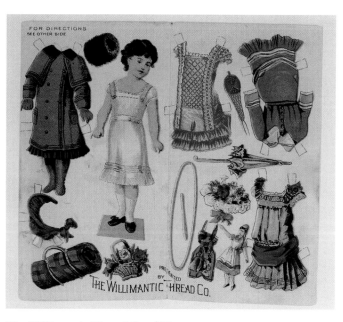

The Willimantic Thread Co., $50

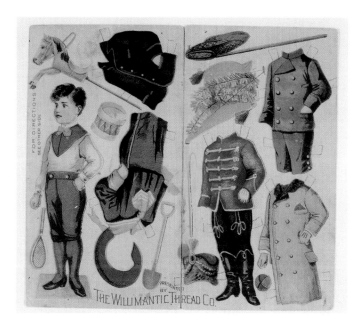

The Willimantic Thread Co., $50

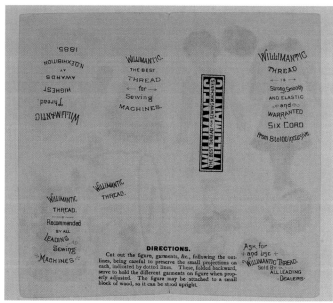

The Willimantic Thread, reversed: New Orleans 1885 Exhibition.

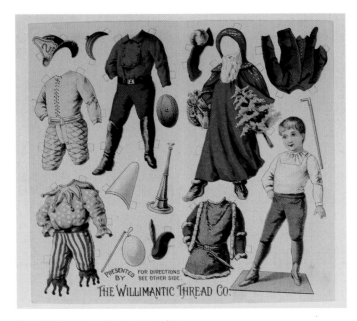

The Willimantic Thread Co., $50

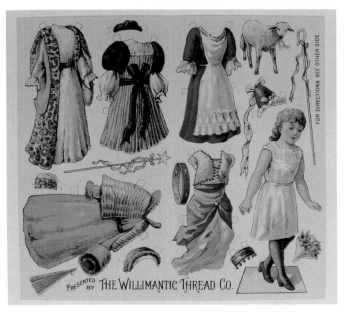

The Willimantic Thread Co., $50

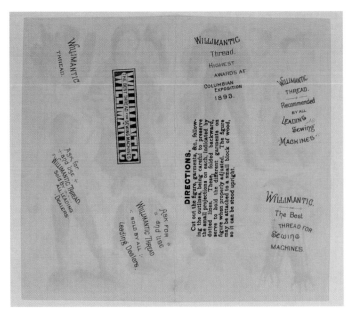

The Willimantic Thread, reversed: Columbian Exposition 1893

The Singer Sewing Machine Company

Isaac Merritt Singer (1811-75), an American inventor, patented in 1851 a practical Sewing Machine which could do continuous stitching. Between 1851 and 1865 Singer patented 20 improvements, including the yielding presser foot and a continuous wheel feed.

An early Singer Sewing Machine puzzle, 7-1/8" x 9-1/4", is the "Singer Buffalo Puzzle." It is in color lithography with a Singer trade wagon being pulled by two harnessed buffaloes.

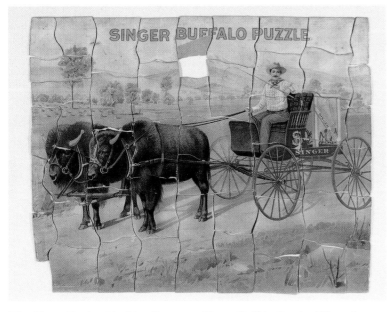

The Singer Sewing Machine Company, Singer Buffalo Puzzle. $10 as shown

Both children and adults enjoyed the trade cards of the latter 19th century which showed a change in facial expressions. Today, these are classified by collectors as metamorphic - one which "changes" from a lesser state to a more developed one.

John C. Meyer & Co., Boston

Why is this card like John C. Meyer & Company?
Because which ever way you twist it's "A - HEAD."

The John C. Meyer & Co., Boston, issued a trade card in color lithography which depicted a change in form. Simply turn the Meyer Thread card upside-down and see the figures change from children to bearded and bald men.

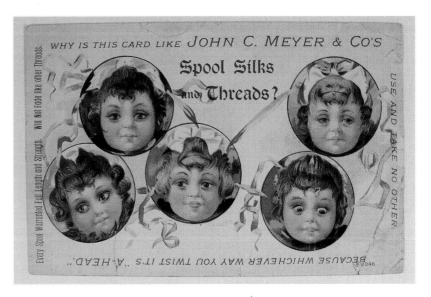

John C. Meyer & Co., metamorphic trade card. $10-15

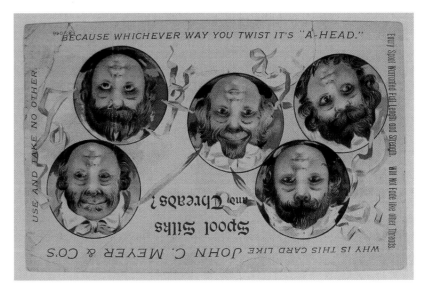

John C. Meyer & Co., trade card (up-side down)

Peters Shoe Co., St. Louis
Peters Weatherbird Shoes

"Uncle Sam Knows That Peters Shoes Are Extra Good. His Soldiers Boys Wore Them."

The Peters Shoe Company gave a fold-out leaflet, 2-1/4" x 4", in color lithography with changing sections. The leaflet advertised their "Weatherbird" shoes.

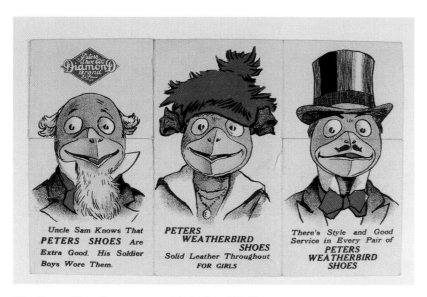

The Peters Shoe Co., metamorphic leaflet. $15-20

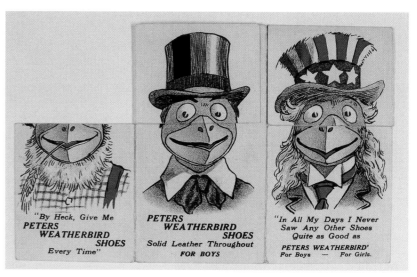

The Peters Shoe Co., metamorphic leaflet/flipped

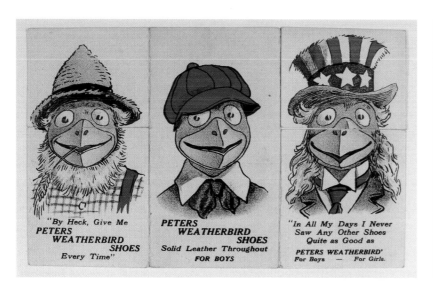

The Peters Shoe Co., metamorphic leaflet reversed

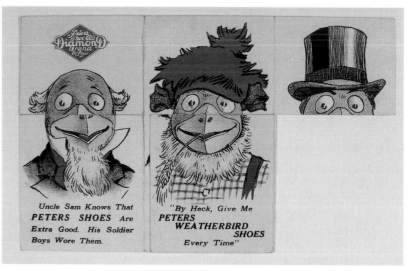

The Peters Shoe Co., metamorphic leaflet/flipped

"Hip, Hip, Hurrah!"

In 1920, "Weatherbird" issued a cutout set, 10" x 10-1/2", named Parade of Nations. The weatherbirds are shown in ethnic costumes of nations around the world, and one is dressed as Uncle Sam.

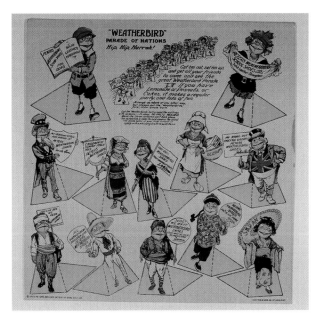

The Peters Shoe Co., 'Weatherbird' Parade of Nations. *Courtesy of Virginia A. Crossley.* $35

A clever fold-down card printed in color lithography showing a change in facial expression was issued for Solar Tip Shoes, John Mundell & Co., Phila. One of their poems had great similarity to a tune from a popular Gilbert and Sullivan comic opera.

> Three little kids from school are we;
> Our shoes don't fit, as you plainly see.
> We're in an awful agony -
> Three little kids from school.
>
> Six little feet with aching toes,
> Papa out to the shoe-shop goes,
> When he comes, he'll end our woes -
> Three little kids from school.
>
> Now you see what a happy thought -
> Solar Tips our Papa's bought.
> Here's comfort that we long have sought -
> Three little kids from school.

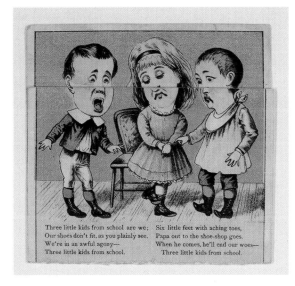

John Mundell & Co., Solar Tip Shoes, fold-down card. $25

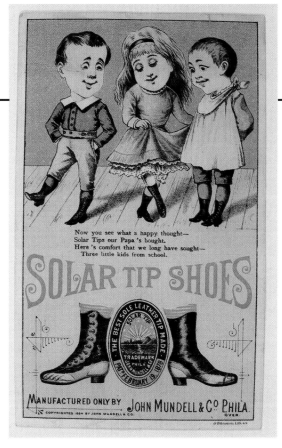

Solar Tip Shoes, unfolded

Pingree & Smith, Detroit
Pingree Shoes

*"Always dependable for a day of toil,
or an hour of sport"*

This shoe company gave "front and back" cards to local retail shoe stores to be given to customers. The local store's advertising also appeared on the Pingree card.

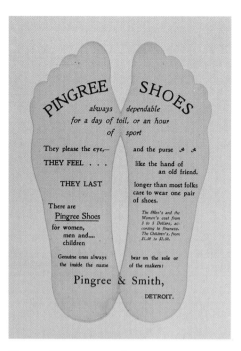

Pingree Shoes, reversed

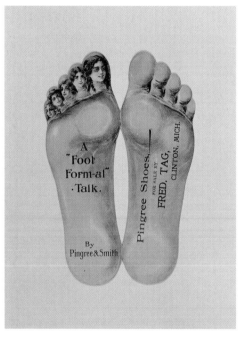

Pingree & Smith, Pingree Shoes. $10-15

Colgate's Ribbon Dental Cream
GOOD TEETH, GOOD HEALTH

Colgate & Company, N. Y., was established in 1806. In 1911, the company offered a colorful booklet, 4-1/2" x 6-1/2", entitled *The Jungle Pow-Wow (Jungle Jokes for Nursery Folks)* by Jessie Imbrie Miller. In the story, the animals of the jungle extol the virtues of Colgate's Ribbon Dental Cream.

Colgate & Co., "The Jungle Pow-Wow," double page

Colgate & Co., "The Jungle Pow-Wow." $15-20

Later, in 1913, the company issued *THE CASHMERE BOUQUET* booklet, *"Mary, Mary Quite Contrary and other Mother Goose Melodies."* This booklet, 5-1/4" x 3-1/2", does not have rhyming advertising lines, but some pages show advertisements for Colgate's dental cream.

Colgate & Co., "Mary, Mary, Quite Contrary," $15

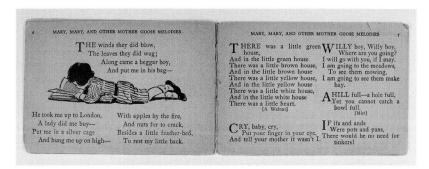

Colgate & Co., "Mary, Mary, Quite Contrary," double page

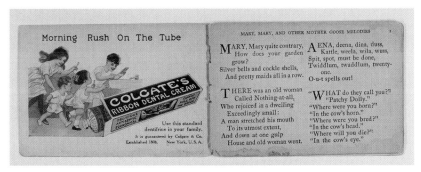

Colgate & Co., "Mary, Mary, Quite Contrary," inside cover/page 1.

Colgate & Co., "Mary, Mary, Quite Contrary," back cover

Household / Farm

STAR ★ SOAP
"Best For Family Soap"

One early premium booklet, *Old Mother Hubbard's Star Rhymes*, was offered by Schultz & Company, The Soap Boilers, of Zanesville, Ohio. This soap product was first brought out in 1865 and patented in 1866. The wording "Star Soap" appears in the Mother Goose illustrations, and below each picture is an advertisement.

Star★Soap, "Old Mother Hubbard's Star Rhymes." $20-25

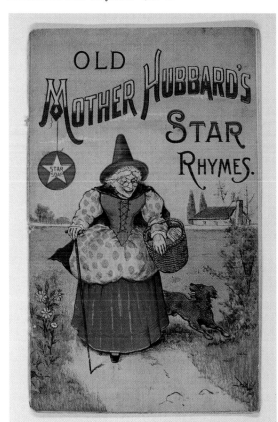

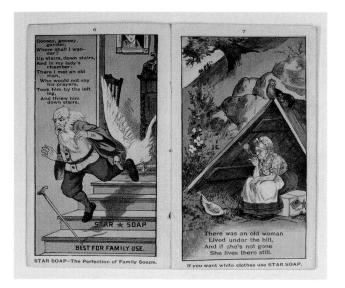

Star★Soap, "Old Mother Hubbard's Star Rhymes," double page

Star★Soap, "Old Mother Hubbard's Star Rhymes," double page

Star★Soap, "Old Mother Hubbard's Star Rhymes," rhyme in German/inside back cover

"This is the House that Jack built"

The D. W. Williams & Co., Glastonbury, Connecticut, was the manufacturer of fine soaps for the family. The trade cards from the Mother Goose Jingles of Williams' Soaps include additional lines about the company's products.

"This is the Rat that ate the Malt
That lay in the House that Jack built."
Then away he ran with all his might,
Tracking the floor, made so clean and white
With Granulated Soap,—just the thing
To clean our houses in fall or spring.

Star★Soap, "Old Mother Hubbard's
Star Rhymes," back cover

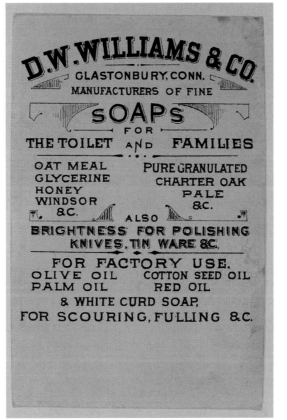

D. W. Williams & Co., "The House
That Jack Built," a card reversed

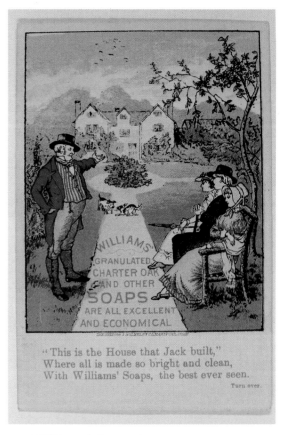

D. W. Williams & Co., "This is the House
that Jack built." Set: $35

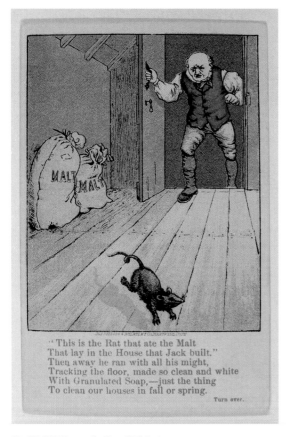

D. W. Williams & Co., "This is
the Rat that ate the Malt..."

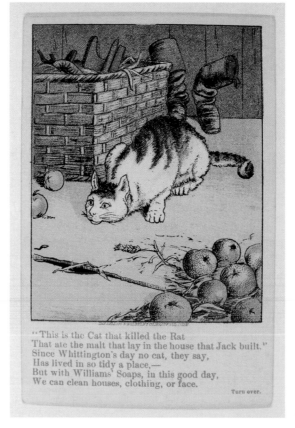

D. W. Williams & Co., "This is
the Cat that killed the Rat..."

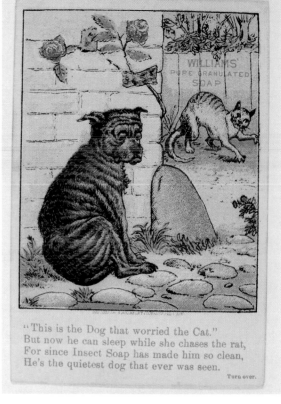

D. W. Williams & Co., "This is
the Dog that worried the Cat."

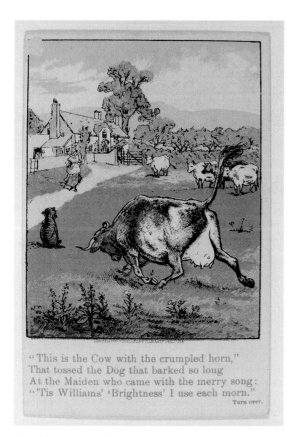

"This is the Cow with the crumpled horn,"
That tossed the Dog that barked so long
At the Maiden who came with the merry song:
"'Tis Williams' 'Brightness' I use each morn."

Turn over.

D. W. Williams & Co., "This is the
Cow with the crumpled horn,"

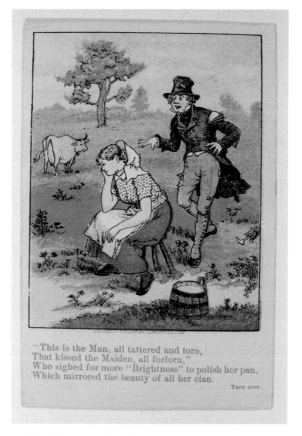

"This is the Man, all tattered and torn,
That kissed the Maiden, all forlorn,"
Who sighed for more "Brightness" to polish her pan.
Which mirrored the beauty of all her clan.

Turn over.

D. W. Williams & Co., "This is the Man, all tattered
and torn, That kissed the Maiden, all forlorn,"

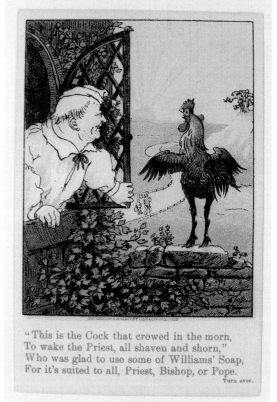

"This is the Cock that crowed in the morn,
To wake the Priest, all shaven and shorn,"
Who was glad to use some of Williams' Soap,
For it's suited to all, Priest, Bishop, or Pope.

Turn over.

D. W. Williams & Co., "This is the
Cock that crowed in the morn,..."

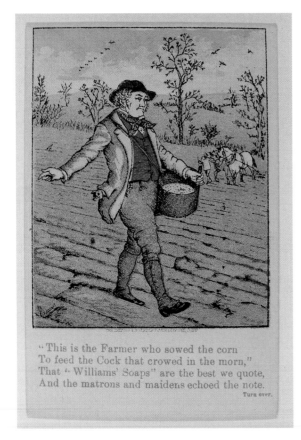

"This is the Farmer who sowed the corn
To feed the Cock that crowed in the morn,"
That "Williams' Soaps" are the best we quote,
And the matrons and maidens echoed the note.

Turn over.

D. W. Williams & Co., "This is the Farmer who sowed the corn..."

At the turn of the 20th century, the United States had many ethnic groups, and dialects pertaining to them and to different regions of the country appeared in advertising. At the time they were used, the dialects were accepted in the theater, on radio, and later on television, but some of them are offensive today.

Higgins' German Laundry Soap

"Days of the Week"

This company put out a set of trade cards on the Mother Goose rhyme, "Days of the Week," which pictures a Black-American woman doing her many household jobs throughout the week. Today, among collectors, Black Americana items have become a hot collectible field.

Monday—
Monday is de wash day,
an I neber sulk or mope
because de close am nice
and clean, by using
Higgins' Soap.

Higgins' German Laundry Soap, "Days of the Week," Monday. Set: rare

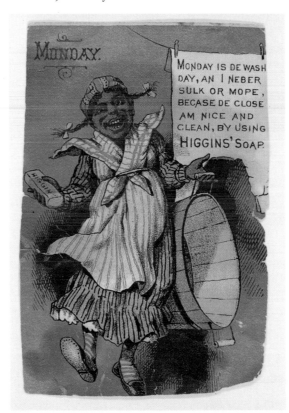

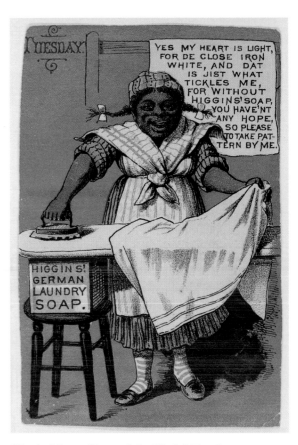

Higgins' Soap, "Days of the Week," Tuesday

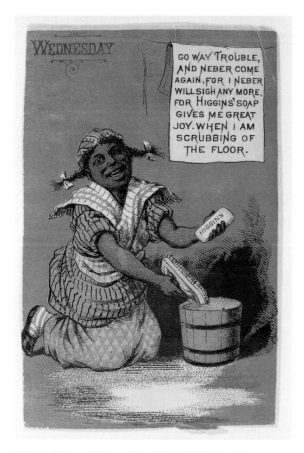

Higgins' Soap, "Days of the Week," Wednesday

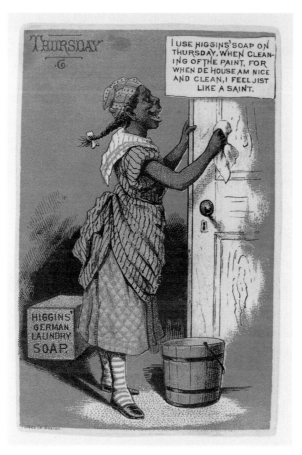

Higgins' Soap, "Days of the Week," Thursday

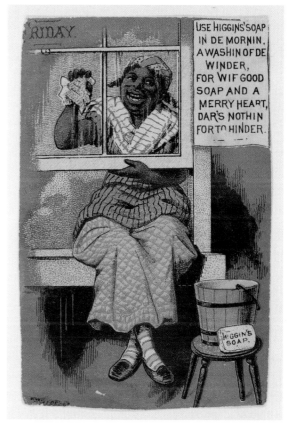

Higgins' Soap, "Days of the Week," Friday

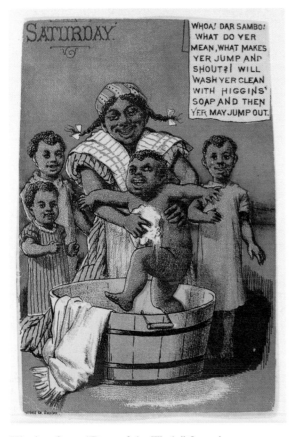

Higgins, Soap, "Days of the Week," Saturday

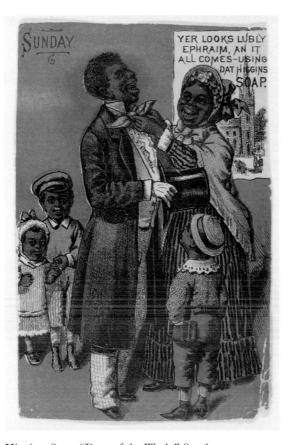

Higgins, Soap, "Days of the Week," Sunday

The Krein Mfg. Co., Wapakoneta, Ohio

"ACETYLENE" The Home Made Gas Light
"Volume for volume, your acetylene will give you *ten times* more light than your city cousin gets from the best city gas."

This company issued *Puzzletters*, an alphabetical problem game. Each of the four front and back triangular-shaped cards had all the letters of the alphabet printed on each, thirteen letters on a side, but with a different combination of letters on each card. The problem was to place the four cards inside the triangular space, so as to expose at one time all twenty-six letters of the alphabet. Patent Applied For by D. S. Littlefield, Chicago.

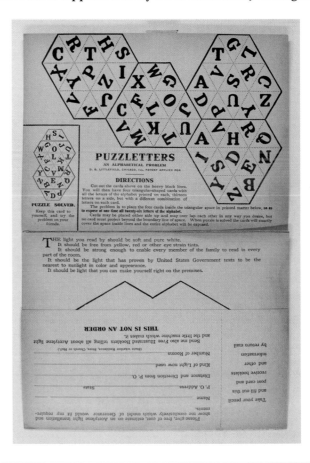

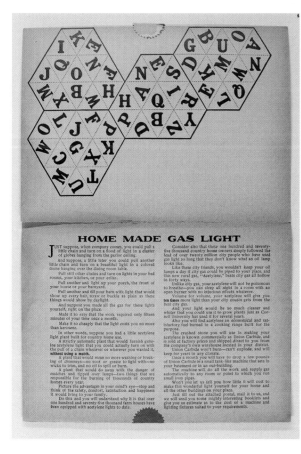

HOME MADE GAS LIGHT

JUST suppose, when company comes, you could pull a little chain and turn on a flood of light in a cluster of globes hanging from the parlor ceiling.

And suppose, a little later you could pull another little chain and turn on a beautiful light in a colored dome hanging over the dining room table.

Pull still other chains and turn on lights in your bed rooms, your kitchen, or your cellar.

Pull another and light up your porch, the front of your house or your barnyard.

Pull another and fill your barn with light that would show up every hair, straw or buckle as plain as these things would show by daylight.

And suppose you made all the gas for these lights yourself, right on the place.

Made it so easy that the work required only fifteen minutes of your time once a month.

Make it so cheaply that the light costs you no more than kerosene.

In other words, suppose you had an acetylene light plant built for country home use.

A strictly automatic plant that would furnish genuine acetylene light that you could actually turn on with the pull of a chain whenever or wherever you wanted it, *without using a match*.

A plant that would mean no more washing or breaking of chimneys—no soot or grease to light with—no wicks to trim, and no oil to spill or burn.

A plant that would do away with the danger of matches and tipped over lamps—two things that are responsible for the burning of thousands of country homes every year.

Picture the advantages in your mind's eye—stop and think of the safety, comfort, satisfaction and happiness it would bring to your family.

Do this and you will understand why it is that over one hundred and seventy-five thousand farm houses have been equipped with acetylene lights to date.

Consider also that these one hundred and seventy-five thousand country home owners simply followed the lead of over twenty million city people who have used gas light so long that they don't know what an oil lamp looks like.

Like these city friends, you wouldn't keep your oil lamps a day if city gas could be piped to your place, and this new rural gas, "Acetylene," beats city gas all hollow in forty ways.

Unlike city gas, your acetylene will not be poisonous to breathe—you can sleep all night in a room with an open burner with no injurious effects whatever.

Volume for volume, your acetylene will give you **ten times** more light than your city cousin gets from the best city gas.

And your light would be so much cleaner and whiter that you could use it to grow plants just as Cornell University has used it for several years.

Also you will find acetylene an economical and satisfactory fuel burned in a cooking range built for the purpose.

The crushed stone you will use in making your acetylene is known commercially as Union Carbide, and is sold at factory prices and shipped direct to you from the company's own warehouse located in your district.

Union Carbide won't burn—can't explode, and will keep for years in any climate.

Once a month you will have to drop a few pounds of Union Carbide in a small tank-like machine that sets in your basement or in an out-building.

The machine will do all the work and supply gas automatically to any room or point to which you run small iron pipes.

Won't you let us tell you how little it will cost to make this wonderful light transport for your home and all the other buildings on your place.

Just fill out the attached postal, mail it to us, and we will send you some mighty interesting booklets and give you an estimate as to the cost of a machine and lighting fixtures suited to your requirements.

Above:
"Acetylene," Puzzletters

Left:
The Krein Mfg. Co., "Acetylene," Puzzletters. $18-20

"How the Boys Found the Band"

Many companies used fold-down trade cards to show the wonders of their products. One example was the Edison Phonograph. Their card, in color, revealed a garden party with music being played on an Edison Phonograph.

Right:
The Edison Phonograph, How the Boys Found the Band, fold-down card. $45-65

Far right:
The Edison Phonograph, unfolded

How the Boys Found the Band

THE HAPPIEST HOURS OF LIFE ARE THOSE SPENT IN THE HOME, IN EASY ENJOYMENT OF PLEASING MELODIES. NO NEED TO GO TO PLACES OF AMUSEMENT WHEN HOME IS MADE BRIGHT AND ATTRACTIVE BY

THE EDISON PHONOGRAPH

LET THE DEALER PLAY ONE FOR YOU.

Form No. 946

In 1901, Emile Berliner and Eldridge Johnson formed the Victor Talking Machine Company. Their puzzle, 8" x 8-1/4", entitled "All that the Victrola gives to others it will give to you," was copyrighted in 1922. The famous trademark of Nipper listening to *His Master's Voice* is shown on the lower left corner of the puzzle.

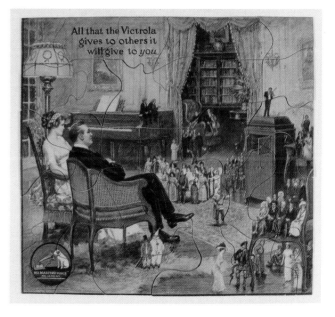

Victor Talking Machine Company, 1922 puzzle. $45-55

128

Use The McCORMICK Right Hand Machines Or You Will Get LEFT

On this card the McCormick Company had the right and left hands open-
ing and closing. Pictured inside were the colored prints of a McCormick Light
Draft NEW 4 MOWER and a McCormick Light Draft BINDER.

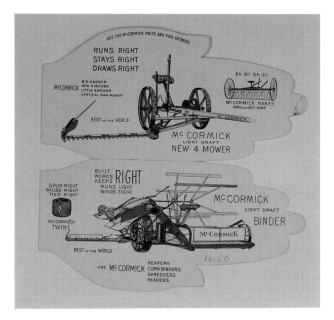

McCormick Company, opened

McCormick Company, trade card,
(right hand). $15 as shown

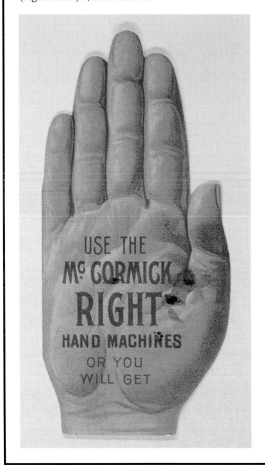

McCormick Company, reversed, (left hand)

Buckeye Works, founded in 1831, Greentown, Ohio

"Buckeye received the first Gold Medal ever awarded to a harvesting machine / United States Agricultural Society MDCCCLII."

The Buckeye Works at Canton, Ohio (C. Aultman & Co.), and the Buckeye Works at Akron, Ohio (Aultman, Miller & Co.), issued a trade card in 1899 showing their first shop's double doors. When these doors are opened, they reveal pictures of their modern factories. The reverse side shows Buckeye accepting the gold medal, with their competitors — McCormick, Champion, Deering, and others — watching the ceremony.

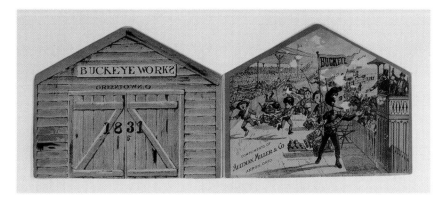

Buckeye Works, Greentown, Ohio, (front/back). $15-20

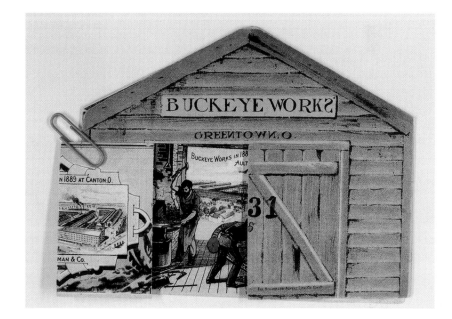

Buckeye Works, front cover (door opened)

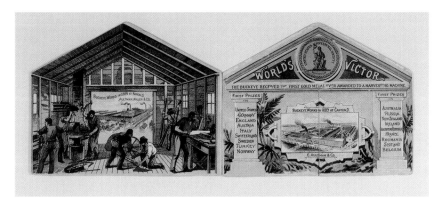

Buckeye Works, reversed

The Stover Mfg. Co., Freeport, Illinois

The "old man" evidently has some curiosity and is taking a great deal of trouble and some risk to satisfy his curiosity by climbing *"Over the Garden Wall."* This company's card opens up to a kissing scene behind a huge bonnet. Here the viewer is informed that the company's wind-mills and feed-mills will give greater satisfaction than "the Old Man's" trip "over the garden wall."

What is the Fireman going to do?
Is he going to put out the fire?
I guess, but you had better look over the wall
　　and see for yourself!

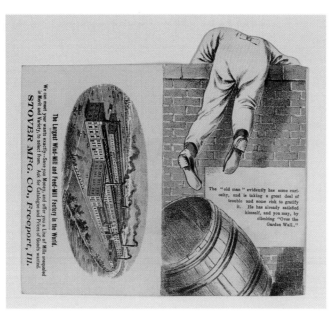

The Stover Mfg. Co., "Over the Garden Wall." $12-18

This card was issued by Phenix Ins. Co. of Brooklyn. On the opposite side of this card, a fireman is shown leaning over the wall.

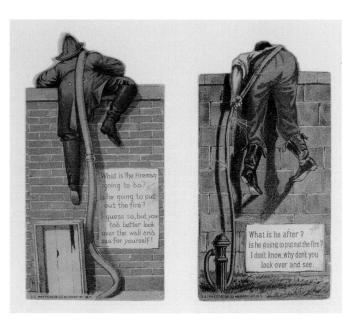

Phenix Ins. Co., "Over the Wall," two cards, (fireman/man). $12-18 each

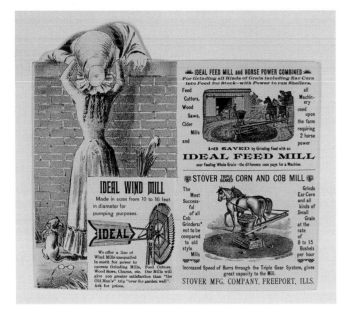

The Stover Mfg. Co., "Over the Garden Wall," reversed

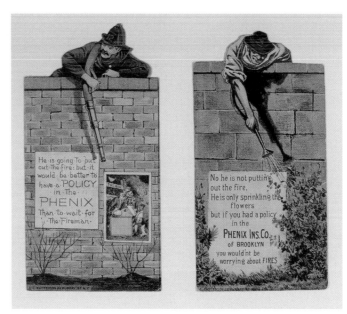

Phenix Ins. Co., "Over the Wall," two cards, reversed

Entertainment World

The record business, vaudeville, theater, and films were affected by radio's emergence into the entertainment world. Eddie Cantor, a vaudeville performer, made his network radio debut in 1931. Within the next five years, other leading comedians on vaudeville, Broadway, and films got their own shows, including George Burns and Gracie Allen, Jack Benny, Bob Hope, Goodman Ace and wife Jane as "Easy Aces," and Fibber McGee and Molly.

The Pepsodent Company

When you buy toothpaste, antiseptic or face cream, we sho would appreciate you useing Pepsodent products. It would help us a lot. Thanks, Sincerely, Amos 'n' Andy

Who were "Amos 'n' Andy?" Charles J. Correll, "Andy," was born in Peoria, Illinois. Freeman F. Gosden, "Amos," came from Richmond, Virginia. On August 19, 1929, Correll and Gosden began to broadcast the "Amos 'n' Andy" episodes for The Pepsodent Company over the NBC network.

Between them, "Amos" and "Andy" took the parts of all the characters they introduced. In blackface character study, "Andy" was domineering while "Amos" was meek. The following identifies the characters that each man played: "Amos"—Kingfish, Lightnin', Brother Crawford, and Prince Ali Bendo; "Andy"—Henry Van Porter, Landlord, and such straight characters as policeman and judge. They enjoyed immense popularity, and interest in them remains high today, although many now look upon their performances as demeaning.

Fresh Air Taxicab Co. of America—incorpulated
Andy Brown—Prez
Order of the Mystic Knights of the Sea

The set of stand-up paper toys was copyrighted in 1931 by The Pepsodent Company. The toys have fold back standards on each side. There is the taxicab, a broken down, old touring car, with Amos in the driver's seat, and another stand-up with Amos discovering a nail in an old tire. Kingfish's stand-up shows him opening the door to his lodge known as "The Mystic Knights of the Sea." Another piece shows Andy sitting behind a desk talking on the telephone, and a final piece has the announcer, W. G. Hay, better known as "Bill" Hay, seated behind his microphone.

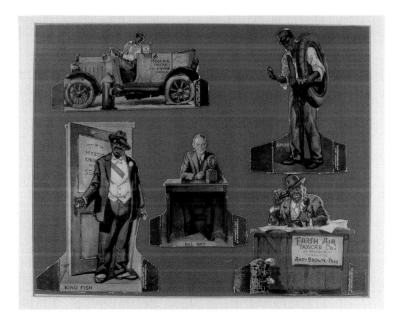

Amos and Andy, 1931, The Pepsodent Company. Set: rare

In 1932, Pepsodent copyrighted the "Amos 'n' Andy" puzzle. It shows Brother Crawford, Lightnin', Andy, Amos, and Kingfish at the O. K. Hotel. It was sent upon request by The Pepsodent Co.

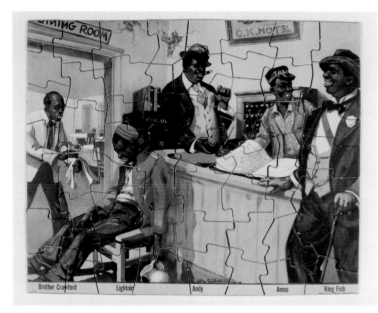

Amos and Andy, puzzle, (8-1/8" x 10-1/8"). $90

This space reserved for Fresh Air Taxicab Company of America, Inc. This plot reserved for the Kingfish's mother-in-law.

A colorful map of Weber City, "Eagle's-Eye View of Weber City (inc.)," was copyrighted in 1935 by The Pepsodent Co. It was sent upon request to listeners of the "Amos 'n' Andy" show.

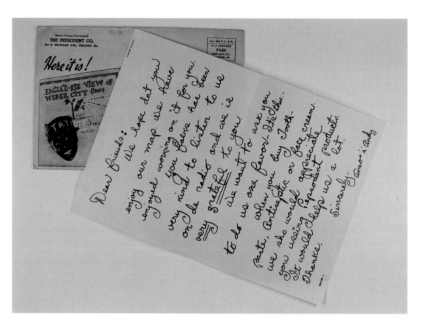

Envelope for Map of Weber City/a letter.

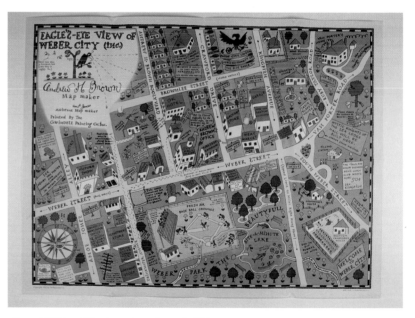

Map of Weber City (envelope/letter). $95

Heah You Is!
Your Own Autographed Copy
of Amos 'n' Andy's Original Radio Episode

This radio script, Episode No. 2225, was presented on Wednesday, December 25, 1936. It is the episode where Ruby and Amos got married.

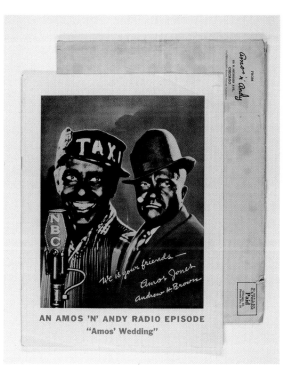

AN AMOS 'N' ANDY RADIO EPISODE
"Amos' Wedding"

Radio Episode, "Amos' Wedding," (envelope). $50

Radio Episode, autographed copy page

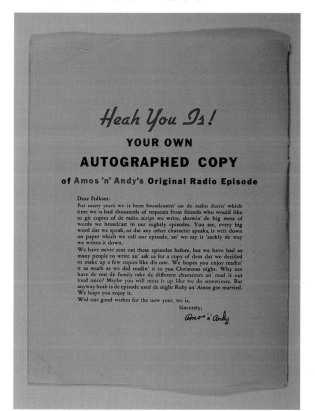

Many paper premiums were printed by the National Broadcasting Company, with the copyright by Correll & Gosden. Some of these were the "Amos 'n' Andy" black-and-white picture prints with an orange background, found on composition books or tablets. One tablet cover shows Andy relaxing in the back seat while Amos is about to change a tire, and another has Amos and Andy looking at their new tablets.

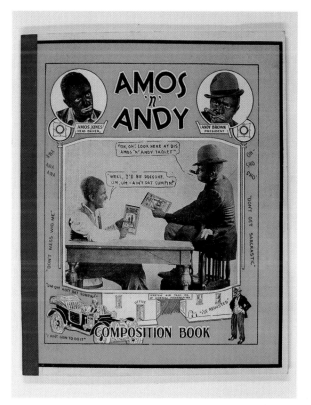

Amos and Andy, School Composition Book. $20

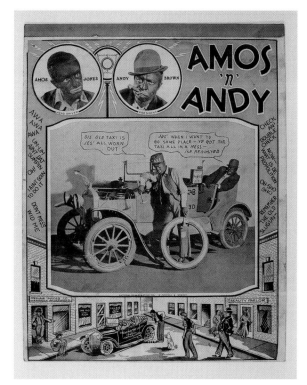

Amos and Andy, School Tablet. $20

COME-ON STOCK
Fresh Air Taxicab Co. of America, Incopolated
AUTO-RIZED CAPITAL STOCK 1,000,000 HEADACHES

A stock certificate of the Fresh Air Taxicab Co. of America, Inc., was an advertising piece by The First National Bank, Cadiz, Ohio.

Standard Oil of Ohio (Sohio)

"Spring Cleaning" for Your Car made easy by SOHIO

Standard Oil of Ohio, prior to being acquired by British Petroleum, was commonly known as Sohio, and used that name in its advertisements. An enclosure in a Sohio's radio jig-saw puzzle box, No. 3, "A BULLY TIME IN SPAIN," explained why you should get your car ship-shape for the summer. These Sohio services were pictured in a cartoon on the enclosure.

Amos and Andy, Stock Certificate, reversed

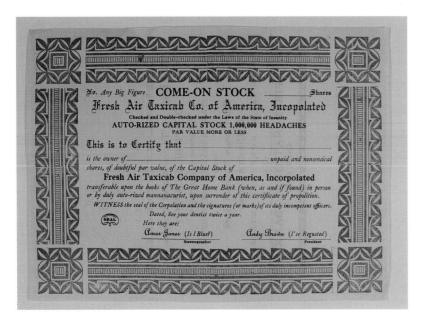

Amos and Andy, Stock Certificate. $20

The puzzle is actually two puzzles in one. On one side is a picture of Gene and Glenn, "The Sohio Boys," with Jake and Lena at a bullfight in Spain. The reverse side shows a picture of the Sohio Radio-Stars themselves. The bullfight scene is in bright colors, and the photo of Gene and Glenn is in hues of gray. The copyright is 1933. Two more Sohio radio jig-saw puzzles are "Just Breezin' Along," and No. 2, "In Dutch."

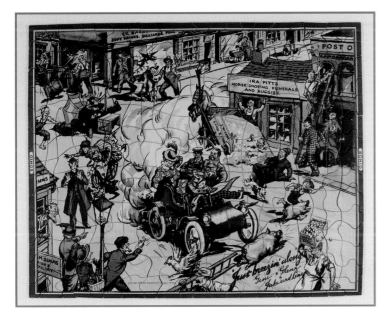

Sohio, "Just Breezin' Along," puzzle. $25-35

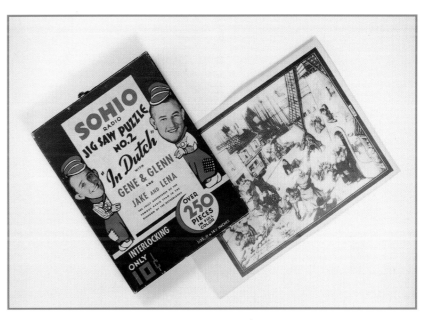

Sohio, "In Dutch," puzzle/box/directional sheet. $25-35

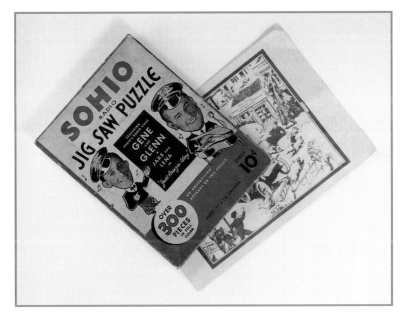

Sohio, "Just Breezin' Along," box/directional sheet

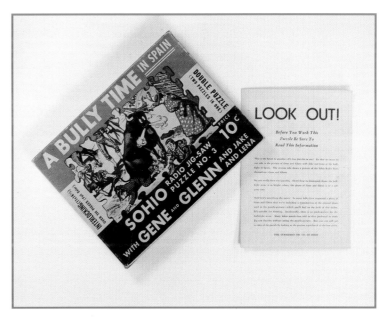

Sohio, "A Bully Time In Spain," double
puzzle/box/information sheet. $25-35

How To Get The Game—Send two Chase and Sanborn Dated Package fronts and two cents to Chase and Sanborn, N.Y.C.
This offer expires November 30, 1938.

The Charlie McCarthy's Radio Party, 1938, Standard Brands Incorporated, consisted of 21 figures, one for Charlie McCarthy, the best known ventriloquist's dummy of the time, and four each of Edgar Bergen, Robert Armbruster, Dorothy Lamour, Nelson Eddy, and Don Ameche. This popular comedy-variety show, "Edgar Bergen and Charlie McCarthy," first aired in 1936 on NBC network.

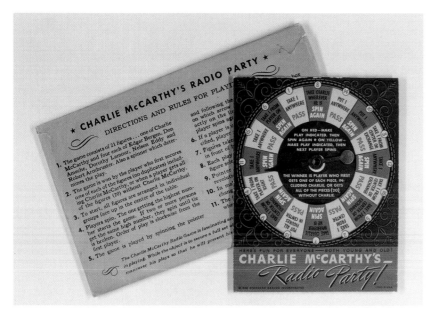

The Charlie McCarthy's Radio Party, 1938, Standard Brands Incorporated, envelope/spinner. Set: $95

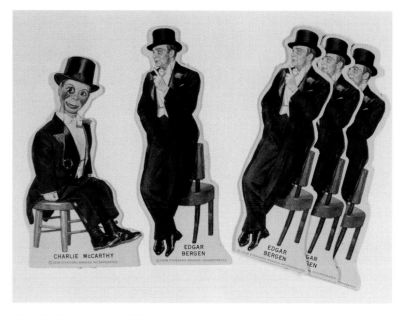

Charlie McCarthy and Edgar Bergan

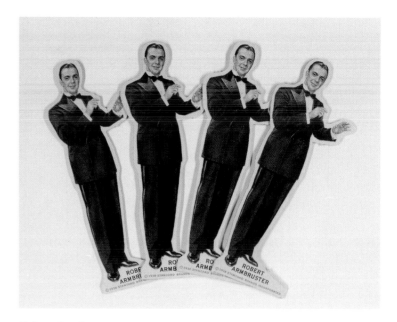

Robert Armbruster

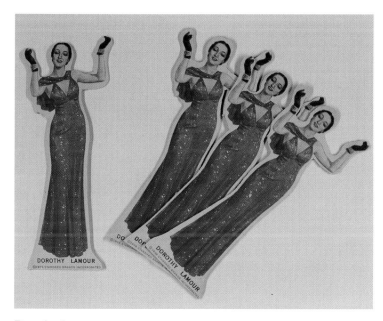

Dorothy Lamour

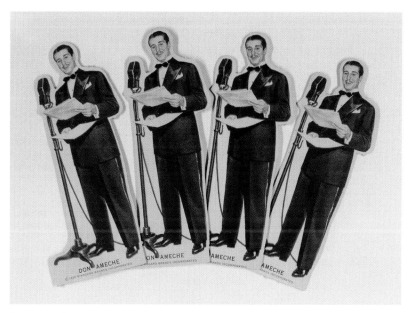

Don Ameche

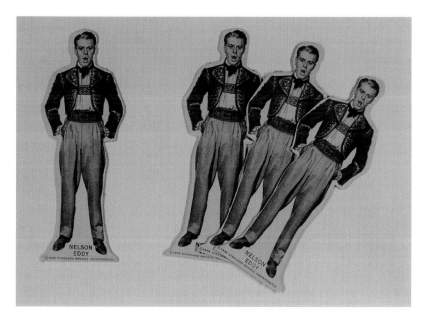

Nelson Eddy

ONE OF THE 20

In 1905, The Pacific Coast Borax Company, makers of Twenty-Mule-Team Borax White Laundry Soap, had as their paper stand-ups the 20 Mule Team Borax toys. On the back of each mule piece were directions to bend back the end pieces at dotted lines to make the mule stand up. These pieces are die-cuts in color lithography.

Hauling 20 Mule Team Borax Out of Death Valley

"Death Valley Days," was a popular radio program from 1931 to 1944. In 1933, The Pacific Coast Borax Company issued a 20 Mule Team puzzle, 10-1/2" x 8-1/4".

Lux Toilet Soap

Let the Beauty Soap of the Stars keep YOUR complexion alluring—9 out of 10 Lovely Screen Stars use Lux Toilet Soap

In 1936, the Lux Radio Theater directed by Cecil B. De Mille was introduced, and these dramatic programs achieved great popularity. These reenactments of picture and stage hits had popular film stars in the lead roles.

The LUX advertising puzzle, "The Wayside Inn," was the inn immortalized by Henry Wadsworth Longfellow in his 1863 poem, "Tales of a Wayside Inn." This picturesque New England house was built in 1683.

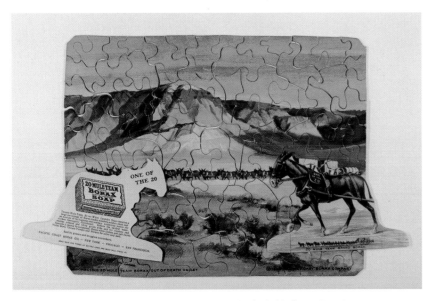

The Pacific Coast Borax Co., puzzle/trade cards. $45-55; $10-15 each

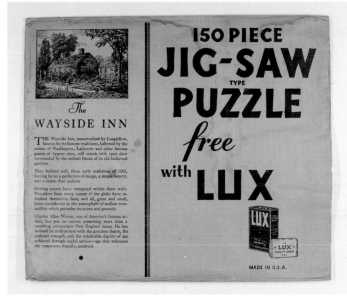

Lux, "The Wayside Inn," envelope

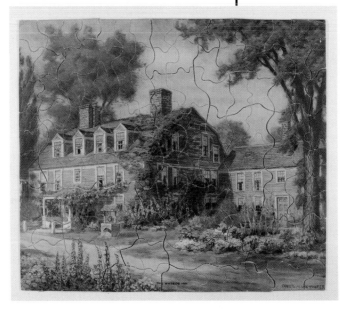

Lux, "The Wayside Inn," puzzle, (envelope). $20

8 WAYS TO HAVE FUN AT A
HALLOWE'EN PARTY
with WIZARD OF OZ MASKS

In 1939, the "Wizard of Oz" masks were copyrighted and released by Lowe's Incorporated in connection with the movie. The PAR-T-MASK trade mark has the Patent No. 2021593, Einson-Freeman Co., Inc., Long Island City, New York. The five masks are Dorothy, the Wizard, and her three best friends, the Cowardly Lion, Tin Woodman, and Scarecrow.

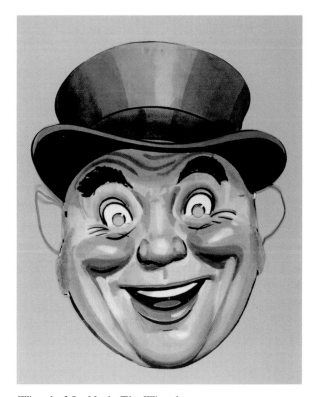

Wizard of Oz Mask, The Wizard

Wizard of Oz Masks, Halloween Party. Set: rare

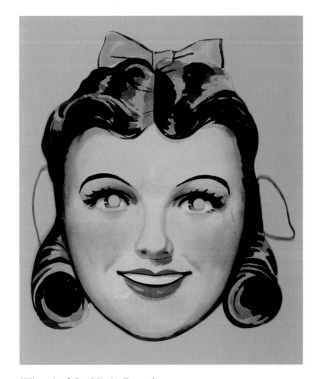

Wizard of Oz Mask, Dorothy

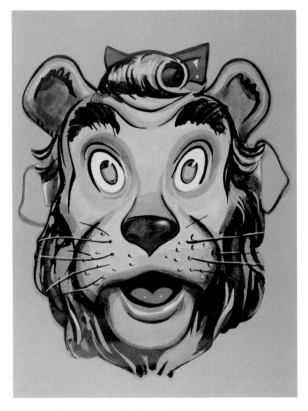

Wizard of Oz Mask, The Cowardly Lion

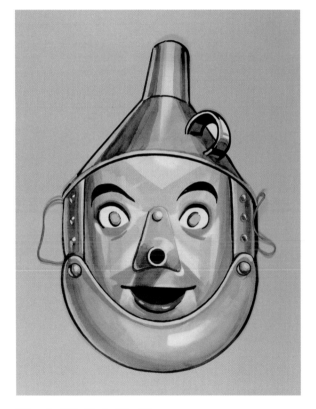

Wizard of Oz Mask, The Tin man

Wizard of Oz Mask, The Scarecrow

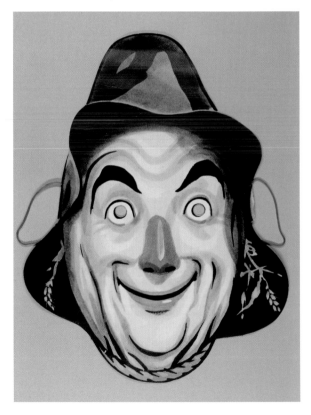

General Mills, Inc.

WHAT IS THE WAFC?
WAFC means Write-A-Fighter Corps

A very popular radio program for youths during World War II was "Jack Armstrong, The All-American Boy," sponsored by General Mills, Inc., to promote its cereal, "Wheaties." The WAFC Kit, Jack Armstrong's "The All-American Boy" envelope packet, included a WAFC Manual with its own squadron number. The members of the WAFC Squadrons would listen to the Jack Armstrong radio program daily to hear the latest news about the WAFC organizations.

Each WAFC Kit contained Honor Bars for one Squadron Leader, five Fighter Pilots and a year's supply of special stars. Six stencils were included for the squadron to make its own stationery. It also included a V-Mail form for overseas service men whose mailing address was via either New York City or San Francisco.

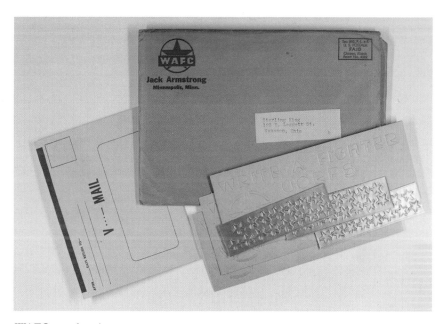

WAFC envelope/contents

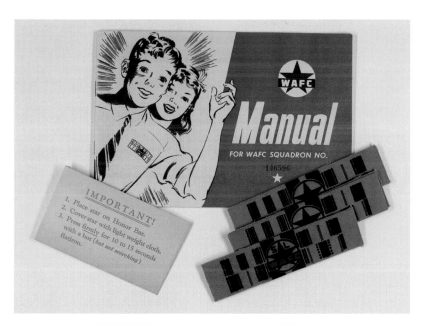

Jack Armstrong, WAFC Kit (Manual and contents). $18-20

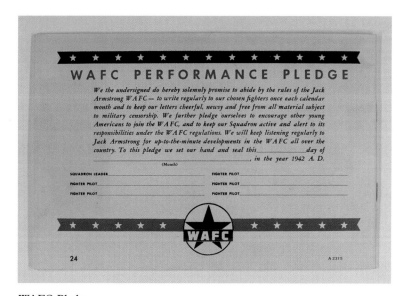

WAFC Pledge

Model kits were offered to the children, too. These kits were obtained by sending in a Wheaties box top to General Mills for a set of two tagboard models. Enclosed would be an order form for the next set of Jack Armstrong's models soon to be released.

BUILD YOUR ZERO FIRST!
It Will Help You Build A Better
"FLYING TIGER"

One side of the instruction sheet explained how to assemble the "OFFICIAL Jack Armstrong MODEL" of a captured Japanese "ZERO" (Mitsubishi 00).

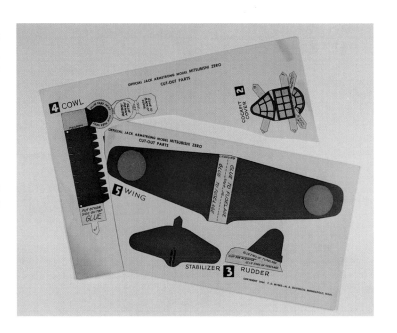

Mitsubishi Zero, model

Model P-40-F, 'Flying Tiger'

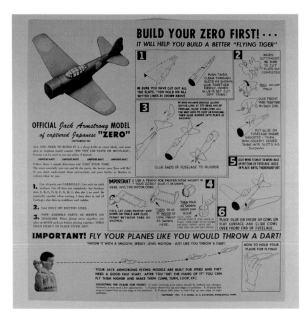

Jack Armstrong, "Build Your Zero First." Set: $20-25 as shown

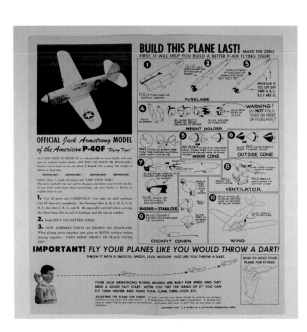

Jack Armstrong, "Build This Plane Last," 'Flying Tiger'

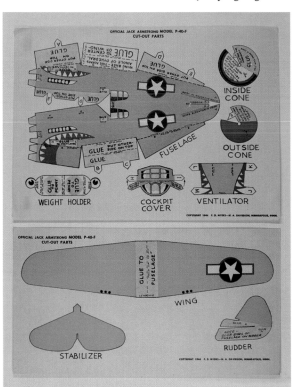

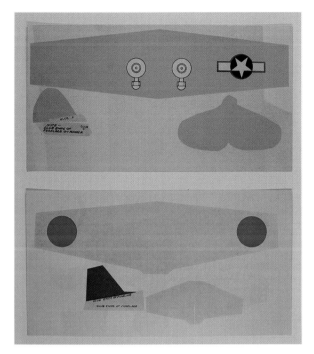

Wings, Stabilizers, Rudders

BUILD THIS PLANE LAST!
Make the Zero First. It Will Help You Build a Better
P-40F Flying Tiger!

The opposite side of the instruction sheet told how to assemble the "OFFICIAL Jack Armstrong MODEL" of the American P-40F "Flying Tiger."

The photograph puzzle of the actor Clark Gable without a mustache was taken before his famous movie, "Gone With the Wind." It was given out as an announcement for an address change of the Walters Tire Co., Sinclair Gas and Oil, Easton, Pennsylvania. The Grande Theatre, Detroit, Mich., "Coming Attractions" leaflets pictures Clark Gable with his famous mustache.

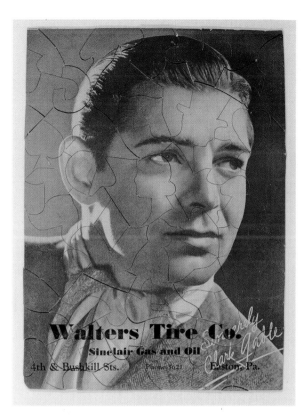

Clark Gable, puzzle,
(6-3/4" x 9-1/8"). $50

Jack Armstrong, envelope/order blank
for new models: Russian/German

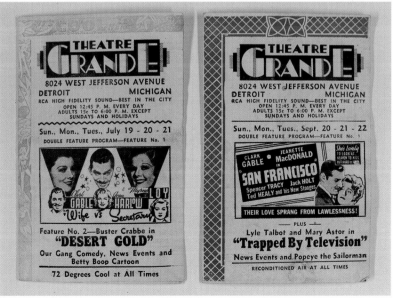

The Grande Theatre,
Clark Gable. $6-8
each

Today's Market

Today, paper advertising pieces that attract children are still used by companies, but television programs are the main means to gain their attention. As the early paper premiums and product enclosures had to give way to the demands of radio advertising, so did radio program premiums have to yield to the demands of television advertising.

A new collector should concentrate on advertising after the 1940s to the present, as these items are more available and are inexpensive on today's collectible market.

After World War II, Americans "hit the road" in their automobiles for vacations, camping, and moving their families to new locations in the United States. *Arm & Hammer* offered a revolving disc chart, "Arm & Hammer Baking Soda Guide for Carefree Camping." The company's baking soda offered a camping kit in a cardboard box, and the revolving chart was designed to show the many uses of the soda in camping or in the backpack for hiking.

U-Haul Finest and Safest Rental Trailers

The U-HAUL stand-up paper toy is designed in one piece, which folds up to a four-sided enclosed U-HAUL trailer. On top is a slot to be opened, and the toy then becomes a bank. No copyright is indicated.

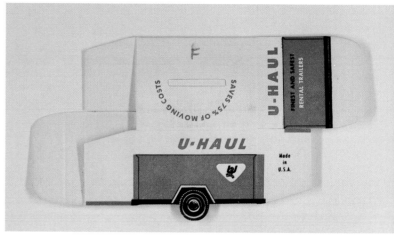

U-Haul Trailer, bank. $10-12

Arm & Hammer, revolving disc. $10-12

Arm & Hammer, reversed (disc)

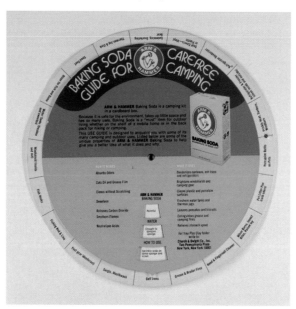

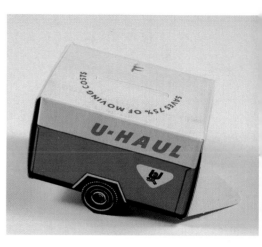

U-Haul Trailer, bank (built)

North American Van-Lines, Inc.

Trailblazers of America

In 1956 this World-Wide Moving Service offered a fold-up, stand-up paper toy of a North American Trailer Van in two pieces. The rear of the trailer featured an advertisement, *A truckfull of Goodness!* Nabisco Shredded Wheat.

H. J. Heinz Company, Pittsburgh, Pa.

Heinz makes "KETCHUP" not catsup

The booklet entitled "How A Little Boy's Dream Came True" was a story-and-coloring book. It was prepared especially for the H. J. Heinz Company.

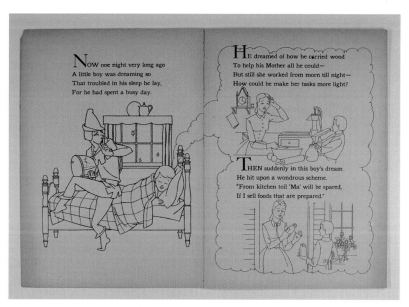

H. J. Heinz Company, "How A Little Boy's Dream Came True," double page

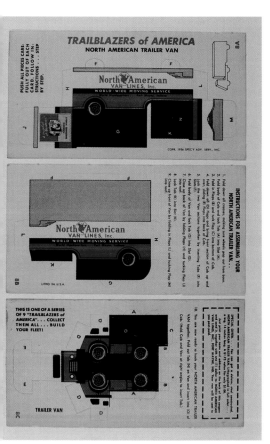

North American Van-Lines. *Courtesy of Virginia A. Crossley.* $10-12

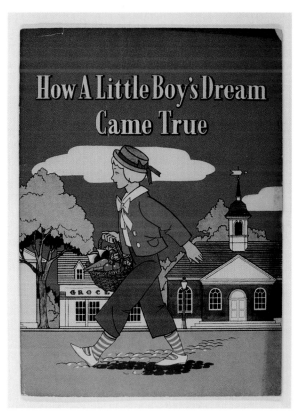

H. J. Heinz Company, "How A Little Boy's Dream Came True," *Courtesy of Virginia A. Crossley.* $15

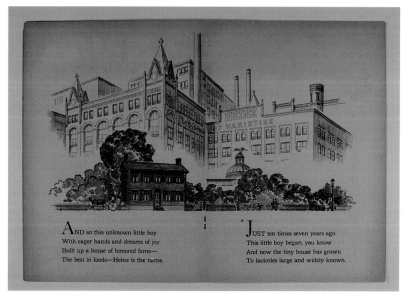

H. J. Heinz Company, "How A Little Boy's Dream Came True," Heinz 57 Varieties, double page

The Metropolitan Life Insurance Company, New York

The Metropolitan Company offered a booklet entitled, *Mother Goose*. The author was Elizabeth C. Watson.

Shoe the horse, and
Shoe the mare,
But shoe the growing
feet with care...

The Metropolitan Life
Insurance Co., "Mother
Goose." $15-20

The Metropolitan Life
Insurance Co., "Mother
Goose," double page

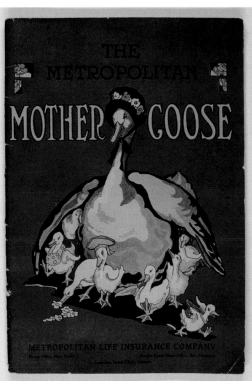

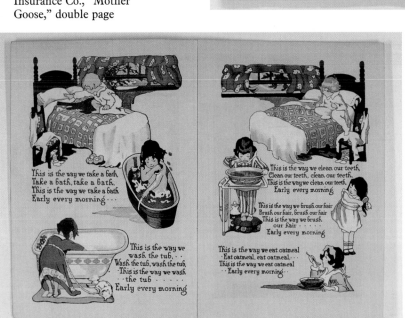

The Western and Southern Life Insurance Co., Cincinnati

"A Mutual Company"

The company gave out a coloring book for young children entitled, *My Own ABC Book of Words*.

Western and Southern
Life Insurance Co., ABC
Book. $8-10 as shown

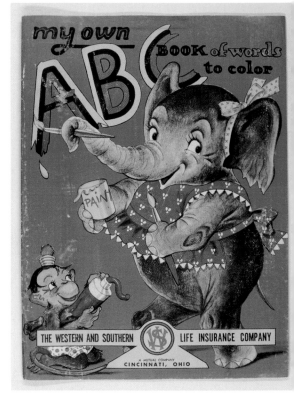

Western and Southern Life Insurance Co., ABC Book, double page

Brooke Bond Canada, Ltd.

Red Rose and Blue Ribbon Tea and Coffee

This company offered several sets of 48 small cards measuring 1-7/8" x 2-3/4". These cards were enclosed in packages of their tea or coffee from the 1940s-1960s. The noted wildlife painter, Roger Tory Peterson, did the texts for Birds of North America, Songbirds of North America, and Wild Flowers of North America. The colorful prints are from The National Wildlife Federation Collection. R. T. Peterson, Don R. Eckelberry and Maynard Reece were three of the painters represented. Two other sets the company issued were Tropical Birds and Dinosaurs.

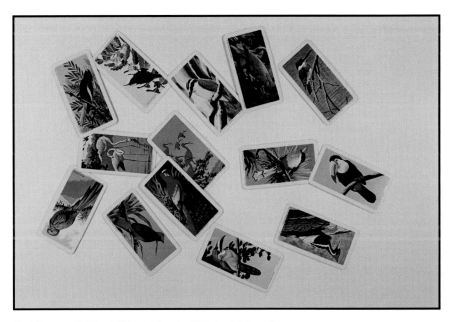

Red Rose and Blue Ribbon, Tropical Birds. $1-2 each

Red Rose and Blue Ribbon Tea and Coffee, Song Birds of North America. $1-2 each

Red Rose and Blue Ribbon, Dinosaurs. $1-2 each

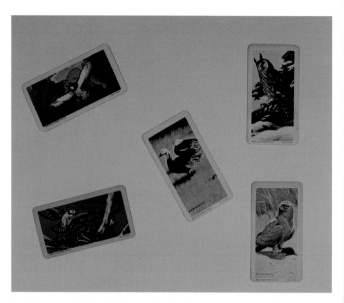

Red Rose and Blue Ribbon, Birds of North America. $1-2 each

Sambo's Restaurants

The Sambo's Gliders

This restaurant chain with its controversial name issued three cutout toy gliders. These were a Gliding Tiger, a Star Ship, and a Strato Glider. Directions for construction were printed on each sheet.

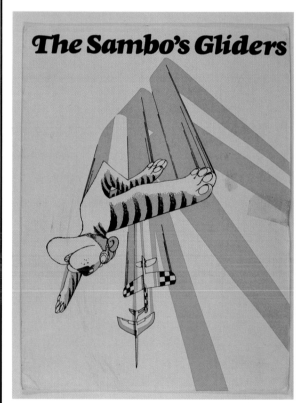

Sambo's Restaurants, The Sambo's Gliders. *Courtesy of Virginia A. Crossley.* Set: $20-25 (envelope)

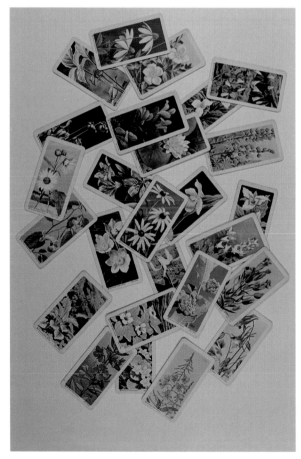

Red Rose and Blue Ribbon, Wild Flowers. $1-2 each

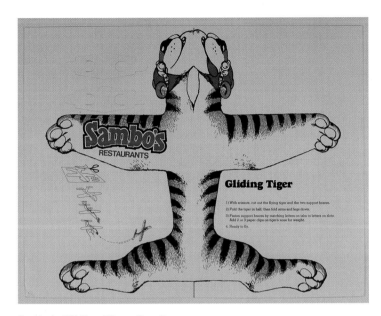

Sambo's Gliding Tiger, Part I.

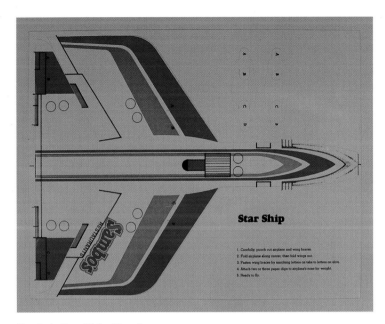

Sambo's Star Ship, Part I.

Sambo's Gliding Tiger, Part II.

Sambo's Star Ship, Part II.

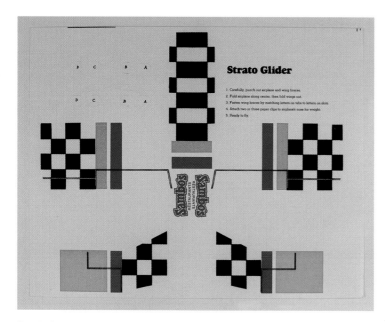

Sambo's Strato Glider, Part I.

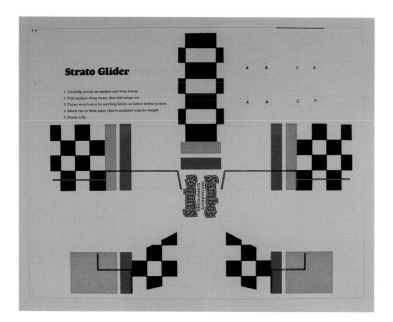

Sambo's Strato Glider, Part II.

Kroger, 100th Anniversary (1883-1983)

This company offered a FUN BOOK on their 100th anniversary. The book has 14 pages for children to color or to connect-the-dots.

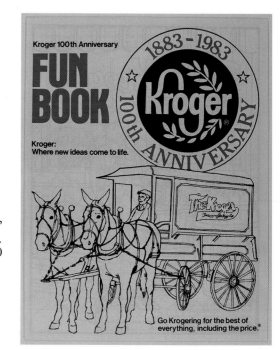

Kroger, "Fun Book."
*Courtesy of Virginia A.
Crossley.* $10

Kroger, "Fun Book,"
double page

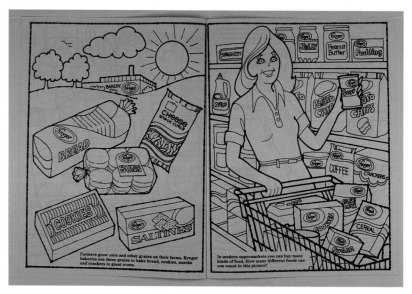

According to "Professor" Hoyle ...

The Pocket Trivia Game, Series #5, is a sports game with 53 Trivia cards and 848 questions and answers. This game was handed out by National Car Rental, and has a copyright, 1984, by Hoyle Products, St. Paul, Minnesota.

National Car Rental, Pocket (Sports) Trivia Game. Set: $8-10

National Car Rental, Pocket (Sports) Trivia Game

Hewlett-Packard Presents Winning Edge '91

The seminar folder of Hewlett-Packard has a Dalmatian dog holding an invite card. Directions are given for separating the paper toy along perforated lines, turning the toy into a "faithful" reminder to attend Winning Edge '91. No copyright is indicated.

Hewlett-Packard, Winning Edge '91. $6

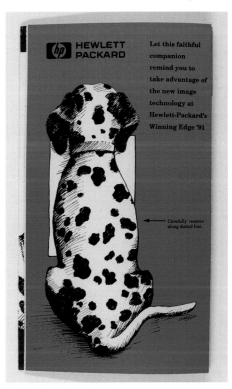

Hewlett-Packard, reversed

Holiday Inn (VISA)

WHERE IN THE USA IS
CARMEN SANDIEGO?

 This travel game was given out by the Holiday Inn chain, with the compliments of the credit card company, VISA. It is a double-sided game that on one side has a puzzle of the United States, and on the reverse side a deck of cards with directions for the common game of person, place, or thing. Copyrighted in 1992 by the University Games Corporation.

Holiday Inn/VISA, puzzle (Carmen Sandiego reversed)

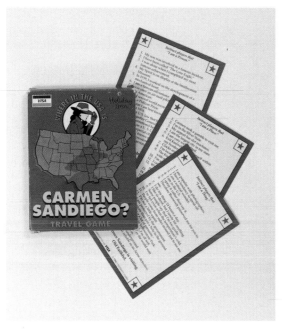

Holiday Inn/VISA, Carmen Sandiego?
(box/cards/puzzle). Set: $8-10

Index

154

MORE SCHIFFER TITLES

www.schifferbooks.com

AMERICA'S EARLY ADVERTISING PAPER DOLLS
Lagretta Metzger Bajorek
Colorful paper dolls helped to sell goods from coffee to corsets. Toys to generations of children from the 1890s to the First World War, these paper dolls depicted the era's culture through advertising by featuring folk and fairy tales, people at work and play, and costumes of many nations. Here, over 500 color photos display clever advertising in delightful diversity.
8 1/2" x 11" 508 color photos
price guide and index 160 Pages
soft cover $29.95 0-7643-0702-9

ADVERTISING DOLLS
Myra Yellin Outwater
Advertising got personal when dolls were created to carry the messages home. This comprehensive book traces the emergence of hundreds of advertising dolls like stuffed Aunt Jemima and Betty Crocker, and chronicles the extraordinary rise in popularity recently of those like Ronald McDonald or the California Raisins. Current values are listed providing the perfect reference tool for an advertising or doll collector.
8 1/2" x 11" 498 color photos
Price Guide 160 Pages soft cover
$29.95 0-7643-0303-1

VALENTINES FOR THE
ECLECTIC COLLECTOR
Katherine Kreider
Valentine novelties, postcards, and other ephemeral artifacts are presented with hints on collecting for love and for value. Valentines as party favors, paper dolls, and brand-name advertising are featured. 398 color photos with descriptive captions and values illustrate the interesting text.
8 1/2" x 11" 398 color photos Price Guide/Index
128 Pages soft cover $24.95 0-7643-0917-X

VALENTINE TREASURY
A Century of Valentine Cards
Robert Brenner
From the first reference to a valentine card in 1625 to modern times, this book celebrates sentimental charm, wit, and romance over the decades in antique valentines. European origins and American traditions, celebration and card sending customs, card designs and themes, artists and manufacturers from Howland, Whitney, Prang, to Gibson, Hallmark, and American Greetings are included.
8 1/2" x 11" 565 color photos Value Guide
208 Pages hard cover $49.95 0-7643-0195-0

ANTIQUE ADVERTISING ENCYCLOPEDIA
Ray Klug
This refreshing reminder of creative and memorable items of the past includes over 1000 color photos of advertising memorabilia—from tin containers and tobacco cutters to gum machines and thermometers. Many famous companies and little-known items are represented with newly revised pricing information throughout. Here American free enterprise is reflected in its advertising.
8 3/4" x 11 1/4" 1100+ photos Price Guide
240 Pages hard cover $49.95 0-7643-0819-X

COCA-COLA PRICE GUIDE
Al and Helen Wilson
Filled cover-to-cover with approximately 2000 bright, color pictures of the most sought-after Coca-Cola products made, from advertisements, trays and bottles to haberdashery, jewelry and amazing one-of-a-kind novelties. Helps to identify, date and price a full range of collectibles. This book has become an important reference in Coke collecting.
9" x 12" 2000 photos Revised Price Guide
256 Pages soft cover $29.95 0-7643-0983-8

ENCYCLOPEDIA OF
PORCELAIN ENAMEL ADVERTISING
Michael Bruner
Porcelain enamel advertising signs display beauty and diverse graphics to promote every type of product. The book is divided by manufacturing designs, with a chapter devoted to popular gasoline pump signs. Captions include description, measurements, and approximate age of each sign.
8 1/2" x 11" 500 color photos Price Guide
176 Pages soft cover $29.95 0-7643-0816-5

CRACKER JACK TOYS
Larry White
Prize toys found in the Cracker Jack candy box from the late 19th century to the 1990s are shown and identified. Over 290 color photos depict the front and back of many prizes and aid in identifying individual toys and sets of prizes. The categories of prizes assist in easy cataloging.
8 1/2" x 11" 295 color photos Price Guide
262 Pages soft cover $29.95 0-7643-0189-6

PEPSI-COLA COLLECTIBLES
Everette and Mary Lloyd
Pepsi, the great American soft drink, presented through 400 color photos and descriptions including trays, advertising, glasses, dispensers, memorabilia, etc. and a brief history of the Pepsi Cola company.
8 1/2" x 11" 400 color photos Price Guide
160 Pages soft cover $29.95 0-88740-533-9

OYSTER CANS
Vivian and Jim Karsnitz
Over 800 color photographs and identifications display old, original containers for oysters sold throughout the world: oyster cans, oyster jugs, and oyster bottles. The text provides wonderful details and anecdotes about the history of the oyster industry in Europe and America.
8 1/2" x 11" 831 color photos Rarity Guide
160 Pages soft cover $29.95 0-88740-462-6

VINTAGE ANHEUSER-BUSCH
An Unauthorized Collector's Guide
Donna Baker
Celebrates the early years of Anheuser-Busch, today's prevailing leader in the brewing industry. Over 400 color photos trace the company's colorful advertising from the late 1800s through the mid-20th century on lithographed prints, signs, trays, calendars, corkscrews, jewelry, and much more. Features Budweiser, Faust, Malt-Nutrine, Bevo, and other brands, as well as many rarely seen items. Values included with captions.
8 1/2" X 11" 420 color photos Price Guide/Index
160 Pages soft cover $29.95 0-7643-0739-8

www.schifferbooks.com **(610) 593 1777**

CIGAR BOX LABELS
Portraits of Life, Mirrors of History
Gerard S. Petrone
Beautiful paper images from cigar boxes are show-cased including the finest examples produced by the stone chromolithographic method between 1860 and 1910. The rich historical past that surrounds cigar manufacturing, marketing and their mystique and contemporary anecdotes, poems, and other literary cigar whimsy to amuse and educate.
8 1/2" x 11" 530 color photos Price Guide
176 Pages hard cover $39.95 0-7643-0409-7

COLLECTIBLE BEER TRAYS
Gary Straub
With over 600 color photographs of different beer companies' advertising trays and an engaging text, the reader follows the rise and fall of the litho-graphed tin beer tray from its 1890s introduction, through its golden years, and eventual post-World War II decline. Manufacturers of the trays, their artwork, and their marks are described in detail.
8 1/2" x 11" 610 color photos Price Guide
160 Pages soft cover $29.95 0-88740-840-0

COCA-COLA TRAYS
William McClintock
Coke trays are a prolific part of advertising history that show the evolution of American popular cul-ture. From ribbons-and-lace girls of late Victorian era through Roaring Twenties flappers, World War II brides, and working women of today, Coca-Cola has called upon images of glamour girls and girls-next-door to sell Coke. Warm family scenes, base-ball and children at play add to the wholesome ap-peal of Coke.
6" x 9" 250 color photos Price Guide
144 Pages soft cover $12.95 0-7643-0984-6